EISENSTAEDT *Remembrances*

EISENSTA

EDT *Remembrances*

ALFRED EISENSTAEDT

EDITED BY DORIS C. O'NEIL

INTRODUCTION BY BRYAN HOLME

A BULFINCH PRESS BOOK

LITTLE, BROWN AND COMPANY

BOSTON · NEW YORK · TORONTO · LONDON

TITLE PAGE: *Young monks hurrying along the River Arno toward the Ponte Vecchio, Florence, 1935.*

FIRST EDITION, *1990*

THIRD PRINTING, *1995*

Many of the photographs reproduced in this book are used with the permission of LIFE magazine.

Library of Congress Cataloging-in-Publication Data

Eisenstaedt, Alfred.

 Eisenstaedt: remembrances/Alfred Eisenstaedt; edited by Doris

 C. O'Neil; introduction by Bryan Holme.—1st ed.

 p. cm.

 "A Bulfinch Press book."

 ISBN 0–8212–1778–X

 1. Photojournalism. 2. Eisenstaedt, Alfred. I. O'Neil, Doris C.

 II. Title.

 TR820.E393 1990 *90-5723*

 779'.990982—dc20 *CIP*

Bulfinch Press is an imprint and trademark of Little, Brown and Company (Inc.).

Published simultaneously in Canada by Little, Brown & Company (Canada) Limited

PRINTED IN ITALY

To the loving memory of my late wife, Kathy, and to my sister-in-law, Lucille,
with great affection.

Kathy Eisenstaedt, 1957.

I am most grateful to Doris O'Neil, director of exhibitions and vintage prints at LIFE,
for assembling and editing my pictures for this book. Her editor's eye and unfailing
energy made it all possible.

My thanks also go to Bryan Holme, former editor at the Studio Books division of Viking
Press, for writing the introduction to Remembrances. *A friend of mine for many years,*
he edited nine of my books and started me on my career as an author.

I am also very much indebted to John Downey and Heike Hinsch of Time-Life Photo
Labs, who were responsible for overseeing the printing of my photographs.

Alfred Eisenstaedt

Foreword

In the course of reviewing photographs for the retrospective exhibition upon which this book was based, it was my happy duty to look at the file—of some ten thousand prints—comprising Alfred Eisenstaedt's work for LIFE magazine. In addition, I was extremely fortunate to have been permitted to explore Eisenstaedt's own vast file of his life's work, which began in the 1920s. This personal collection contains approximately 280,000 images, most of them in the form of 35mm contact prints, and most, "Eisie" tells me, rarely seen before. I selected a quarter of the photographs in this book from that file.

Although I have looked at a good many of these pictures at one time or another during the past thirty-five years, I had never looked at them one by one in such a concentrated way. In the process, I have been struck again by the apparently unlimited scope of this man's work. Not only in breadth does it loom so large, but also in sensitivity, humor, and insight.

Edward K. Thompson, who was managing editor of LIFE for a longer period than was any other person, once wrote a short article on what he considered the most significant qualities of a LIFE photographer. At the top of the list he put "intuitive sympathy and identification with the people in the story." One can see these characteristics shining out of Eisie's pictures at every turn.

Jacob Deschin, longtime photography editor of the *New York Times*, wrote one of the very best summations of Eisenstaedt's work: "Eisie is still an amateur at heart. After fifty [now more than sixty] years of professionalism he is still excited by his medium, enthusiastic as a beginner, and delighted in persons and things."

That observation is worth thinking about for a moment. Those qualities of excitement, enthusiasm, and delight describe not only Eisenstaedt the artist, but also Eisenstaedt the human being. They go a long way, as well, to explain why Eisie is such a joy and a challenge to work with.

Doris C. O'Neil, 1990

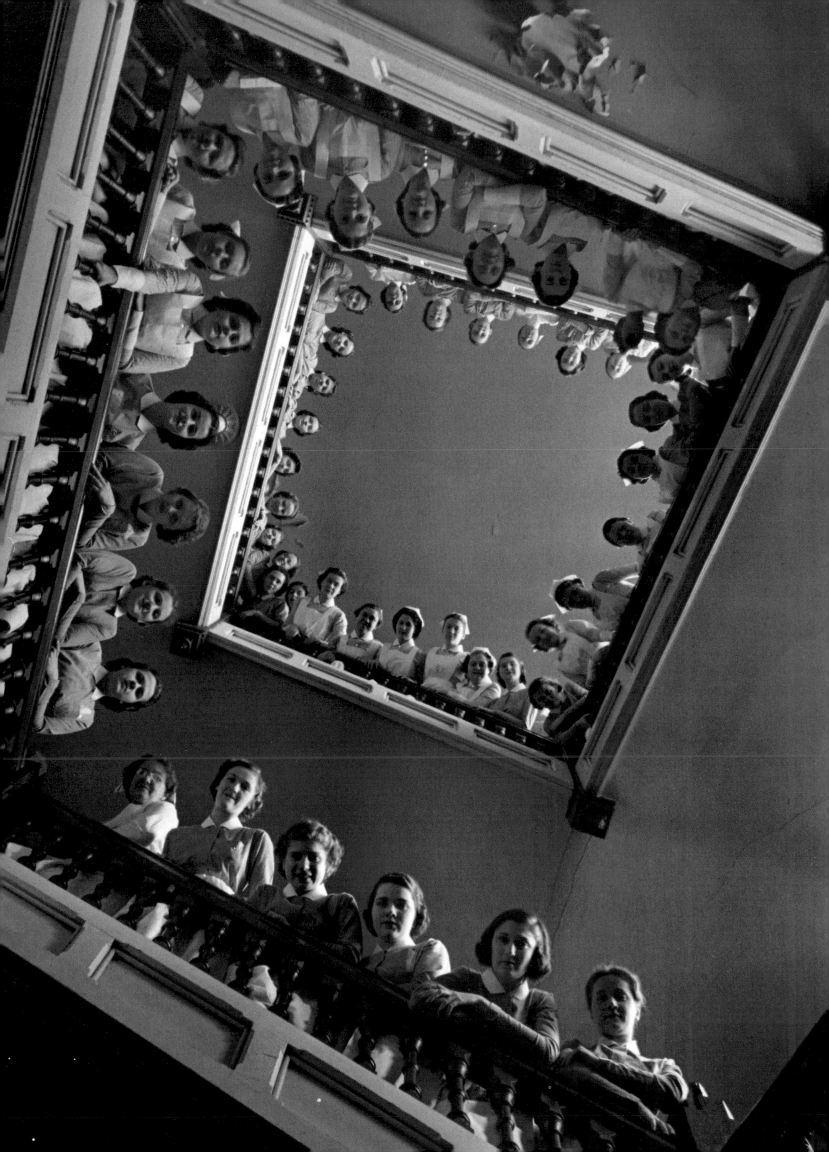

Introduction

Alfred Eisenstaedt, or "Eisie," as his friends call him, foremost photojournalist of this century, has been given a multitude of exhibitions, awards, and medals. In addition, his photographs have been the inspiration for twelve major books on his work and a tribute in verse by Robert Frost. Yet it is difficult to find a more modest, untemperamental, down-to-earth, and friendly person—or, incidentally, to find a master photographer more ready to help others in his profession and to say complimentary things about them.

"Making friends is second nature to me," Eisie says with a broad, instinctive smile that makes one think what a great personal asset this must have been during his countless portrait assignments. "I like photographing people only at their best," he will tell you. "This means making them feel relaxed and completely at home with you from the beginning." Then, with characteristic warmth and an unerring eye he painlessly records the strongest and most natural, yet the most distinguished image possible. This exceptional talent first showed itself when Eisie was still a schoolboy in his native Germany.

Eisenstaedt was born of well-to-do parents in Dirschau, West Prussia (now part of Poland), in 1898. His father owned a department store there until his retirement in 1906, when he moved the family to Berlin. As a boy, Alfred enjoyed listening to the symphonies of the great composers, and he even thought of studying to become a musician himself. But on his thirteenth birthday an uncle, quite by chance, presented him with his future in the shape of a camera. This folding Eastman Kodak Number Three led Eisie to his lifelong dedication to photography. Soon he was learning how to develop and print his own films, "borrowing" the bathroom in his parents' apartment for a makeshift darkroom.

The outbreak of war in 1914 interrupted everything. Within two years Eisie was drafted into the German army, and he served at the front in Flanders until April 1918, when enemy fire crippled both his legs. During a yearlong recovery, Eisie, who walked first with crutches, then with canes, became a familiar figure at the local art museums. There he studied the paintings of the masters, particularly with an eye to their handling of composition and lighting.

Nurses and undergraduates (the latter without caps) line the stairwell at Roosevelt Hospital School of Nursing, New York City, 1938.

The postwar years were critical for the Eisenstaedts as they were for all the German people. On top of having suffered defeat in battle, they had lost their savings in the devastating inflation that swept the country after the armistice. To help out at home, Eisie looked around for any paying job he could find, ending up as a salesman for a wholesaler of belts and buttons. The job, at which he didn't feel he was much good anyway, became less and less attractive to him—except on payday, when he would again have enough pocket money for photographic supplies.

Eisie had never given up his favorite hobby, and in 1925, after becoming the proud owner of a Zeiss camera—which used glass plates rather than film—he started experimenting with enlargements. "It was wonderful," Eisie recalls, "to see the way you could crop out a face, a hand, any detail you wanted from the picture, blow it up, and make it into a composition of its own."

In 1927, while on holiday in Czechoslovakia, Eisie photographed a tennis match, attempting a dramatic, all-but-impossible shot of both players. "The result was disappointing until I saw that by enlarging one section of the photograph—the lady serving the ball, and her shadow on the court—then cropping out the other player, the photograph suddenly became alive . . . and fun [pp. 2–3]. A friend suggested I show my 'masterpiece' to the picture editor of *Der Weltspiegel*. I did so, and after saying he liked it, to my great surprise he not only said, 'We'll buy it,' but encouraged me to bring in more, 'as long as they are good ones.'"

By 1929 Eisie was earning more as a free-lance photographer than he was as a salesman, so he decided to risk devoting all his time to what he loved doing most. As he was leaving the sales office his former boss bade him the dourest of farewells: "You know what you're doing, don't you, Eisenstaedt? You're digging your own grave!"

What Eisie had done, in fact, was to take his first step toward fame and fortune. Within days Pacific and Atlantic Photos (later the Associated Press) sent him to Stockholm to cover Thomas Mann accepting the Nobel Prize in literature (p. xi). Operating out of Berlin, Eisie continued to build a name for himself by taking pictures of topical interest, including images of delegates at the international conferences at The Hague, Lausanne, and Geneva. At the same time he was attracting increasing attention among magazine editors with his pictorial studies such as a haunting, Degas-like image of ballet dancers at the Paris Opera (p. 33). His work regularly found its way into *Die Dame, Berliner Illustrïerte Zeitung, The Graphic, The London Illustrated News*, and other magazines. In 1932, Eisie bought his first Leica, the 35mm camera that was revolutionizing photojournalism.

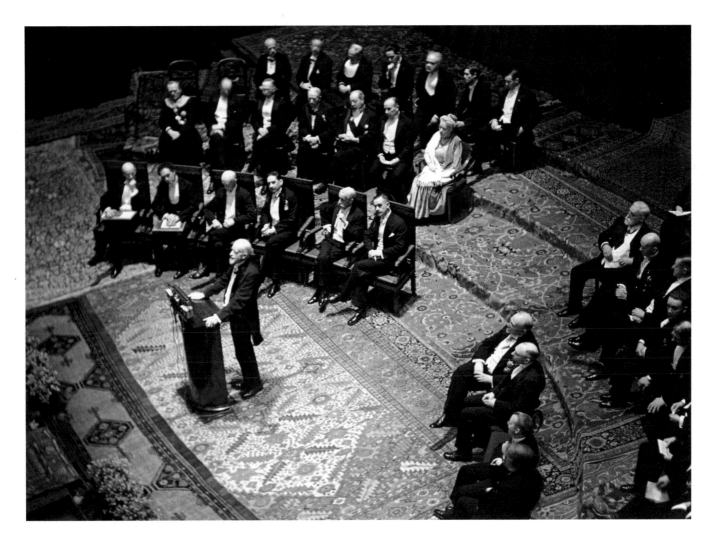

Thomas Mann (first row, far right, behind speaker) receiving the Nobel Prize in literature, Stockholm, 1929. Directly behind Mann is Selma Lagerlöf, also a Nobel laureate. From Eisenstaedt's first assignment as a professional photographer.

Despite his success, Eisie saw more and more clearly that not only was the political climate in Germany deteriorating ominously—in 1933 and 1934, he had photographed with distaste a scowling Joseph Goebbels (p. 24), a goose-stepping Hitler (p. 25), and a bombastic Mussolini (pp. 26–27)—but that, from what he had heard, the greatest opportunity for photojournalists now lay in the United States. In 1935, after several of the best illustrated magazines had folded owing to the rise of Hitler, Eisie finally made up his mind to emigrate. He sailed from Le Havre on the *Ile de France*, arriving in New York at the end of November.

At that time Henry Luce, the publisher of *Time*, was creating journalistic history by purchasing the comic magazine LIFE, with the intention of using only its title for his new pictorial weekly. Within the offices of *Time* the project had been designated "Magazine X," and prototypes were being printed. Kurt Korff, a former editor of the

Berliner Illustriërte Zeitung, had spoken highly to Luce of Eisenstaedt and his work, and a day or two later Eisie was showing his photographs to the executive editor of LIFE, Daniel Longwell. Besides pictures of European politicians and royalty, Eisie's portfolio was overflowing with other newsworthy faces, including Bernard Shaw (p. 16), Marlene Dietrich (p. 11), Gloria Swanson (p. 10), and Charlie Chaplin. Throughout the years Eisie has particularly enjoyed photographing musicians, composers, and conductors, and on his first visit to LIFE he had with him recent shots of Igor Stravinsky, Yehudi Menuhin, Sergei Rachmaninoff, Arturo Toscanini (p. 12), and Vladimir Horowitz and Gregor Piatigorsky (p. 12). Of a very different nature was a photo essay Eisie had made aboard the Graf Zeppelin (pp. 22–23). Longwell was duly impressed, and the magazine hired Eisie on a trial basis.

In 1936, while covering the very poor in the South on his first assignment for LIFE, Eisie took one of his most moving photographs. It showed a sharecropper's family seated around a table at the beginning of a meager meal, their heads reverently bowed as the father prayed, "Bless, O Lord, this food for our use and us to Thy service." This masterpiece was not lost on Longwell, Luce, or, indeed, on anyone else who saw it. In 1946, Luce was to write: "My confidence in LIFE, in our actual ability to do a good job of pictorial journalism, began when Alfred Eisenstaedt came back from his first prepublication assignment."

Within a few months Eisie had become one of the four staff photographers for the new magazine. The other three were Margaret Bourke-White (p. 64), who was already nationally famous in her own right, Thomas McAvoy, and Peter Stackpole.

Extensive research had gone into the potential market—and in those days before television there was a large one—for a first-rate American magazine covering major world events with pictures and brief, informative captions and text. Not only did LIFE accomplish this dramatically, but the magazine also ran features on art, theater, movies, science, sports, education, and other subjects of current interest. With the right backing this formula could hardly fail, and its success exceeded all expectations.

On November 21, 1936, the first issue of the new magazine was the hottest seller on the newsstands. The cover of the second issue featured Eisenstaedt's photograph of the hazing of a cadet at West Point (p. 65), the first of more than eighty cover images that Eisie contributed to LIFE over the next fifty years.

I was a charter subscriber to the magazine, not only for pleasure but because it was my job, always with the potential for a book in mind, to follow the work being done by the world's leading photographers. Within a few years Eisenstaedt was being

referred to as "the father of photojournalism," but it was not until 1965 that I got to know him personally and to develop a lasting friendship, which I value greatly to this day. As editor and director of the Studio Books division of Viking Press, I worked with Eisie on his first book, *Witness to Our Time*. As a tie-in, an immense one-man show opened in the fall of 1966 at the Time-Life Building in New York before traveling throughout the country.

When I first discussed with Eisie the scope of the book and the maximum number of gravure and color pages the budget would allow, he was wide-eyed and not a little worried. "I don't see how you are going to do it. I have taken thousands and thousands of photographs," he said, waving his arm toward stack after stack of yellow boxes lining from floor to ceiling his little, windowless room—the same one he occupies today—on the twenty-eighth floor of the Time-Life Building.

Being something of an old hand at this kind of book, I was able to reassure him that he would be on completely safe ground if we were to review chronologically all his stories for LIFE. Then, with an eye to whom and what seemed of most current interest, we would begin to edit the images, and keep on cutting until the best of the photographs from the best of the essays were comfortably accommodated—along with a number of unpublished masterpieces. Before I saw Eisie again, he had flagged all his features in the bound volumes of the LIFE library. From the very start there was no disagreement between us as to which pictures and stories simply had to be included and which were second and third choices.

Eisie had twice visited the West Coast, and his coverage of Hollywood in the 1930s was among his strongest work. (I was particularly happy when we unearthed pictures of top box-office personalities which LIFE had never published.) In one or another of his yellow boxes were photos of everyone you would expect, including Will Rogers, Gary Cooper, Katharine Hepburn (p. 56), Cary Grant, Joan Crawford, Jimmy Stewart, Carole Lombard (p. 57), Cecil B. De Mille, and Bette Davis. There were also hundreds of unexpected candids: for instance, a laughing Clark Gable resting between takes, with fake blood running down his face; Bob Hope wisecracking with Lucille Ball at a rehearsal; and a delightful shot of Basil Rathbone lunching in the commissary at Paramount Studios with Angela Lansbury, who, dressed in a fairy-tale costume and glittering crown, was digging into a hamburger (pp. 88–89). This "galaxy of the glamorous" was sufficient to fill a volume of its own, as were Eisie's photos of statesmen, politicians, royalty, scientists, writers, musicians, dancers, artists, naturalists, and religious leaders.

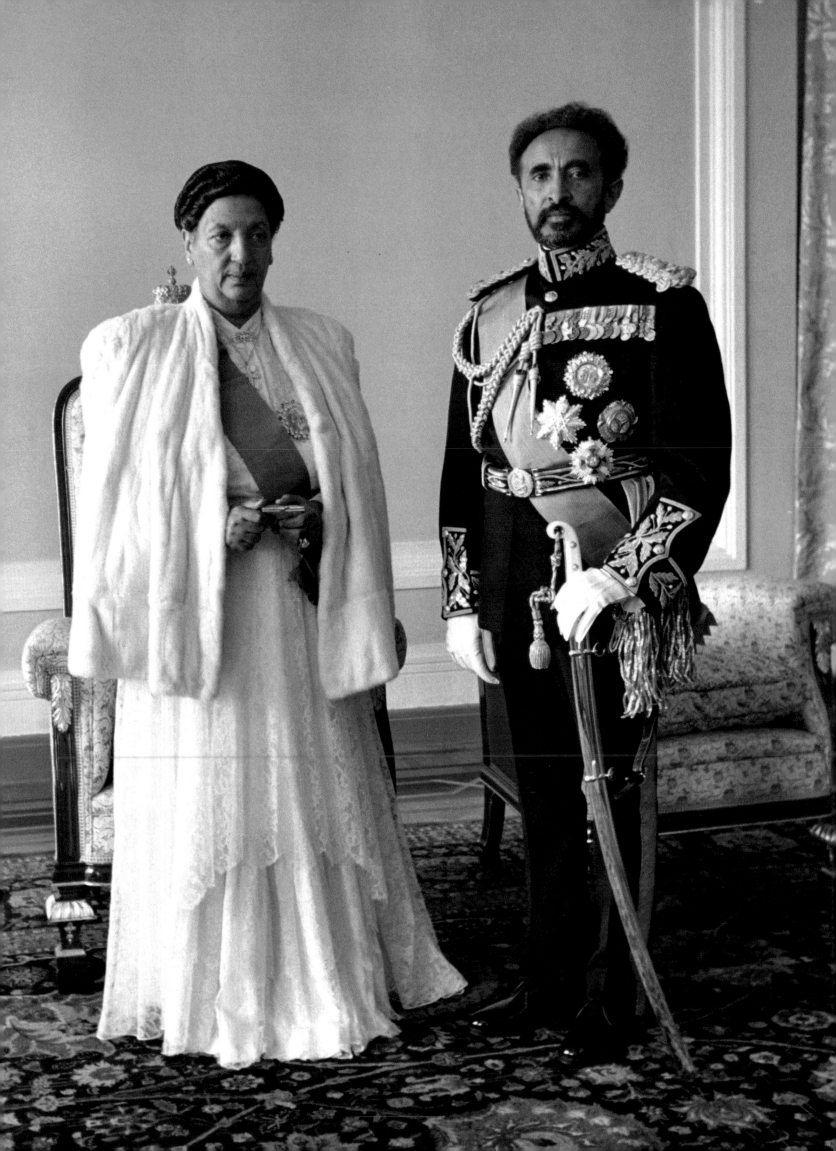

While I was sorting through the photographs one morning, I remember looking up to see Eisie chuckling over a picture he had just found in another box. That there was something of a clown in Eisie I knew from the photos he had shown me of himself standing on his head, squinting, and from pictures of him dressed as Napoleon and as Dr. Jekyll and the most outrageous of Mr. Hydes—not to mention as Veronica Lake. It had amused him to let a Hollywood makeup artist go to work on his clear-cut features in order to demonstrate—no doubt with a feature for LIFE in mind—the miraculous transformations that were possible through dexterously applied grease-paint, a wig, and a costume. There was a mischievous expression on Eisie's face as he came over to me. "Want to see something funny?" he asked. "Look at this." The picture he handed me was of Sophia Loren surrounded by her young family—and with who else but Eisie perched on her lap and grinning like a Cheshire cat.

"Great Scott!" I laughed.

"She's a fantastic girl," Eisie said.

"Obviously. And don't tell me you didn't fix the camera to give you as long a time as possible on *that* pair of knees."

"Sophia is a wonderful friend. . . . The first time I photographed her was in Italy when she was filming *Madame Sans-Gêne* [or *Madame* as it was called in the English-language release]. You know what she once told me? 'Beauty is no hardship if you don't think about it.' Really! We hit it off from the very beginning, and I always looked forward to photographing her whenever she flew to New York." The most famous of Eisie's collection of "Sophias" raised many a reader's eyebrows in 1966 when it hit the stands on the cover of the September 16 issue of LIFE (p. 93).

Just as Sophia has remained Eisie's favorite assignment, Ernest Hemingway was his least favorite. While Eisie was photographing the author for a LIFE tie-in with his latest book, *The Old Man and the Sea*, Hemingway, in a sudden fit of rage, grabbed Eisie and tried to throw him, camera and all, off a dock. "Slave driver," Hemingway shouted at a determined Eisie, who had never yet returned from an assignment without a complete story. He wasn't going to this time either, even if it meant recording a menacing Hemingway with stick in hand.

Eisie has a remarkable memory for the exact date on which he took each of his thousands of photographs. And he always has a story to go along with the documentation. When I pulled a box marked "Marilyn Monroe" from the wall, Eisie was already telling me: "I took those photographs just after she had finished *There's*

Emperor Haile Selassie and his empress on the twenty-fifth anniversary of his coronation, Gibbi Palace, Addis Ababa, Ethiopia, 1955.

No Business Like Show Business and was about to start work on *The Seven Year Itch*. Isn't she beautiful? I always prefer photographing in available light—or Rembrandt-light I like to call it—so you get the natural modulations of the face. It makes a more alive, real, and flattering portrait" (p. 91).

Eisie was also extremely proud of his photographs of John F. Kennedy, particularly the official portrait taken in the White House following his inauguration. "He sent it to close friends and heads of state all over the world," Eisie said, as he handed me the color transparency. During the presidential campaign he exposed roll after roll of the president, and many of Jackie and Caroline as well (p. 77).

The more I worked with Eisie's photos, the more I became aware of how well composed they always were. I wondered how much he might have learned from the early days, when he was making enlargements and cropping in order to create a well-balanced composition, and how much was instinct at the time of exposure itself. "I seldom think when I take a picture," Eisie says. "My eyes and fingers react—click. But first, it's most important to decide on the angle at which your photograph is to be taken." Eisie showed me a portrait of Winston Churchill which he had made at Chartwell in 1951. "I was all set to photograph the Prime Minister from the best side and at the best angle, as he sat in an armchair in his library. But Churchill shook his head. 'Young man,' he called me (I was fifty-two at the time), 'I know how to take pictures. You have to do it from *there*.' In order to please the great man I photographed him 'from there,' and then discreetly skipped back to the opposite side and got the picture I wanted."

While in England Eisie completed a portfolio on "Distinguished Britons" for LIFE. Among them were T. S. Eliot (p. 102), philosopher Bertrand Russell (p. 31), and Dame Edith Evans as Lady Bracknell during the famous interview scene in Oscar Wilde's *The Importance of Being Earnest* (p. 87). He also photographed the Reverend Martin Cyril D'Arcy (p. 32). "Just look at those soul-searching eyes," Eisie said, showing me the portrait. "In a photograph a person's eyes tell much, sometimes they tell all."

Eisie has aimed his camera not only at famous faces. Far from it. The Eisenstaedt phenomenon—he dismisses the word *genius*—also consists of the extraordinary variety of his assignments (some twenty-five hundred for LIFE alone), his boundless energy, his tenacity and, above all, his keen eye for the kind of human-interest picture that most appeals to the public. One of his favorites is of Parisian children excitedly watching a puppet show and exploding with shrieks of delight as the dragon gets slain

(pp. 114–115). Another is Eisie's most famous candid of all: that of a passionate young sailor grabbing a passing nurse for a long-to-be-remembered kiss amid the hurrahs of a Times Square gone wild with joy over the end of World War II (p. 67).

And what could be in greater contrast to Eisie's photograph of the Daughters of the American Revolution sipping tea in Philadelphia than his image of a hairy chieftain of the Ainu skinning a bear and sharing its blood with celebrants at the Hokkaido Bear Festival in Japan? Also, what could be more different from the elegant picture of the Duke and Duchess of Windsor visiting America after Edward's abdication (p. 84) than Eisie's image of wild, dragonlike iguanas on the Galápagos Islands, or that of the anger, frustration, and bewilderment on the face of a victim of Hiroshima?

There is yet another side to the "eye of Eisenstaedt," which was all but unknown until *Witness to Nature*, his fourth book, revealed it so beautifully in 1971. Eisie is never without camera in hand in the country, as elsewhere, and especially during his leisurely holidays on Martha's Vineyard, when the poet in him takes over. He might turn to photograph a field of wildflowers swaying in the summer breeze, be captivated by the graceful lines and movement of a ship in full sail (p. 135), or be inspired by the majestic tracery of the boughs of an ancient oak against the sky (pp. 138–139). This quiet communication with nature is a far cry from Eisie's earlier, more rigorous assignments. Hoisted into the treetops on a roped platform, for instance, he had to record on film the exotic wildlife of the rain forest in Surinam. For hours on end, sweating and with aching muscles, he worked surrounded by snakes, giant mosquitos, ants, and flies that buried their eggs under his skin. Why did he have to go to such extremes? "Because that's where the pictures were," he says with characteristic stoicism.

Today, though his camera is no longer the extension of eye and hand to the degree it once was, Eisie remains, in mind and spirit, "where the action is." "I will never retire," he says, and he indeed keeps busy with exhibitions, books, personal appearances, and bringing his records up to date.

I once asked Eisie if he had ever felt awed by any of the hundreds of famous people he had photographed. "Never when I had a camera in my hand," he said. "I always remembered what Wilson Hicks, the picture editor of LIFE, said to me when I was on assignment photographing the most glamorous stars in Hollywood: 'They may be queens in their profession,' he said, 'but you are a king in yours.' This has always helped me with anyone and everyone."

Bryan Holme, 1990

EISENSTAEDT *Remembrances*

The earliest photograph in this book, this is also the first that Eisenstaedt sold for publication; it was taken in Bohemia in 1927. In taking this picture, the budding photographer realized that sometimes a part is more important than the whole, and that an image can sometimes be improved by enlarging a detail of the composition. This tennis player was originally a minor theme in a much busier scene.

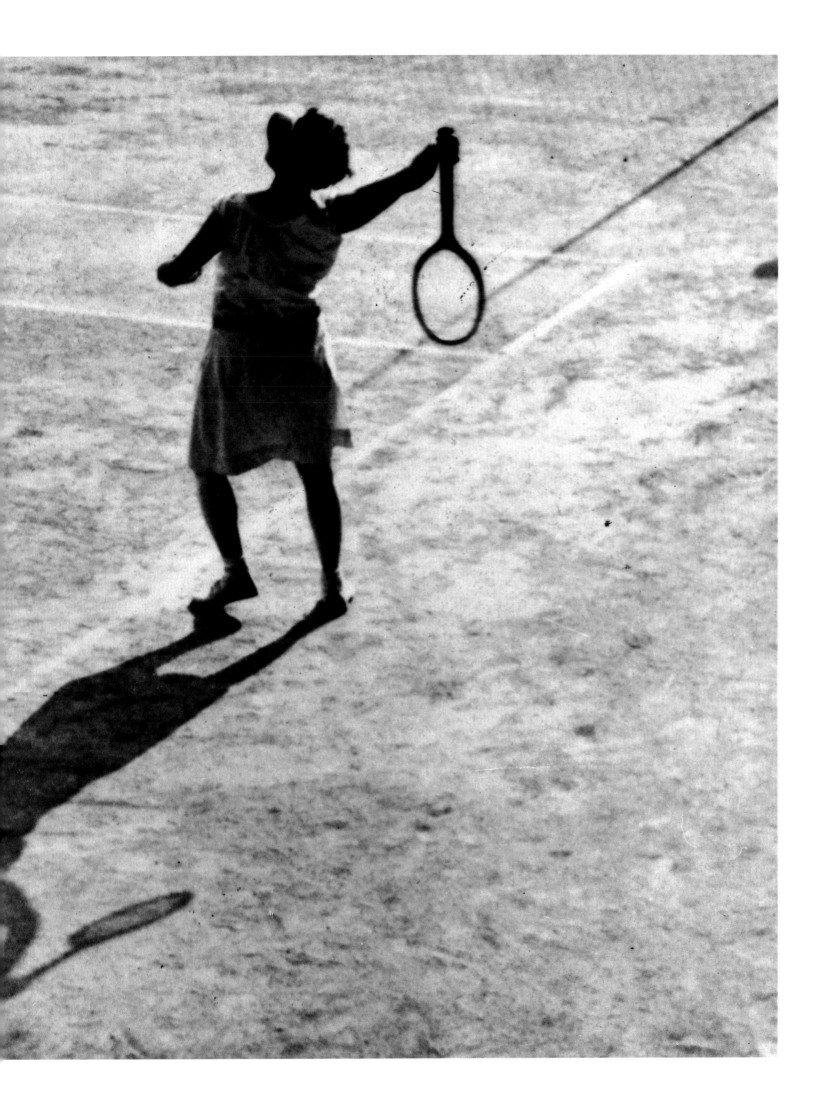

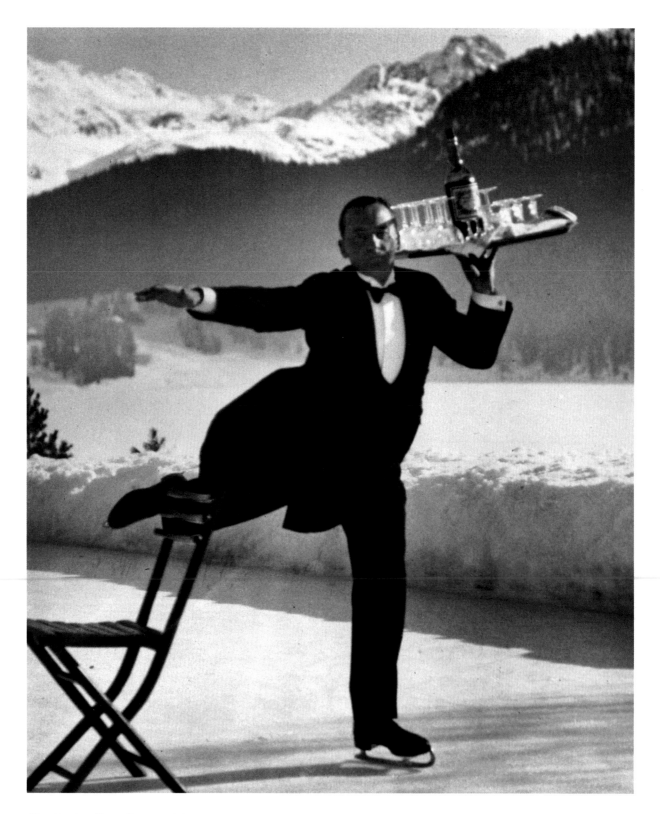

Headwaiter René Breguet brings
aperitifs to English guests at the skating
rink of the Grand Hotel, Saint-Moritz,
1932.

An English couple at a cocktail bar
made of solid ice, at the skating rink of
the Palace Hotel, Saint-Moritz, 1932.

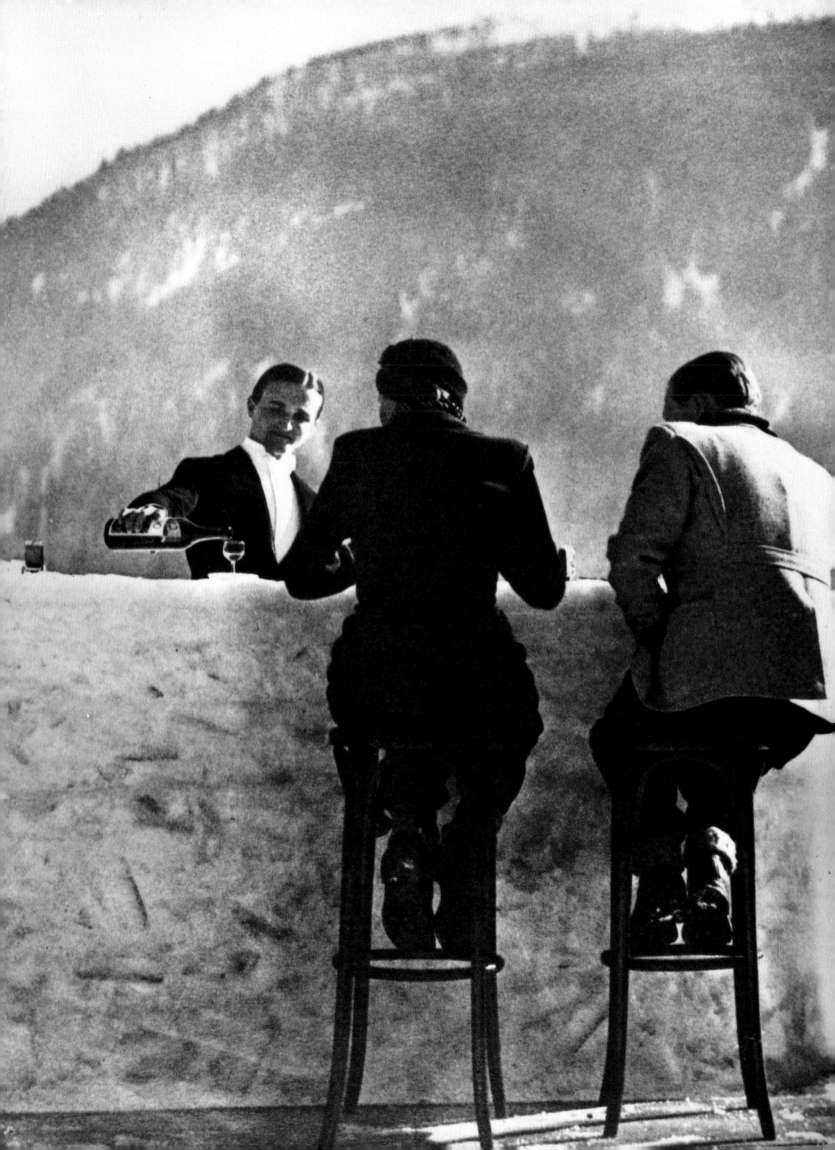

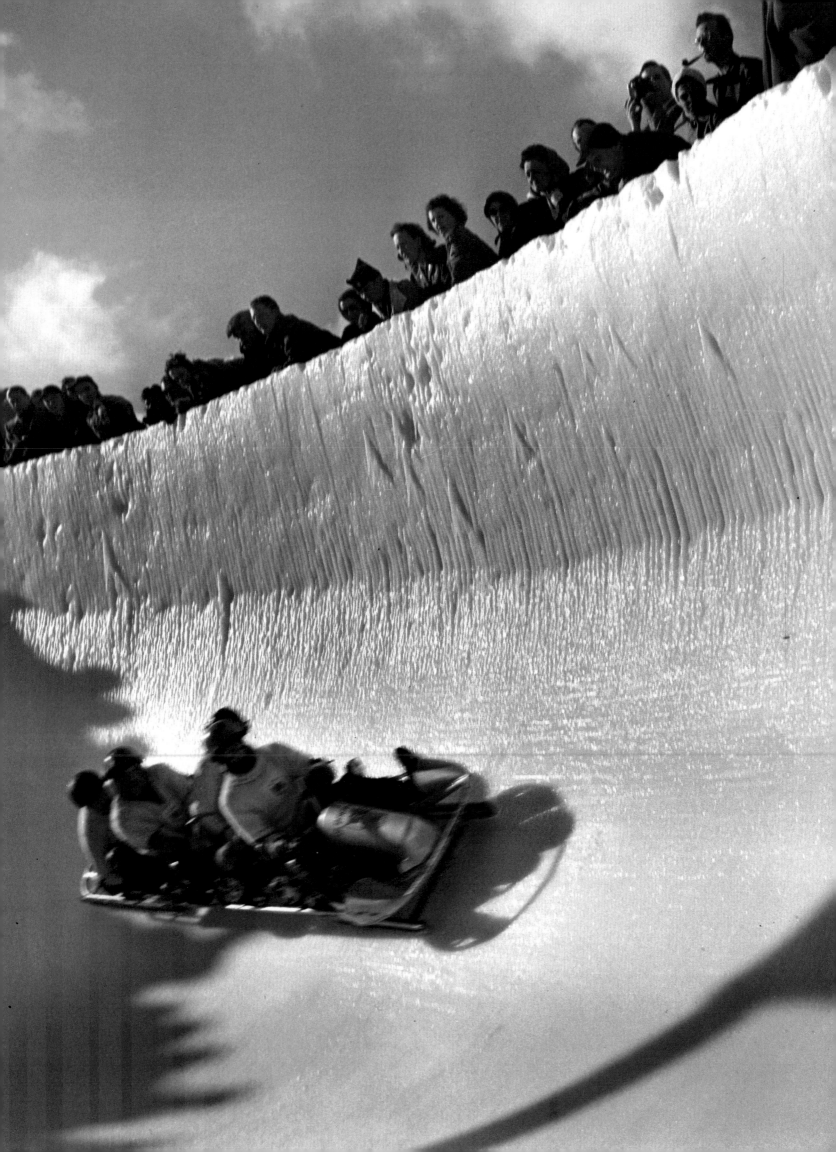

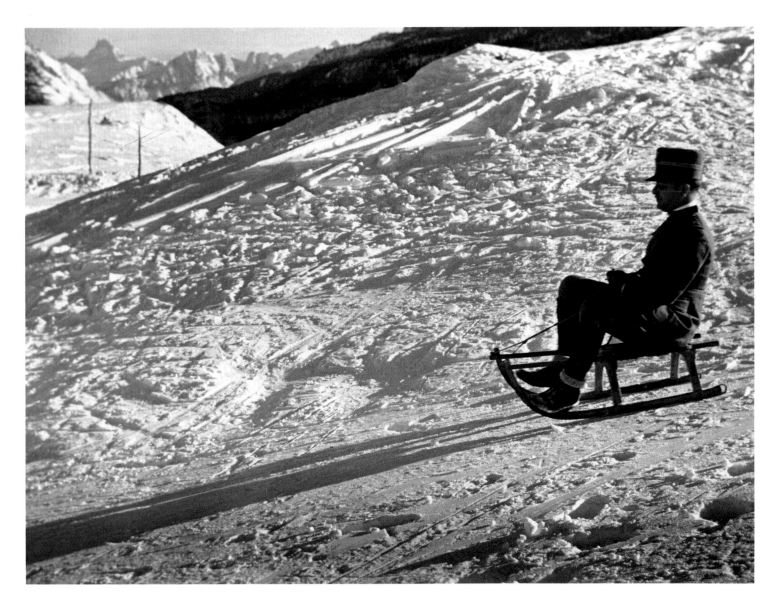

An Italian officer enjoys a sled ride at Sestrière, a resort in the Italian Alps, 1933.

A four-man bobsled rounds the Sunny Corner of the renowned Cresta Run at Saint-Moritz, 1932.

A night photograph of a village in the Harz Mountains of Germany, 1929 or 1930. One of Eisenstaedt's first photographs with the legendary Ermanox camera, which he had bought in 1928, this image marked the beginning of his lifelong devotion to natural-light photography. The first "candid camera"—one capable of taking informal photographs with short exposures even in low light, rather than more formal, posed pictures made in the studio—the Ermanox was designed to permit the photographer to dispense with flash and to work with existing light only. This capability far outweighed the one disadvantage of the new camera: it used only glass-plate negatives, which were expensive, and heavy to carry around on assignment. With the advent of the Leica, even that handicap was overcome.

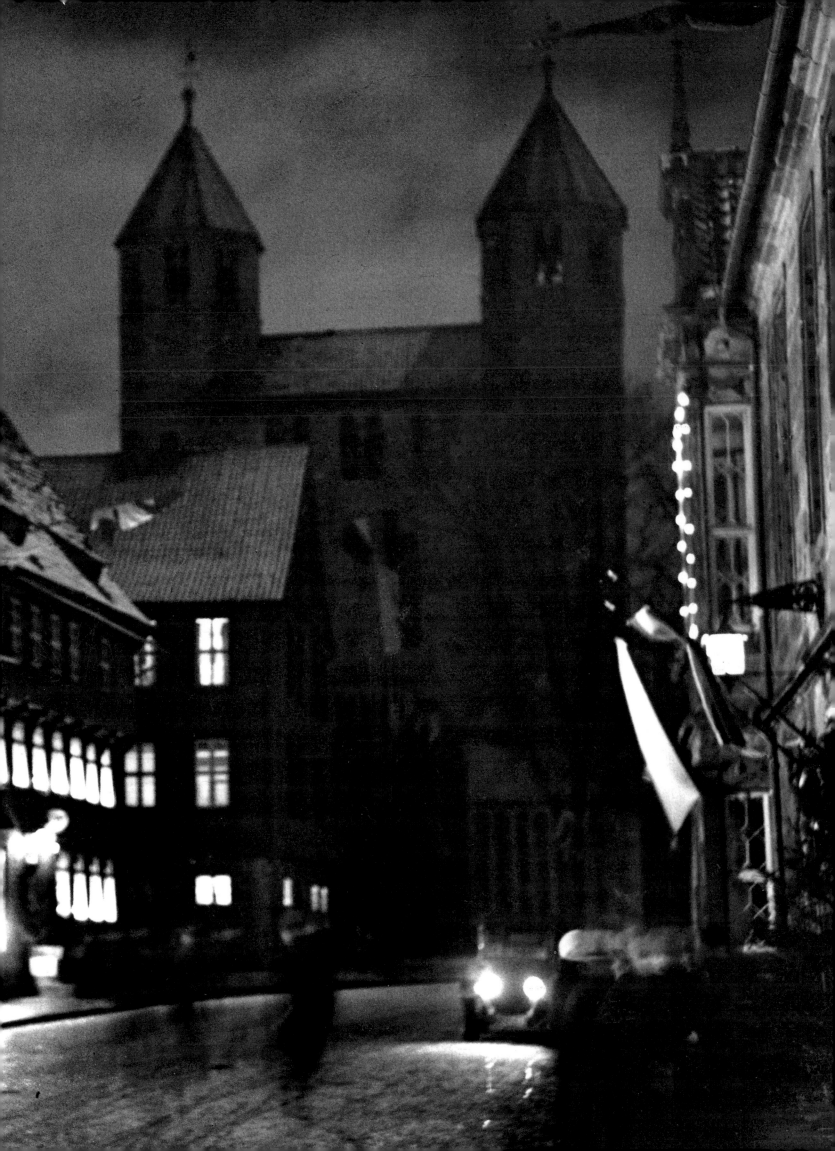

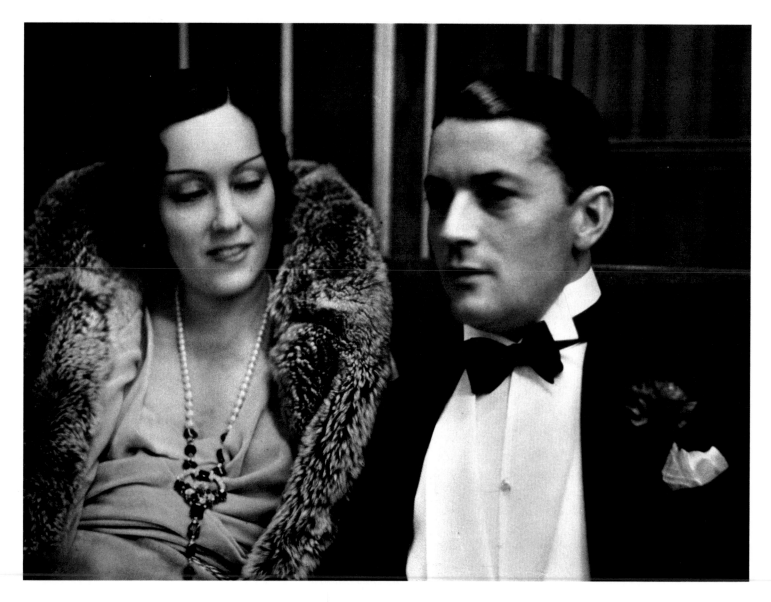

*Gloria Swanson and her fourth
husband, Michael Farmer, in the bar of
the Palace Hotel, Saint-Moritz, 1932.*

*Marlene Dietrich at the annual Ball for
the Foreign Press in Berlin, 1928.
Dietrich was working on Josef von
Sternberg's film* The Blue Angel *at the
time, and went to the party wearing
men's attire.*

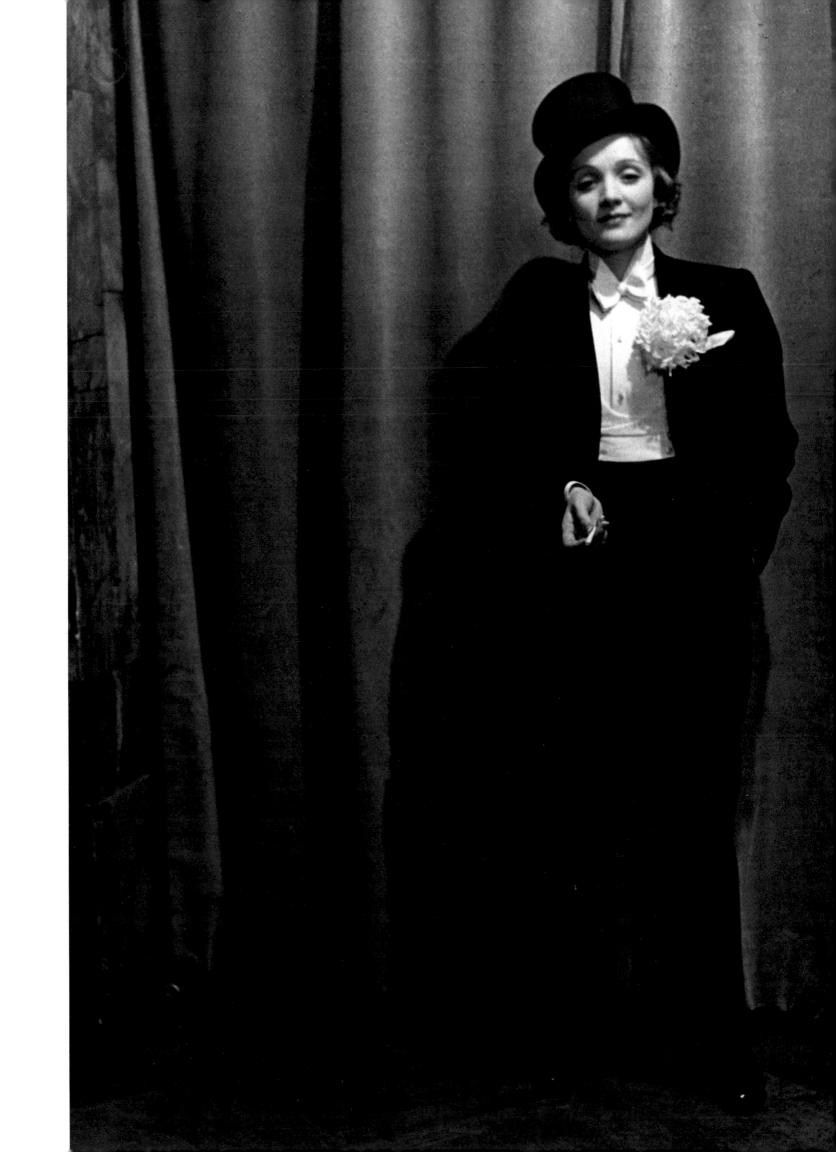

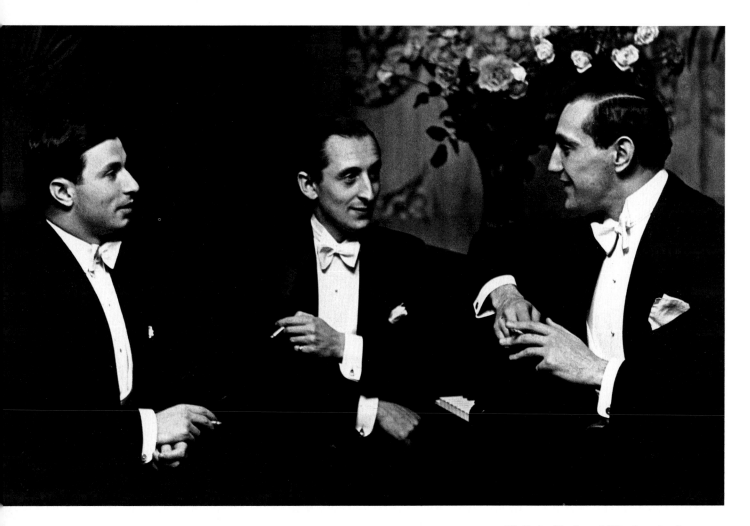

Violinist Nathan Milstein, pianist Vladimir Horowitz, and cellist Gregor Piatigorsky rest backstage during the intermission of a concert at the Berlin Philharmonie, 1932.

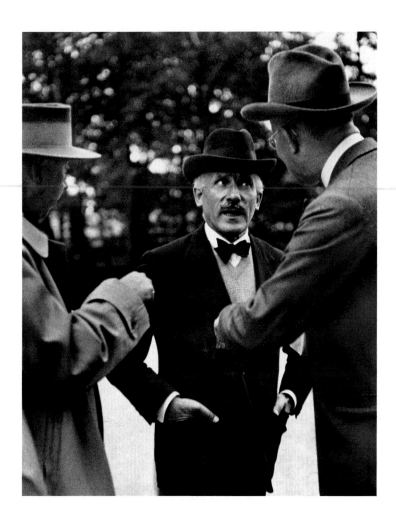

Arturo Toscanini talking with Richard Wagner's grandson Wieland in Bayreuth, Germany, early 1930s.

OPPOSITE: *The gala premiere of Rimsky-Korsakov's opera* Legend of the Invisible City of Kitezh *at La Scala, Milan, 1934. The girl in the foreground was unaware that she was the focus of Eisenstaedt's photograph.*

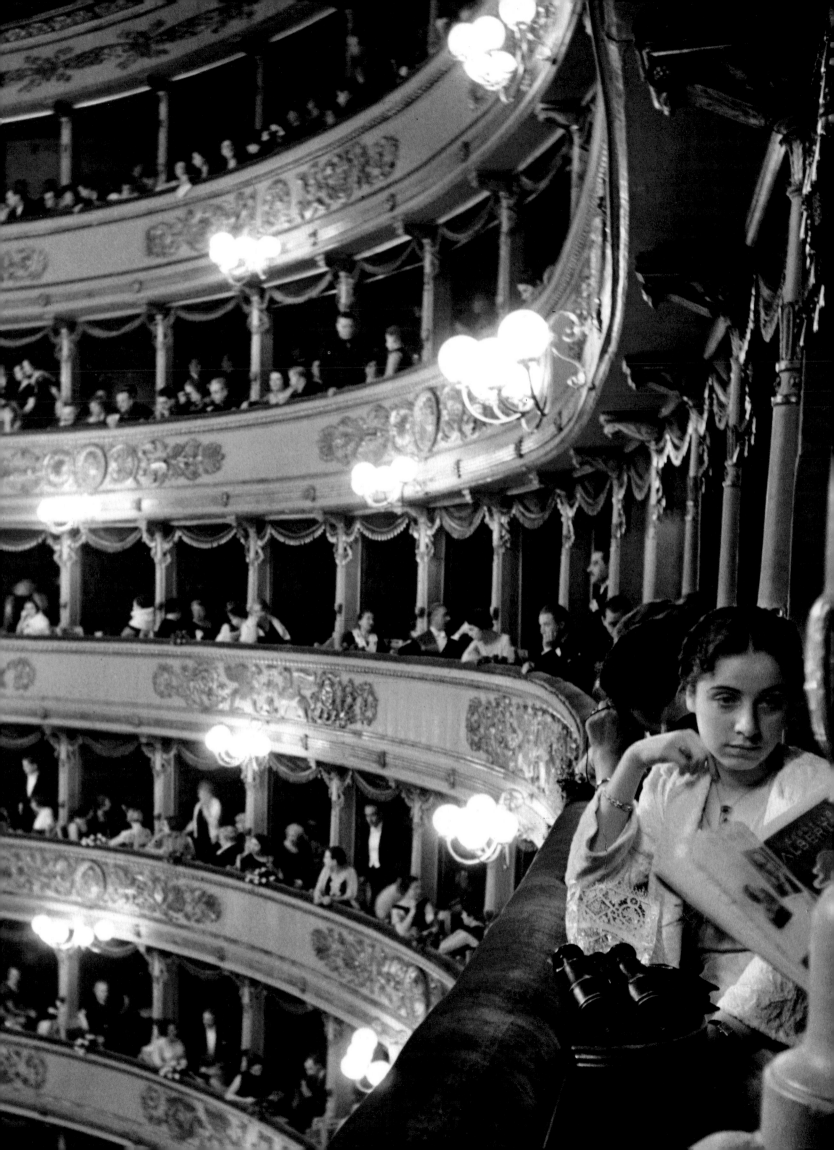

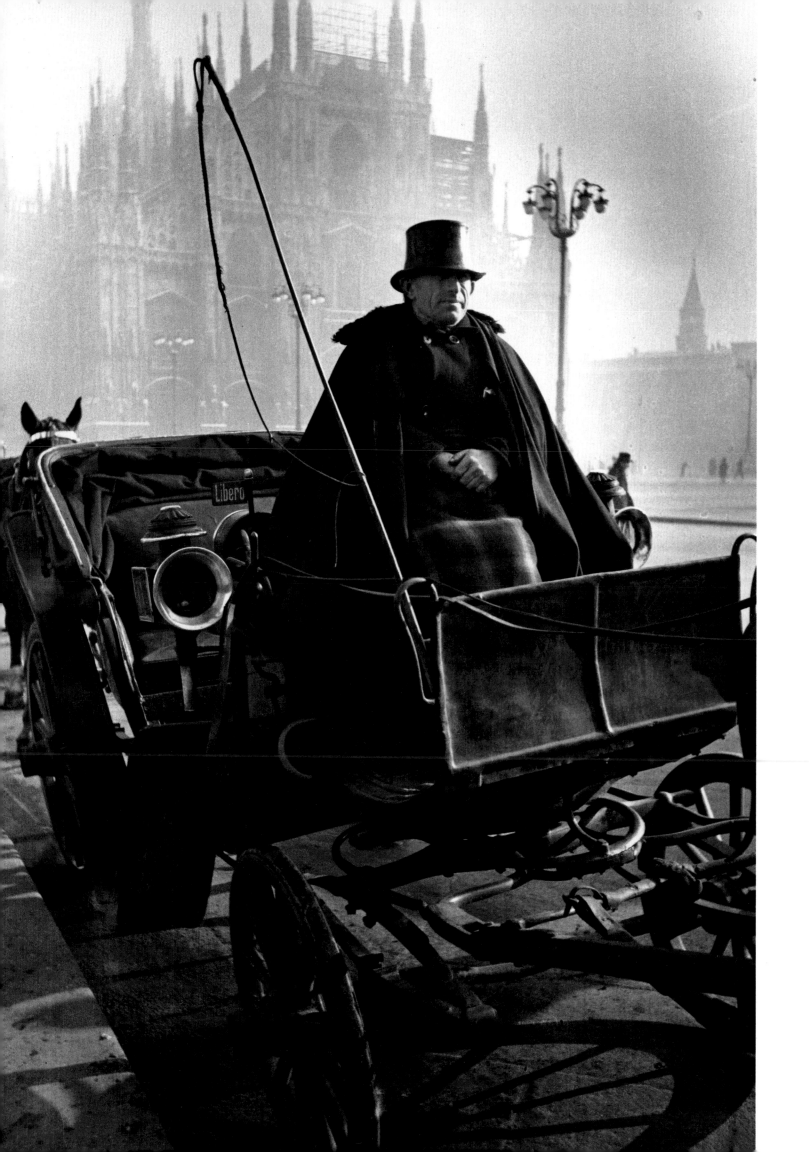

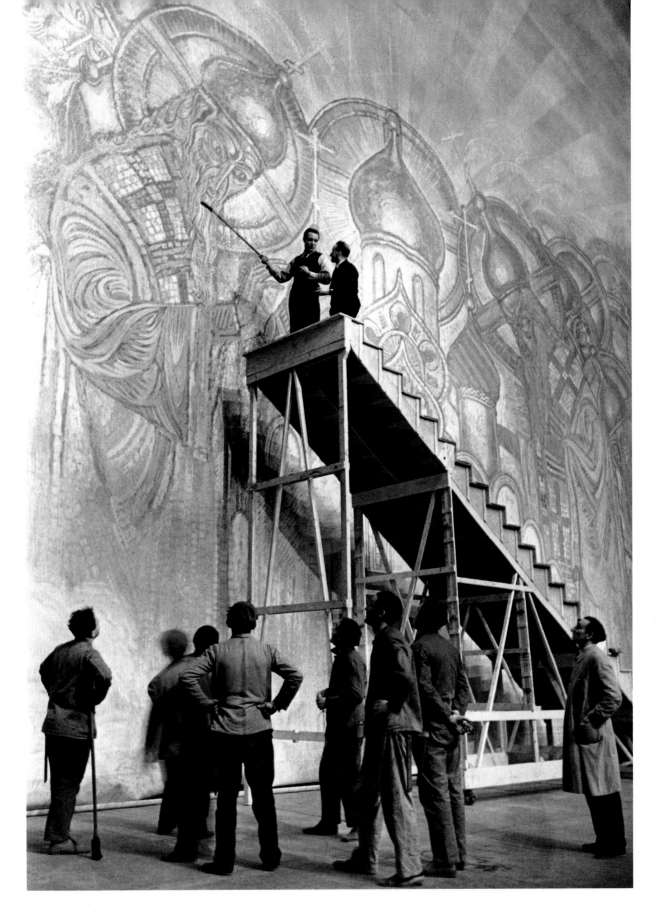

From a high platform in La Scala, stage designer Nicola Benoit works on a backdrop for Rimsky-Korsakov's opera Legend of the Invisible City of Kitezh, 1934.

A horse-drawn carriage waits for a fare near La Scala, 1934. In the background is the Duomo (Cathedral of Santa Maria del Fiore).

15

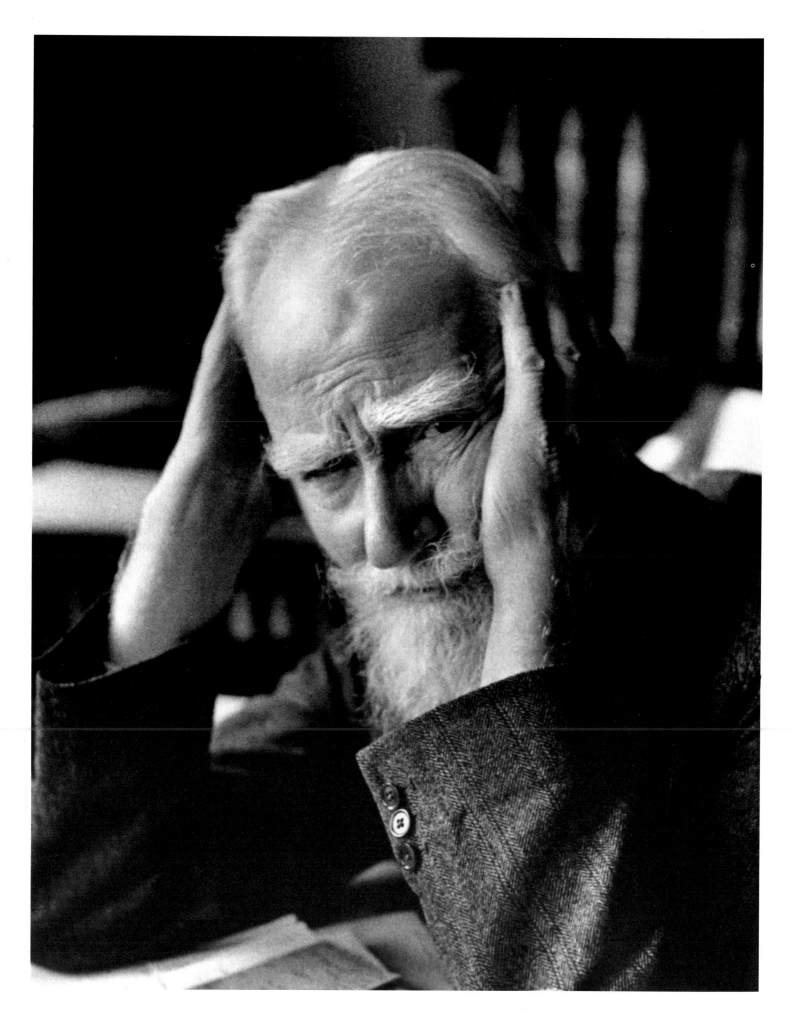

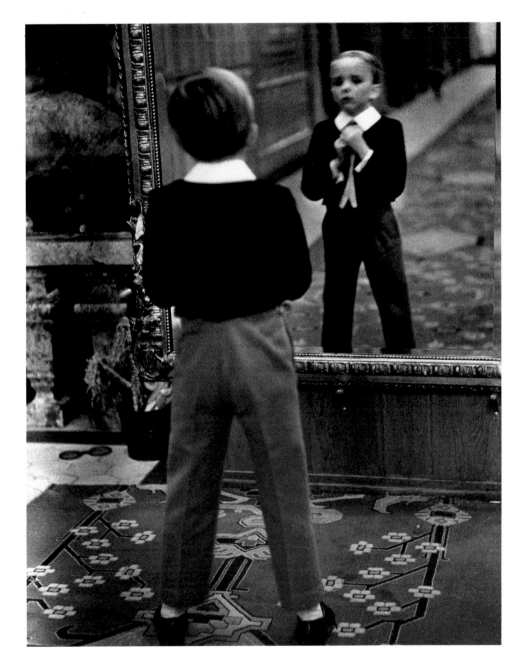

George Bernard Shaw at his home in Whitehall Court, London, 1932. Himself a camera enthusiast, Shaw assumed a pose he said "might be interesting."

A small boy adjusts his tie before the impressive mirror in the foyer of the Grand Hotel, Saint-Moritz, 1932.

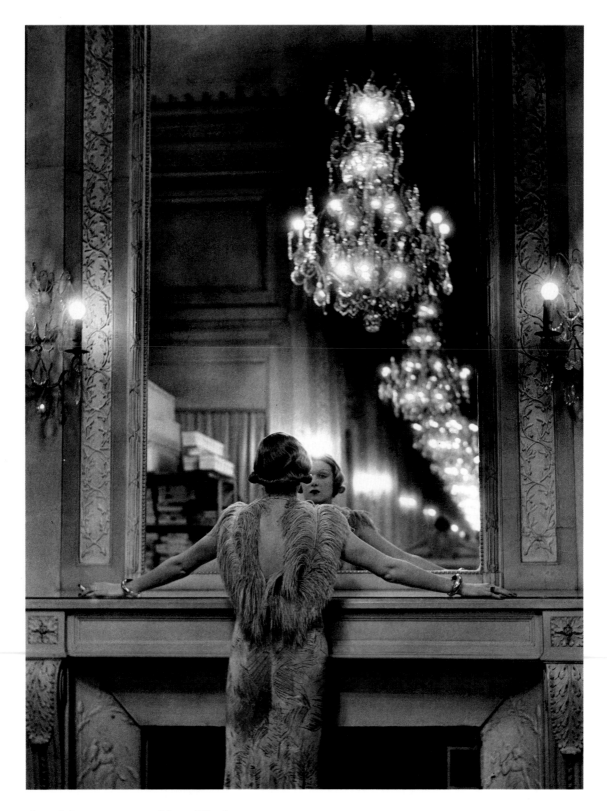

A model pauses to regard herself in the
grand mirror of the Molyneux atelier,
Paris, 1934.

Ruth Bryan Owen, Copenhagen, 1934.
The first woman diplomat from the
United States and the daughter of
William Jennings Bryan, Owen served
as ambassador to Denmark.

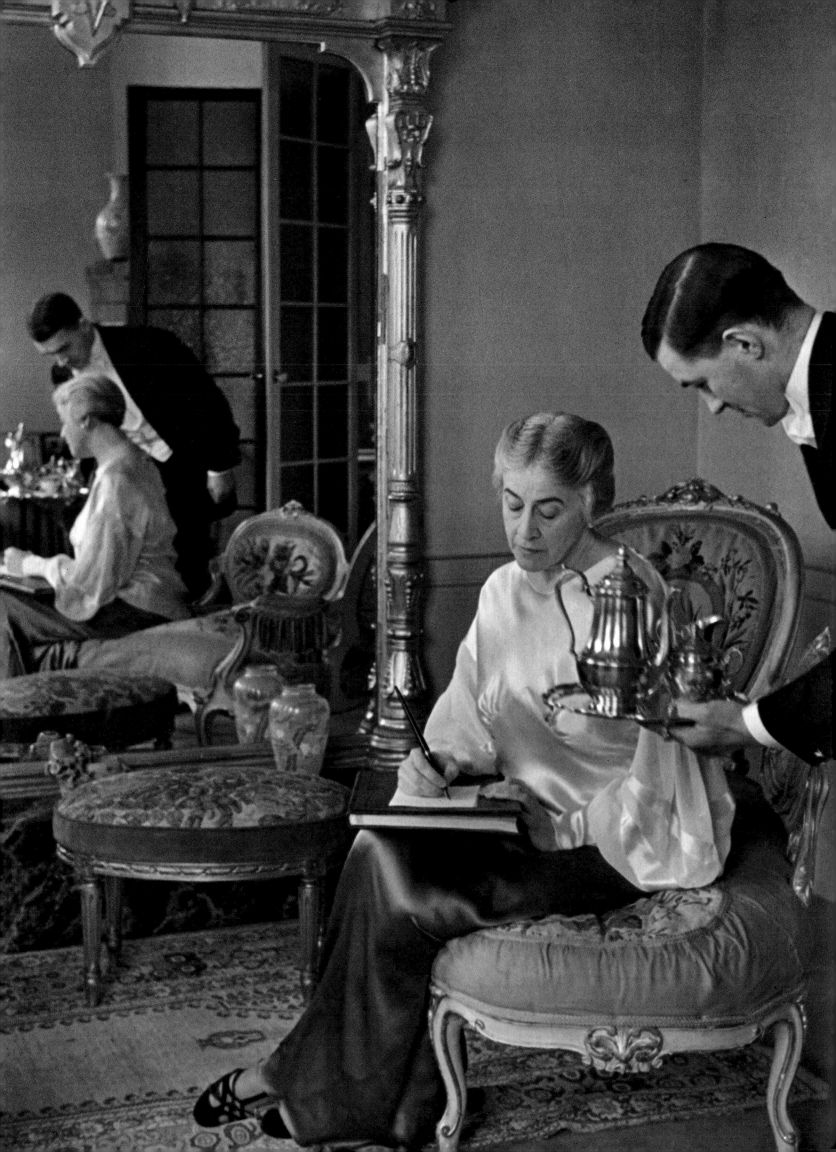

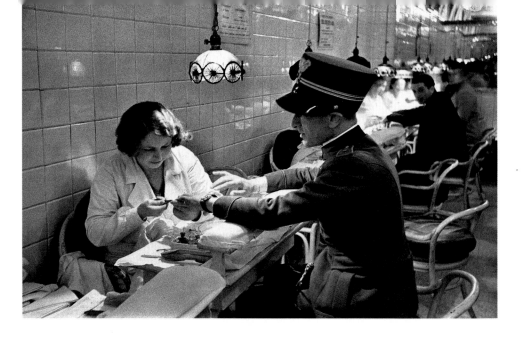

An Italian army officer receiving a manicure, Milan, 1934. Mussolini was angered by this photograph, contending it showed the army in a poor light, and he banned the issue of the German monthly Die Dame *in which the image appeared.*

A Rolls-Royce in front of the Ritz Hotel on a rainy night in the Place Vendôme, Paris, 1932.

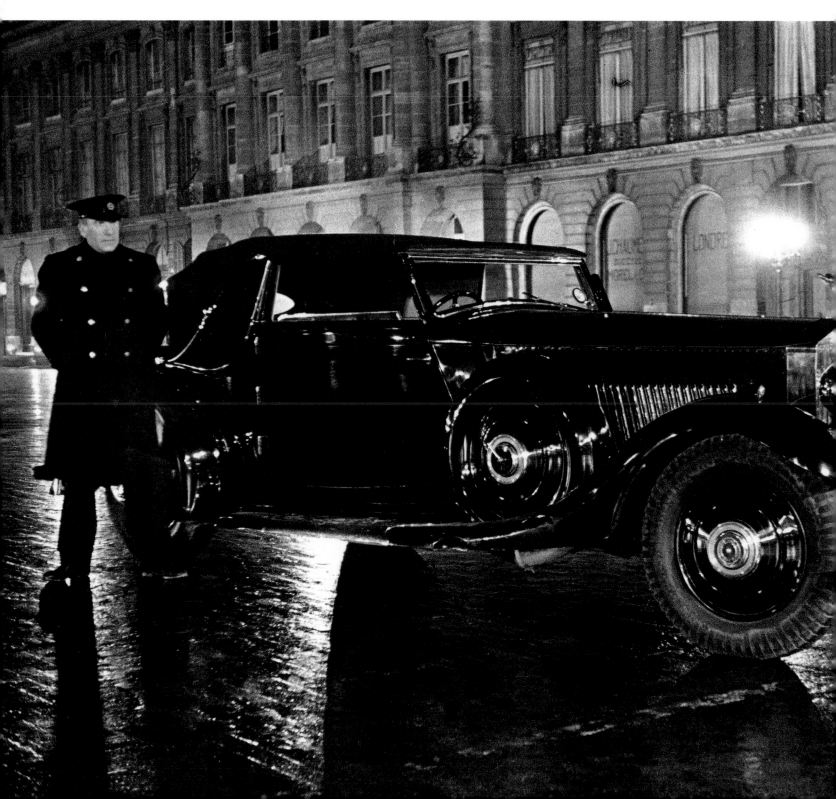

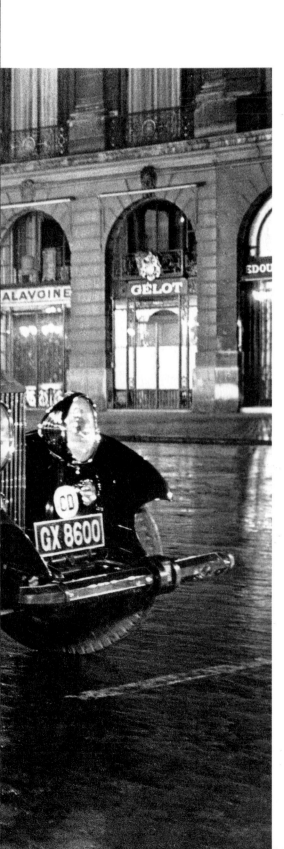

Streetwalker on the Rue Saint Denis, Paris, 1932. Eisenstaedt recalls that she wore knee-high boots and carried a whip. When she saw him with his camera, she whistled for her henchmen. They came running out of nearby buildings in pursuit of Eisie, who managed to elude them.

The Graf Zeppelin, 1933. On a flight from Germany to Rio de Janeiro, the airship encountered a severe storm, which ripped the covering of the ship's hull. In poststorm calm, crew members repaired the damage. Eisenstaedt, with a rope around his waist, leaned out a hatchway to record the remarkable scene, in a photograph that anticipated, by some thirty-five years, the awe-inspiring look of outer space.

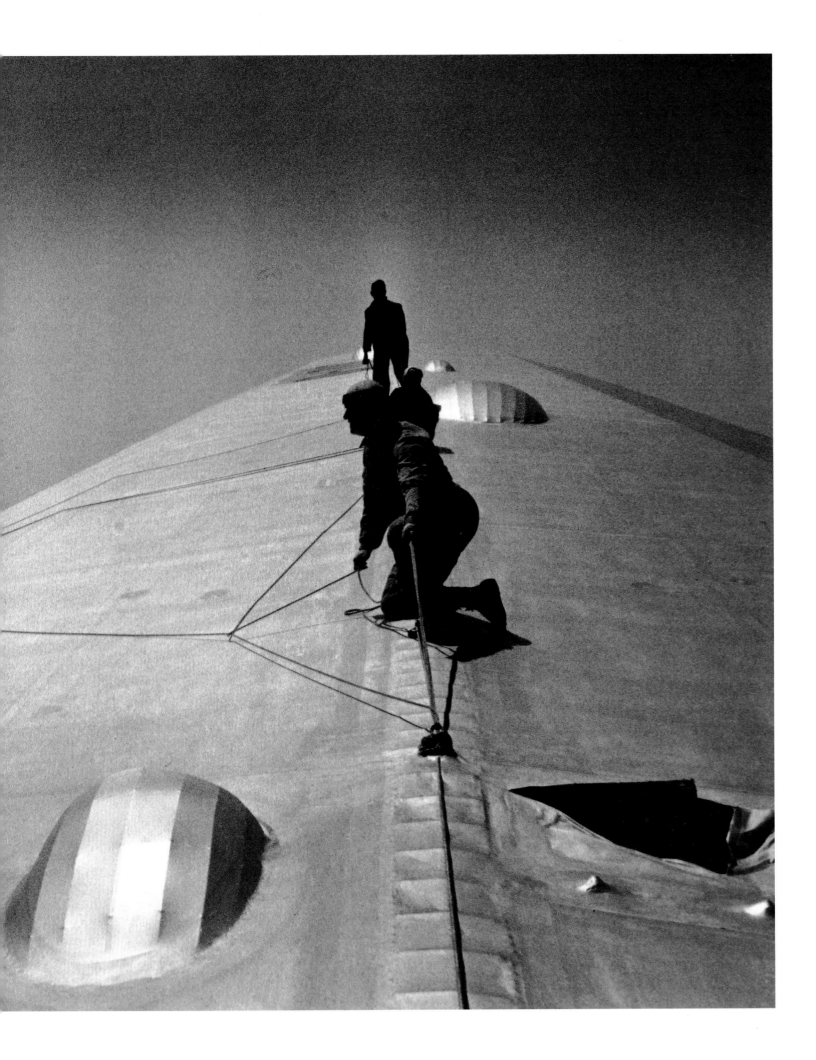

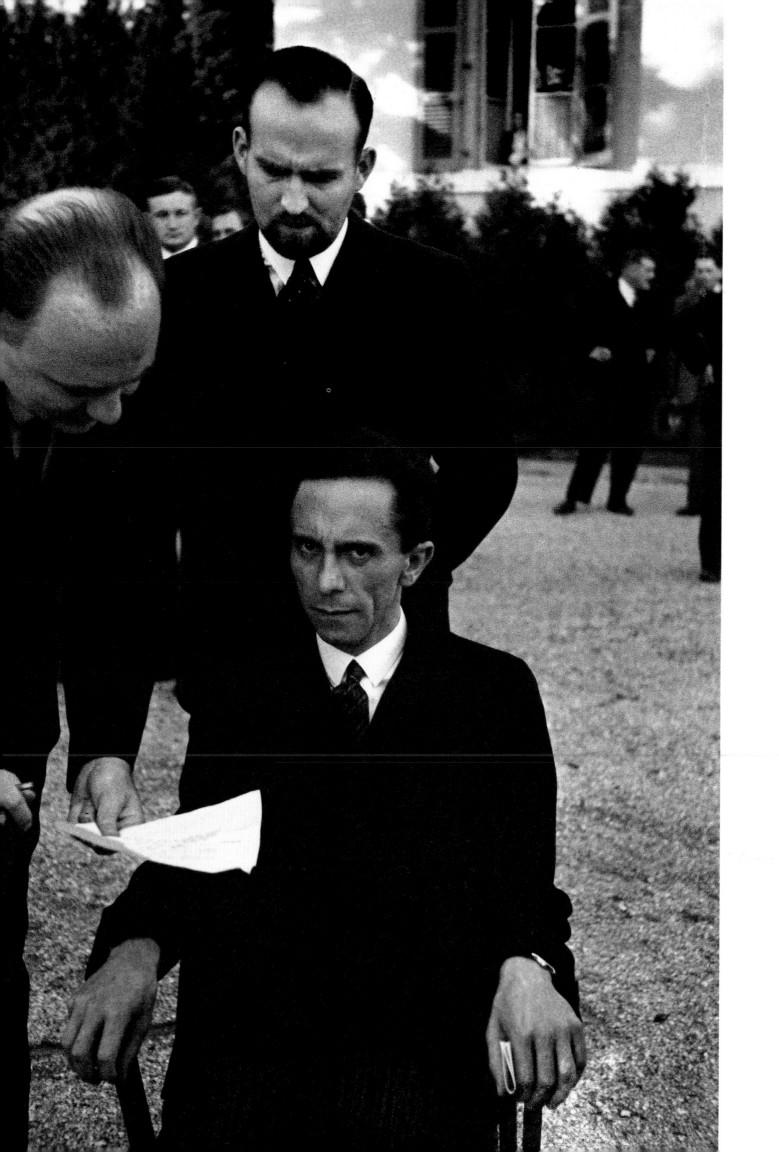

Dr. Joseph Goebbels, Hitler's Minister of Culture and Propaganda, regards Eisenstaedt with keen displeasure, at the fifteenth session of the League of Nations, Geneva, 1933.

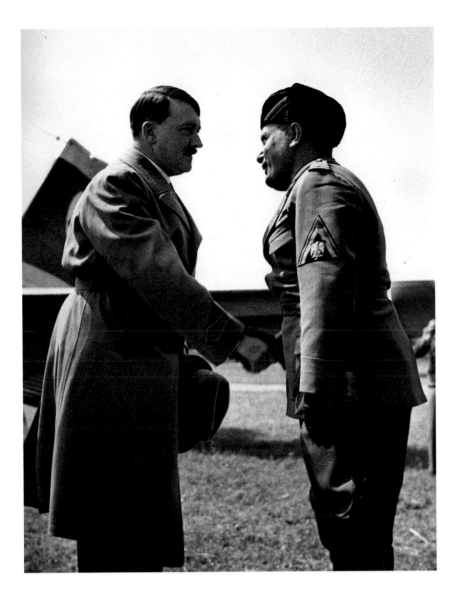

The first meeting of Mussolini and Hitler—who had proclaimed himself Chancellor of Germany in 1933—at the airport in Venice, June 13, 1934. With the death, less than two months later, of President Paul von Hindenburg, Hitler also took the title "Der Führer," and changed from civilian to military dress.

Adolf Hitler strides between the lines of a naval guard of honor at the funeral of Von Hindenburg, East Prussia, 1934. Behind Hitler is Heinrich Himmler, head of the SS, in a dark uniform, with his head bowed (third row, far left).

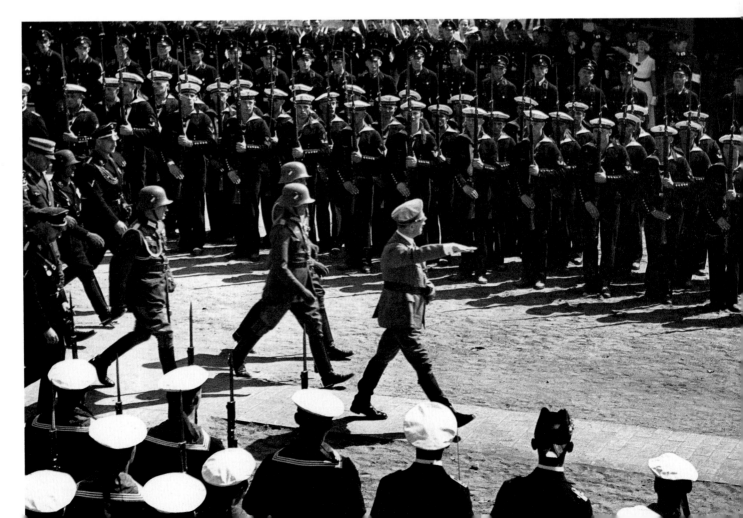

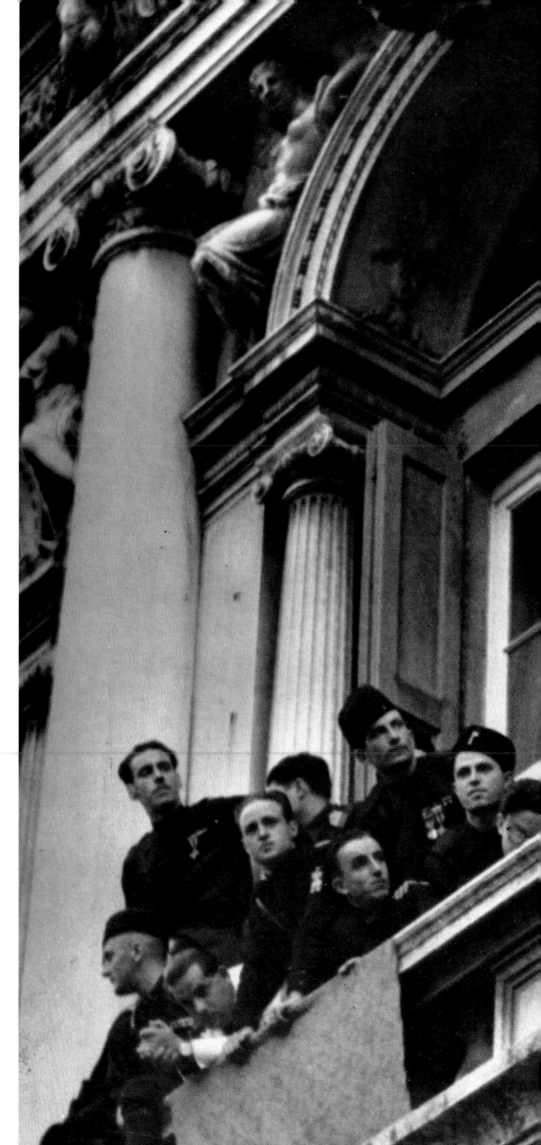

Mussolini giving a speech from a balcony in Piazza San Marco, Venice, 1934. On that occasion, police arrested Eisenstaedt, suspecting that his 35mm Leica, with its 90mm lens, was really a weapon. He was held for an hour, while his identity was checked with the Associated Press, and then released.

26

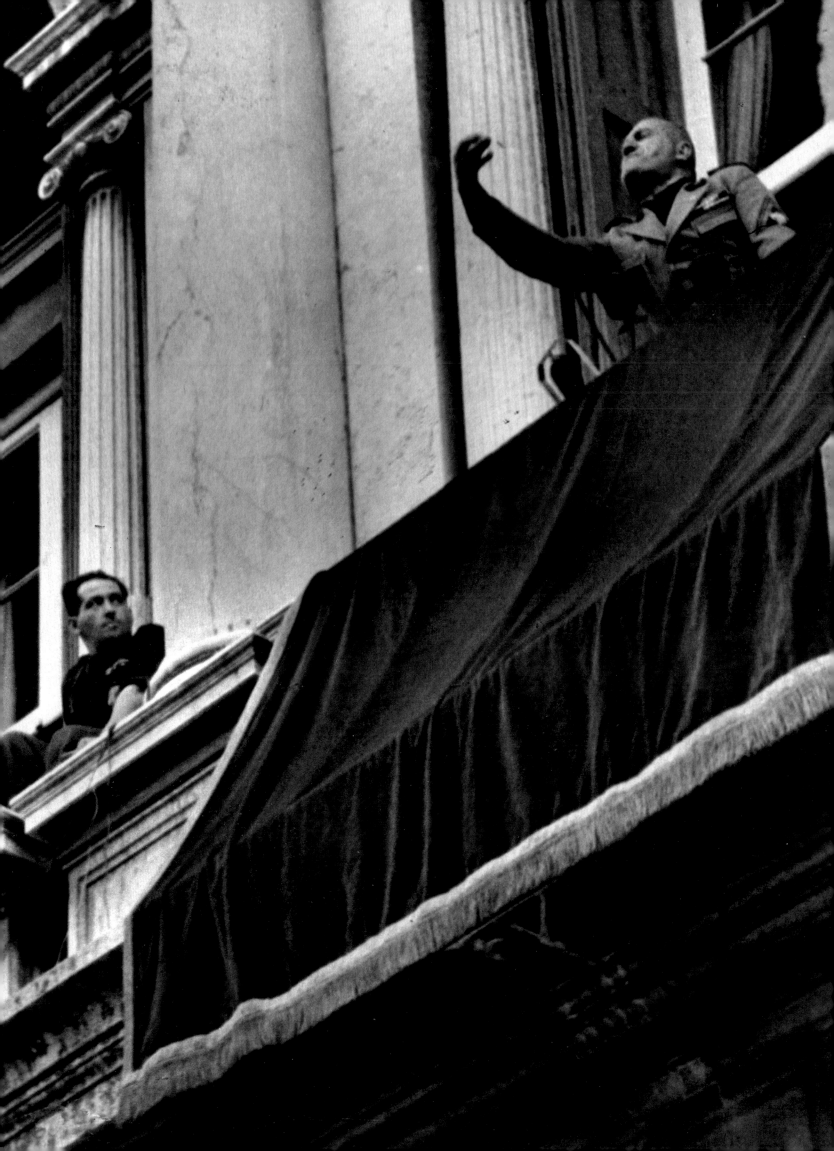

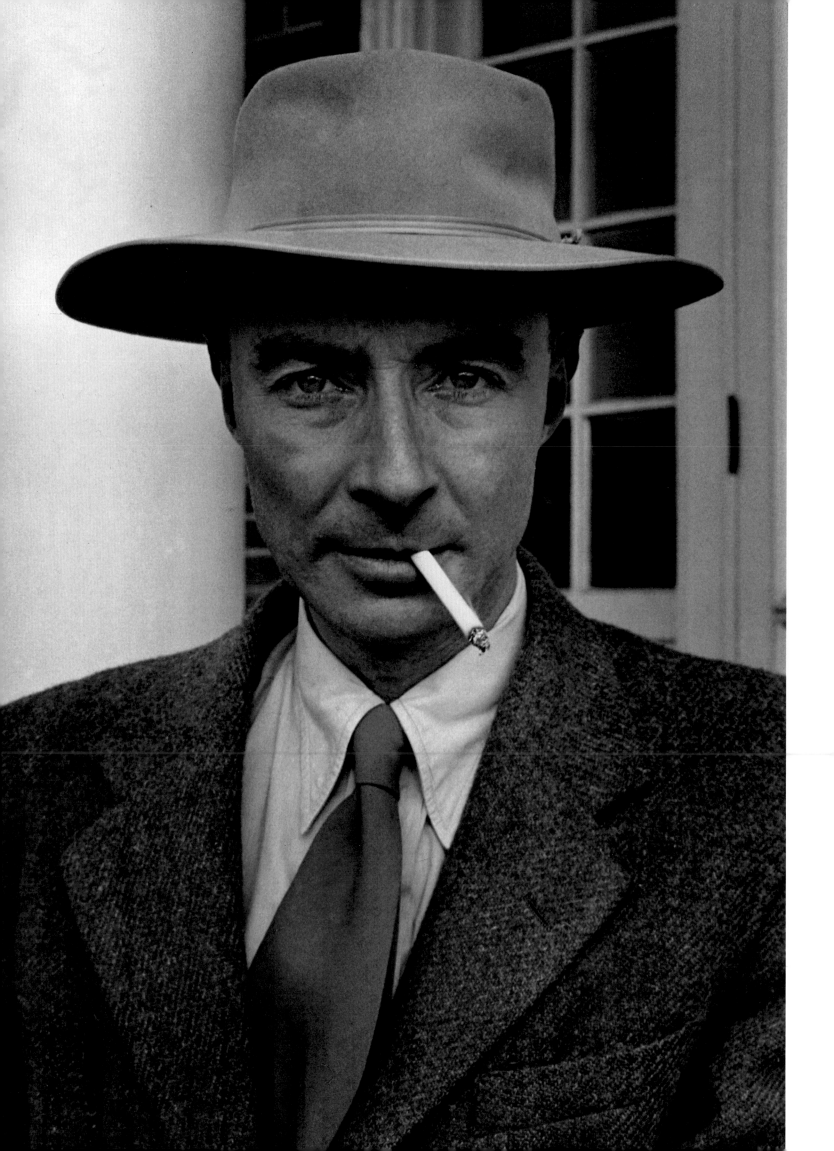

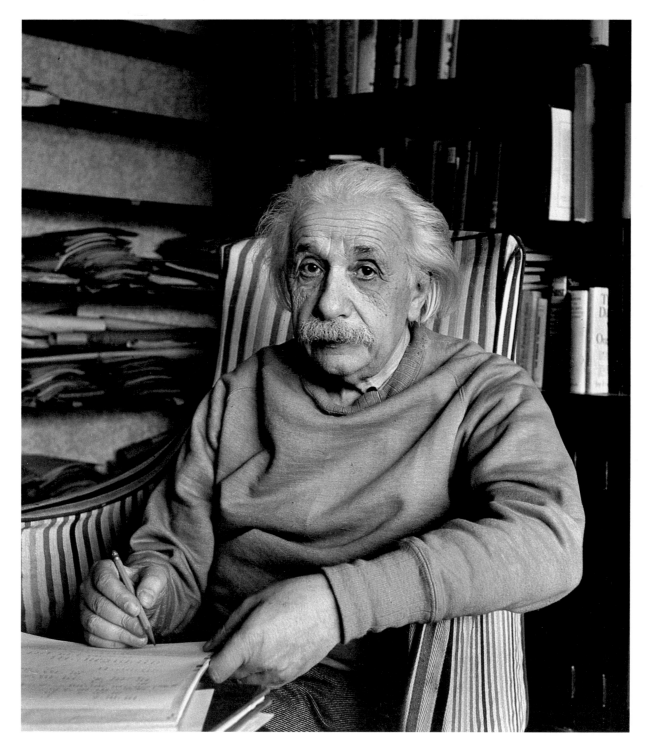

Albert Einstein at work in his home in Princeton, 1949.

J. Robert Oppenheimer in a porkpie hat, Princeton, New Jersey, 1947. Oppenheimer was director of the laboratory in Los Alamos, New Mexico, at which the first atomic bomb was designed and built. He was wearing this hat at the detonation at nearby Alamogordo in the summer of 1945, and he wore it thereafter to many important functions.

Philosopher and theologian Martin Buber at his home in Jerusalem, 1955. At the time, Eisenstaedt was in the city working on a photographic essay on Judaism, and Buber was in the process of writing commentary to accompany the second edition of his illuminating book I and Thou. *Eisie captured Buber's warmth and responsiveness in this remarkable portrait.*

OPPOSITE: *Bertrand Russell, London, 1951. He sat extremely still, and when Eisie commented on this, the great philosopher replied: "A crocodile moves very slowly."*

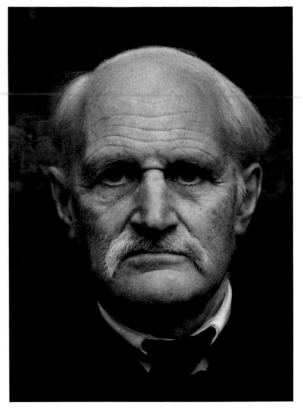

George Macaulay Trevelyan, the British historian and writer, former master of Trinity College at Cambridge, and one of the earliest environmentalists, 1951. He treasured the loveliness of the English landscape, and warned his countrymen that, unless its beauties were protected from the ravages of modern life, "the future of our race will be brutish and shorn of spiritual value."

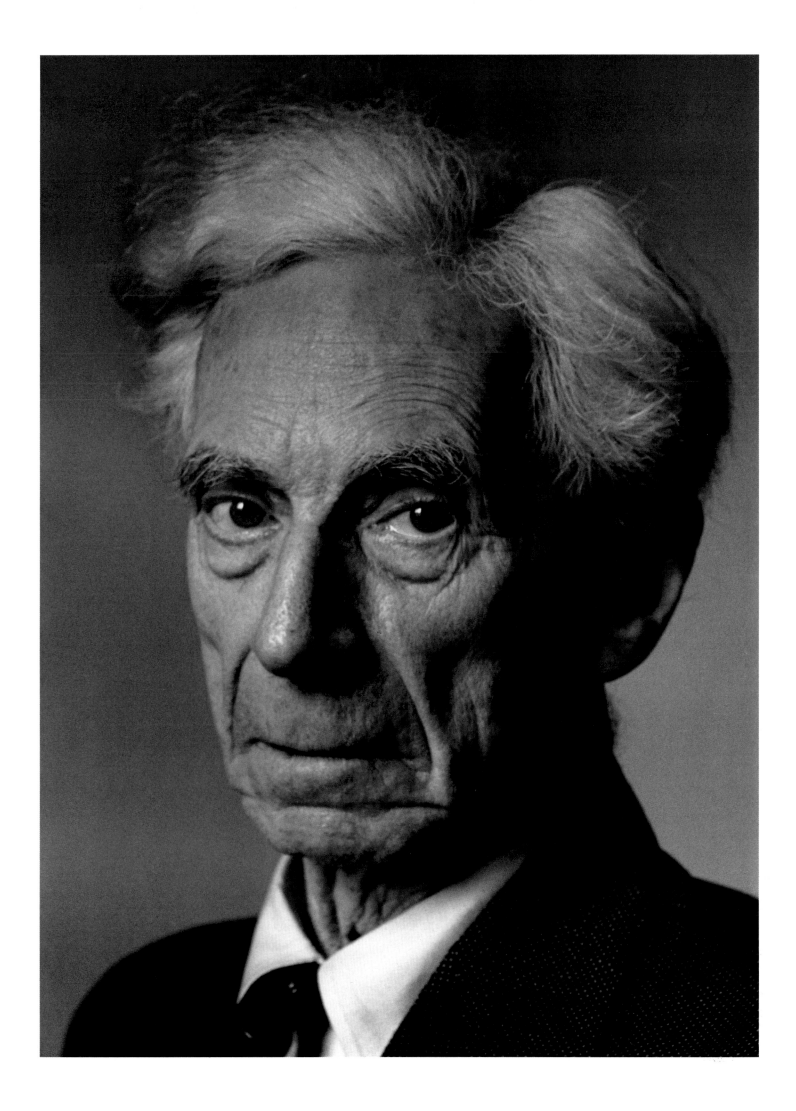

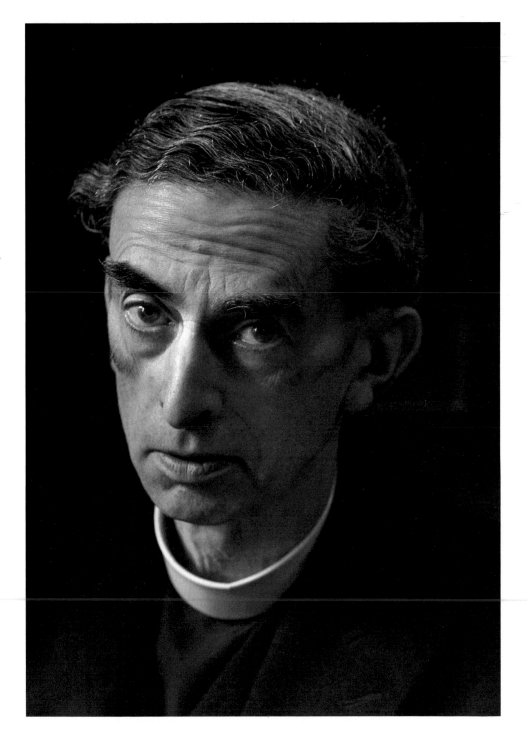

Author of the influential book The Mind and Heart of Love, *the Very Reverend Martin Cyril D'Arcy, S.J., London, 1952. Eisenstaedt described Father D'Arcy as "the ideal priest from a photographer's standpoint: he looks lean and ascetic, yet there is a kindness written all over his unworldly face."*

Dancers rehearse Tchaikovsky's Swan Lake *in the upper tower of the Paris Opera, 1932.*

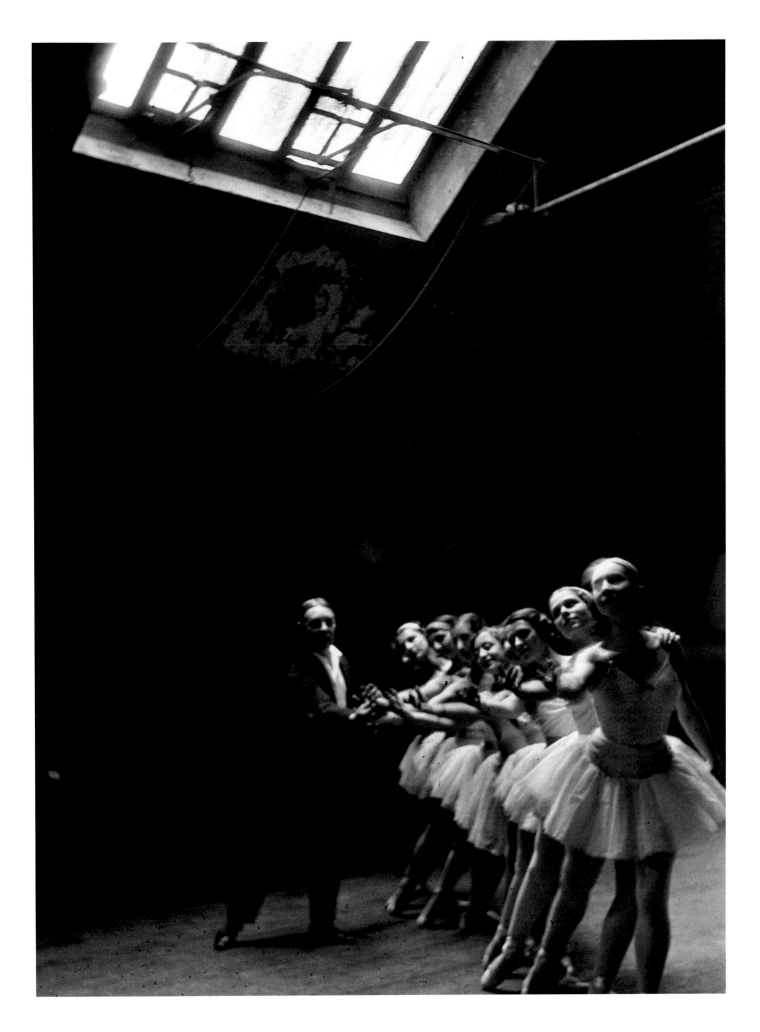

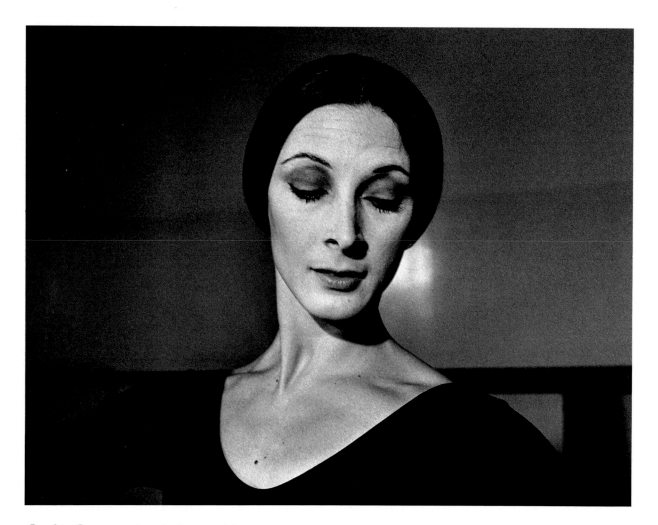

Cynthia Gregory, prima ballerina of the
American Ballet Theatre, New York
City, 1978. In celebration of
Eisenstaedt's upcoming eightieth
birthday, NBC had wanted to make a
film of the photographer on assignment,
as a feature for the "Today" show.
Asked to suggest the topic for the
assignment, Eisie chose ballet, a subject
of lifelong interest to him. Gregory
agreed to participate, and a story of
great beauty resulted.

Dancers pause in the windows of their
rehearsal room at the Balanchine
School of the American Ballet Theatre,
New York City, 1936.

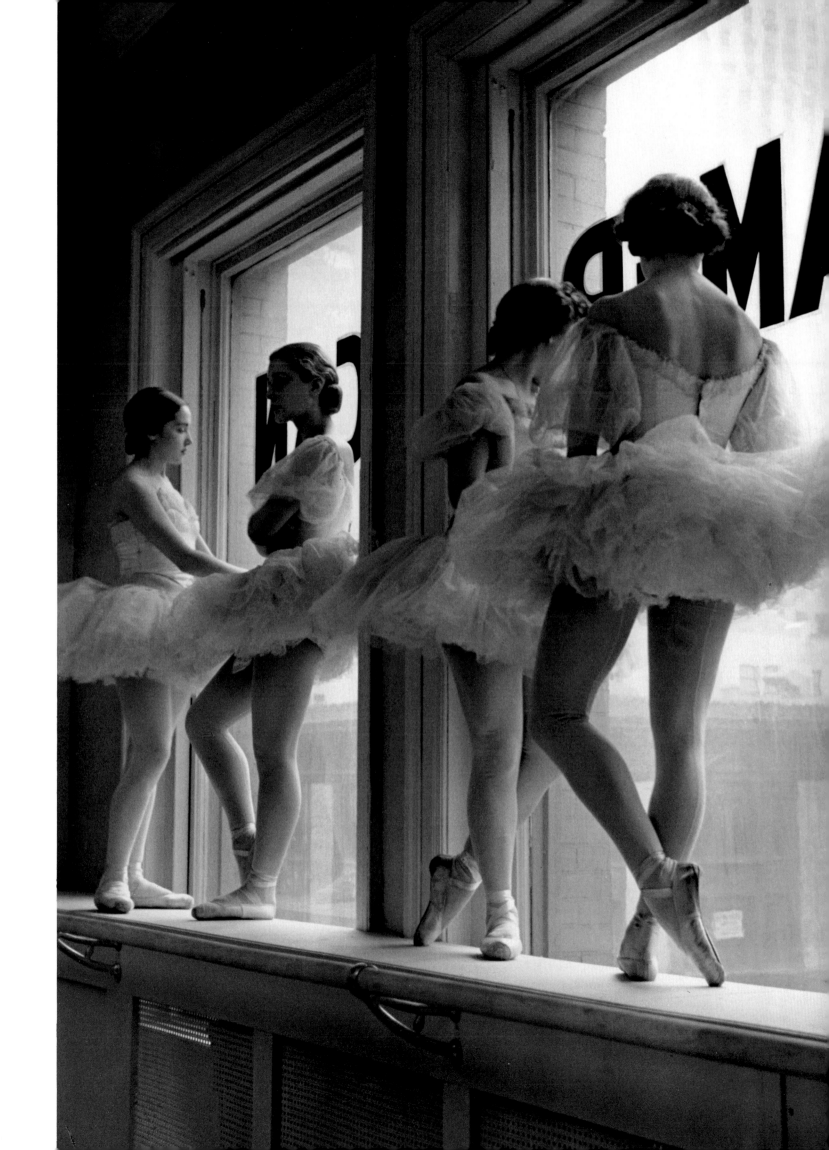

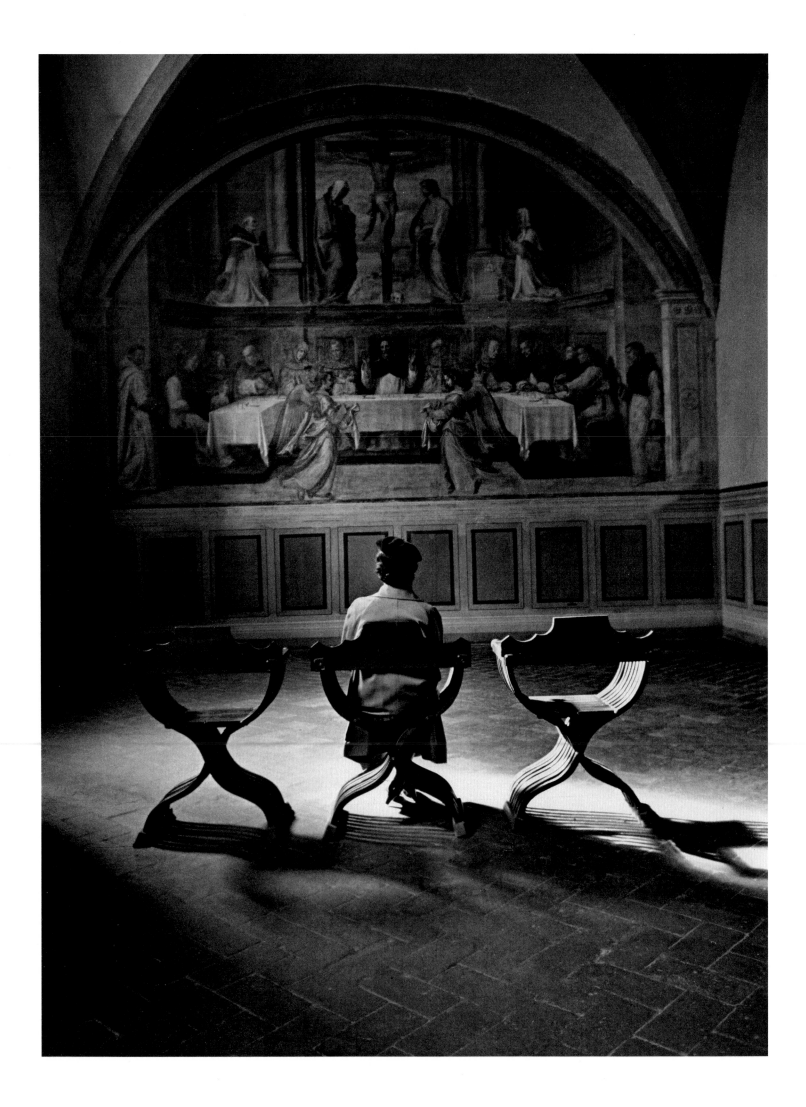

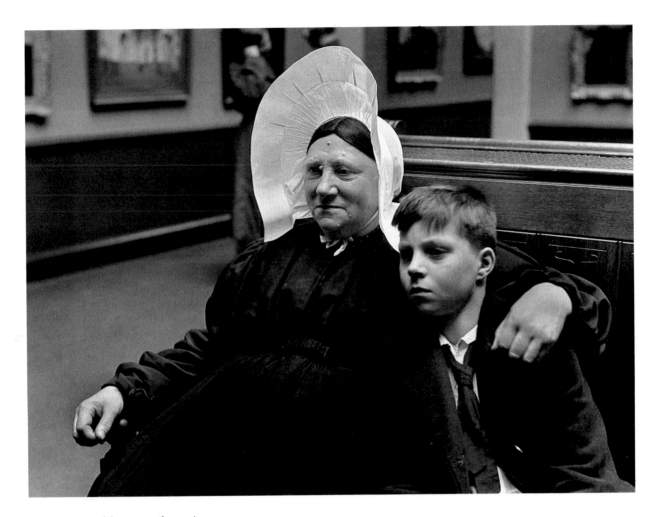

A woman and her grandson view Rembrandt's Night Watch *in the Rijksmuseum, Amsterdam, 1932.*

A visitor contemplates a sixteenth-century fresco—Providence by Giovanni Sogliani—in the refectory of the Dominican Convent of San Marco, Florence, 1935. The painting depicts angels miraculously bringing bread to Saint Dominic and his fellow monks, who had been sitting at a table without food.

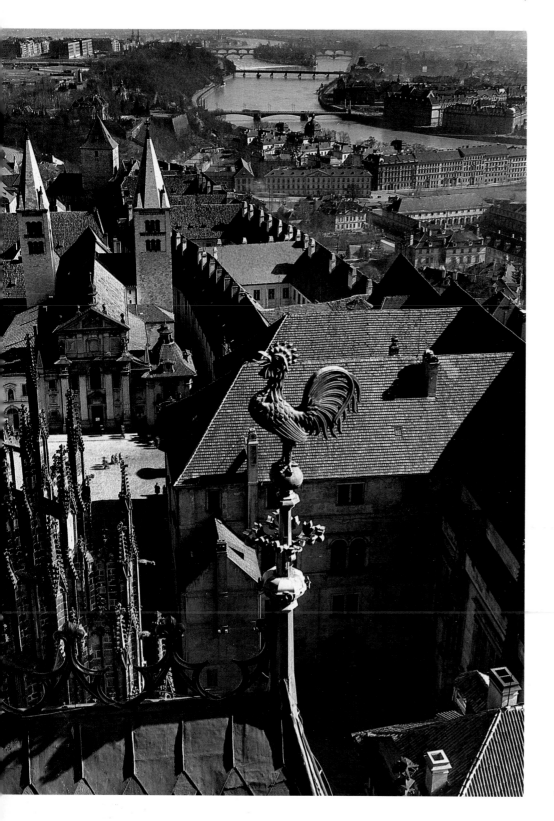

The roofs of Prague, Czechoslovakia, along the Moldau River, 1947.

Homeless men being fed in a church, Rouen, France, early 1930s.

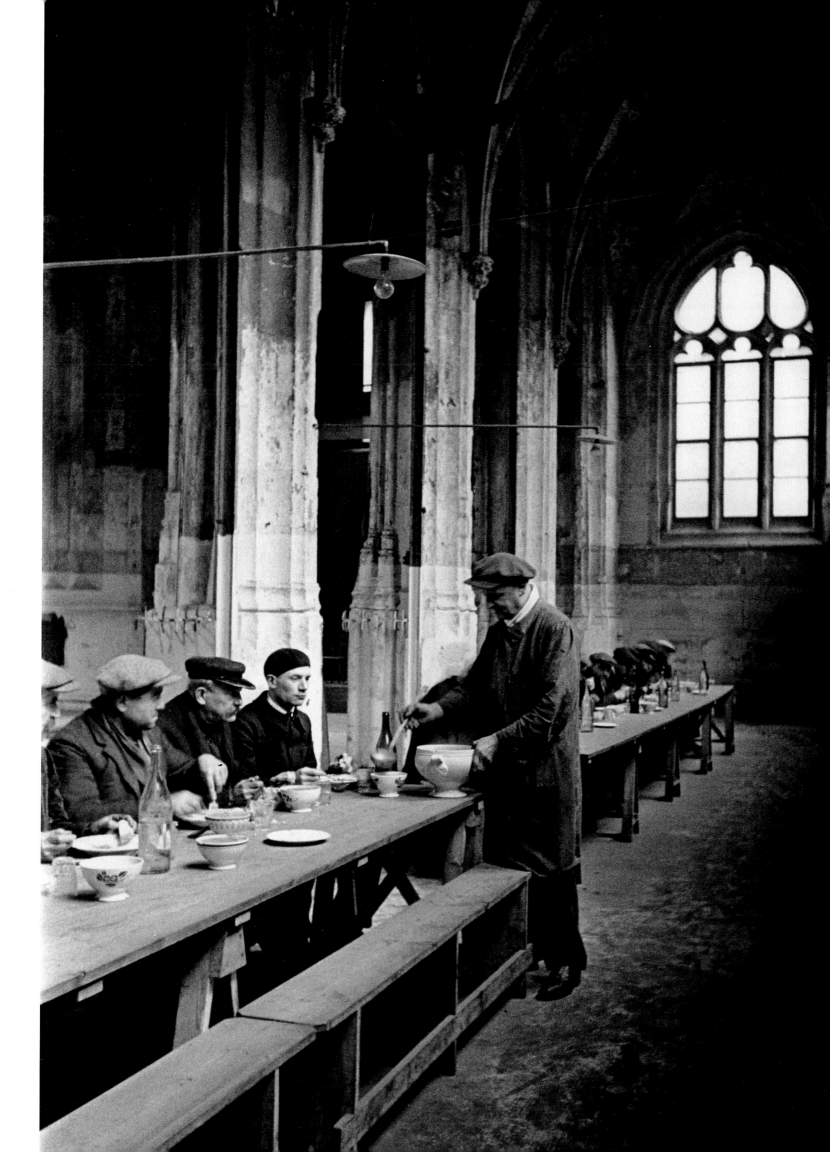

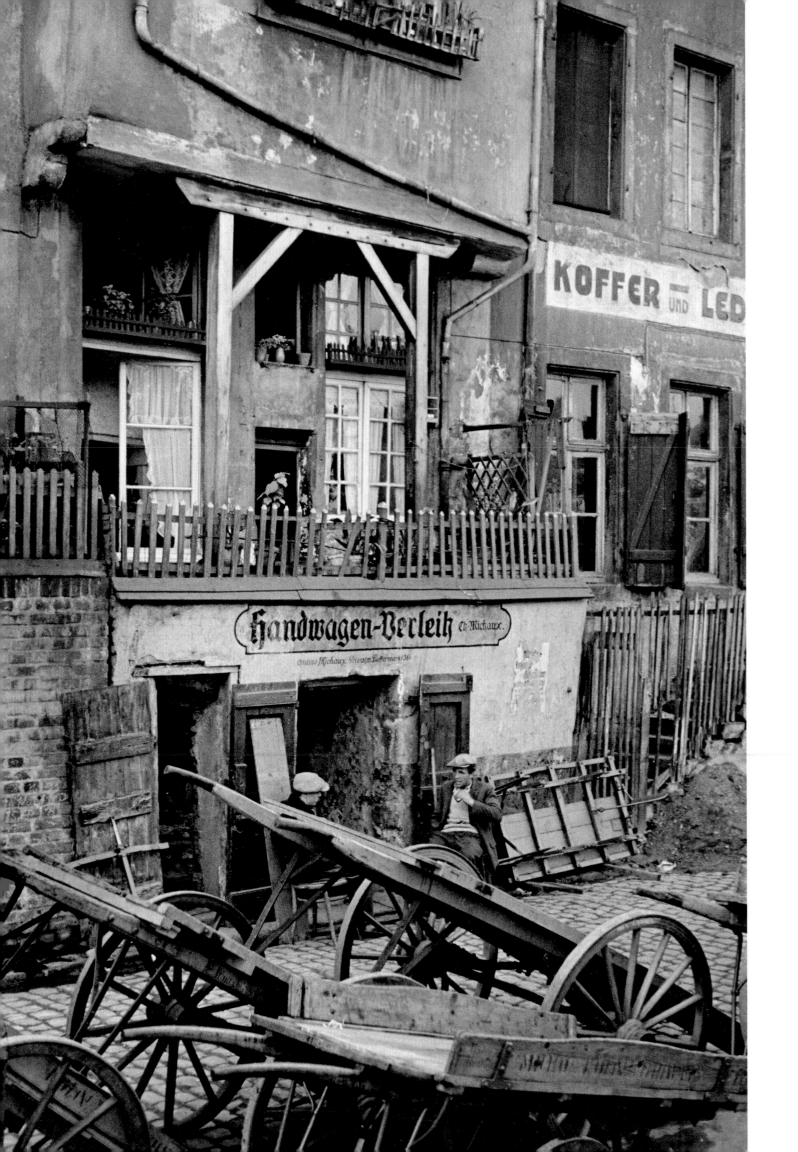

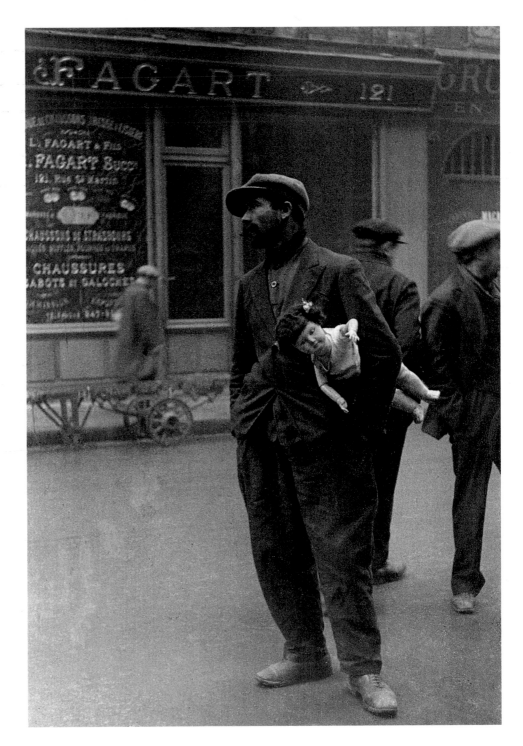

A courtyard where wagons were for hire, in the old section of Frankfurt, Germany, 1934.

A man trying to sell a child's doll, Paris, early 1930s. From a photographic essay on the lives of the poor people near Les Halles.

A horse-drawn trolley provides transportation through downtown Izmir, Turkey, 1934. The Gulf of Izmir is in the background.

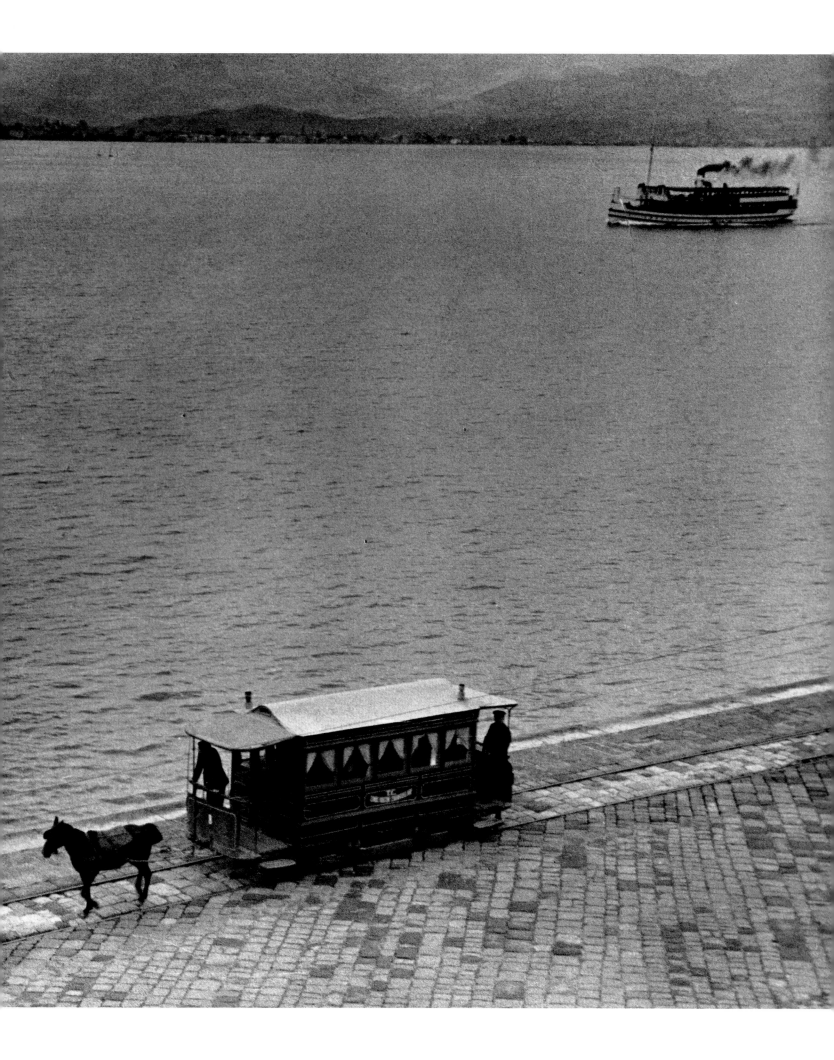

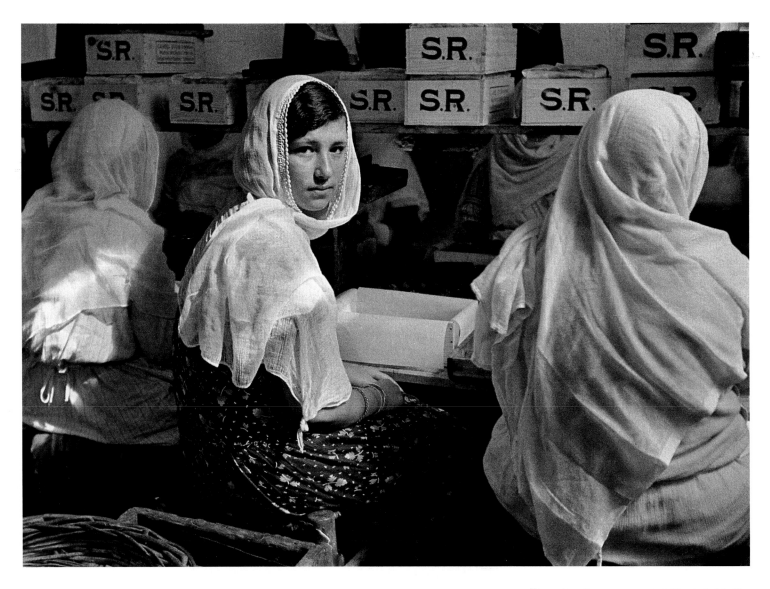

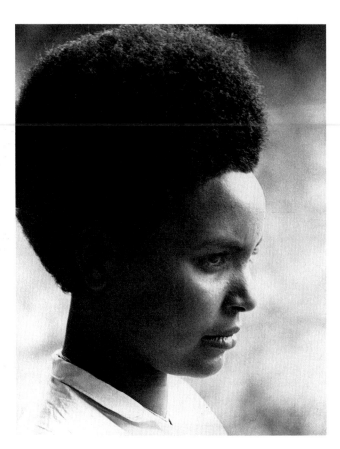

Eisenstaedt accompanied Gustaf Adolf, Crown Prince of Sweden, and his family on a trip through Greece, Turkey, and Syria, 1934. As the group toured a fig-packing factory in Izmir, Turkey, a young worker turned to look at them. Struck by her beauty, Eisie captured this portrait.

A young girl in Ethiopia, 1935. Eisenstaedt had been assigned by the Associated Press to document that country. Shortly after his visit there, Ethiopia was invaded by Italian forces, and his photographs were in great demand by newspapers and magazines. Eisie credits this assignment with establishing his international reputation —and with leading to his decision to move to the United States.

Emperor Haile Selassie's Master of the Hunt, Addis Ababa, 1935. From Eisenstaedt's photographic essay on Ethiopia.

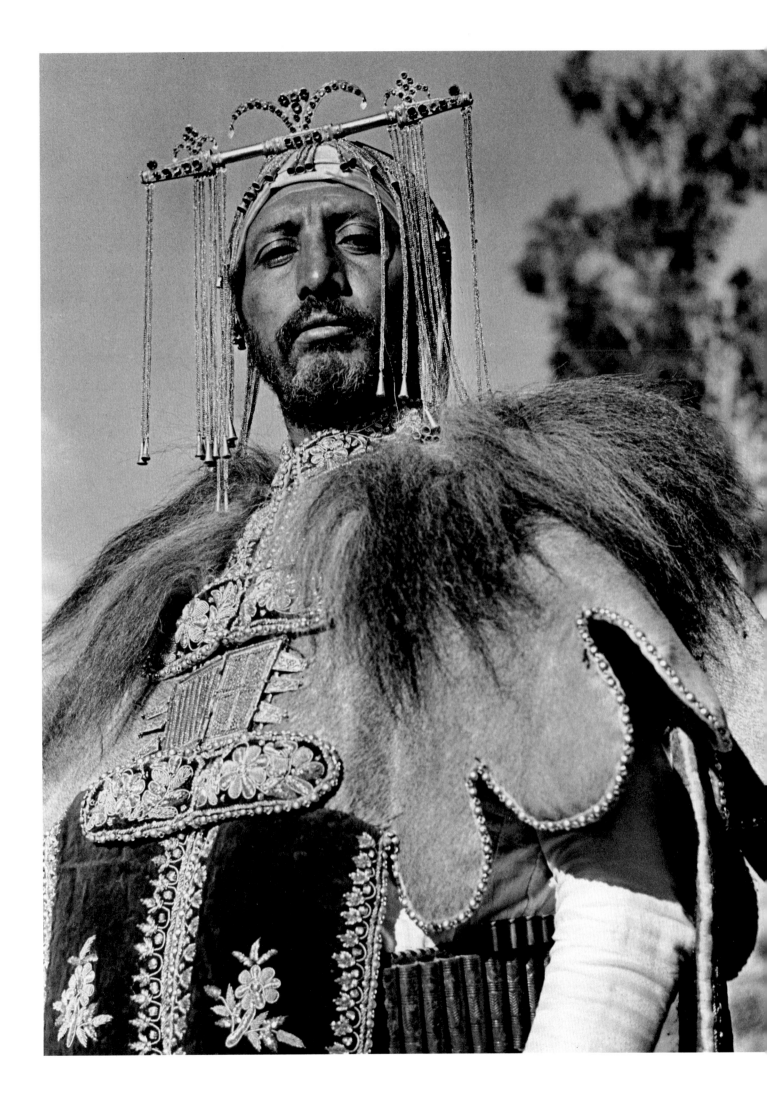

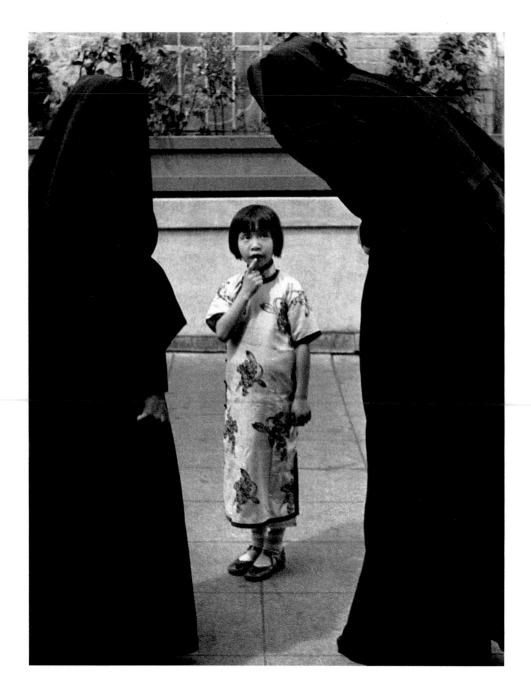

Two nuns stop to talk with a bashful student at a parochial school for Chinese-American children, San Francisco, 1936. From a story in the first issue of LIFE.

Workers take a midday rest under an ancient olive tree in southern Italy, 1943. From a photographic essay on postwar recovery in that region.

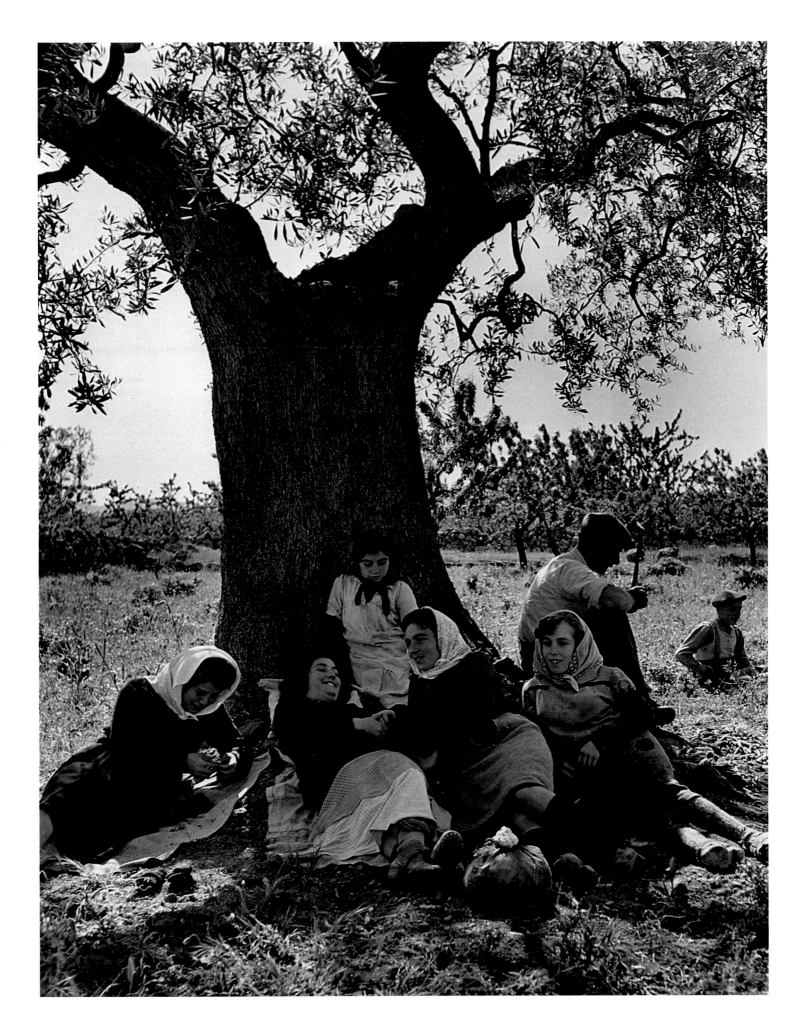

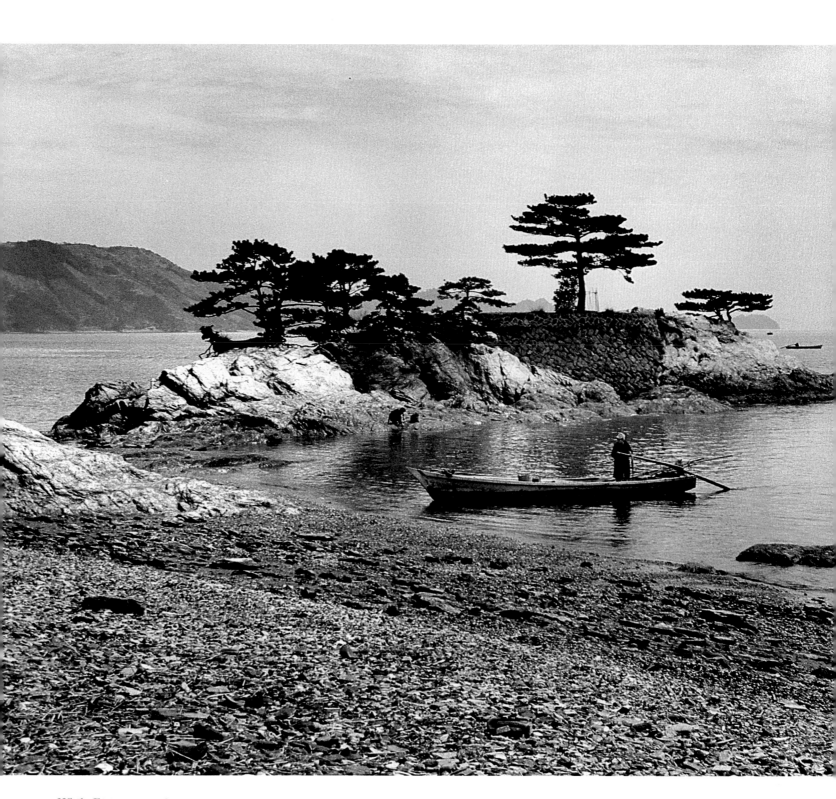

*While Eisie was on his way to visit
Mikimoto, the "cultured pearl king" of
Japan, the train stopped to change
engines, and the photographer took the
opportunity to photograph the islands in
the bay at Toba, 1946.*

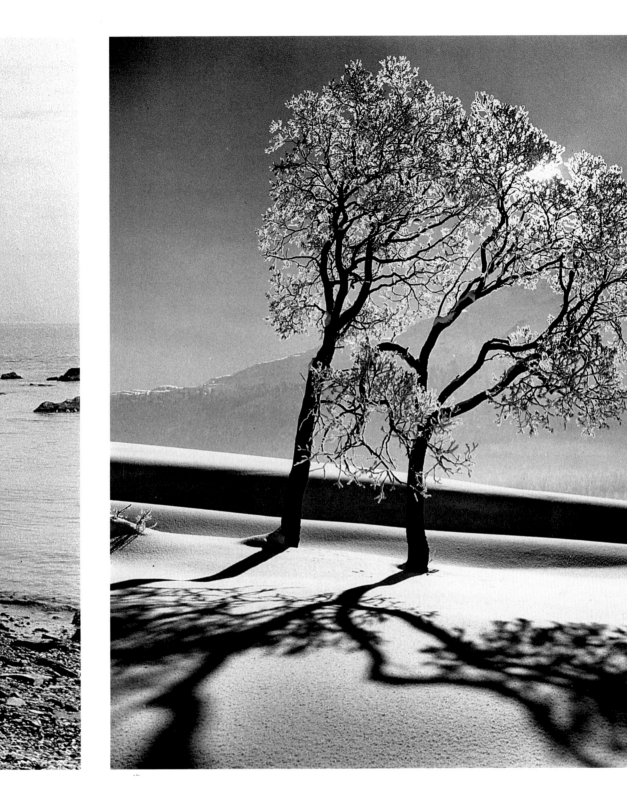

*Trees in snow, near Saint-Moritz, 1947.
In the background are the mountains
bordering the Upper Engadine Valley.
When asked recently what he
remembered about taking this
photograph, Eisie replied: "I used a
Rolleiflex, and . . . I was careful not to
step where my footprints would show."*

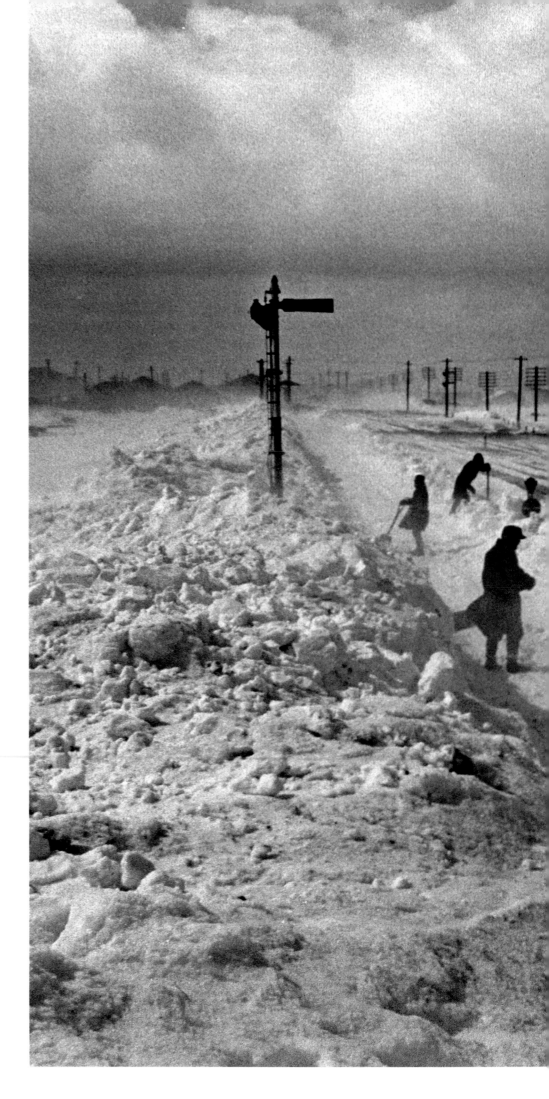

A twenty-man crew clearing train tracks after a heavy snowstorm in Japan, 1946.

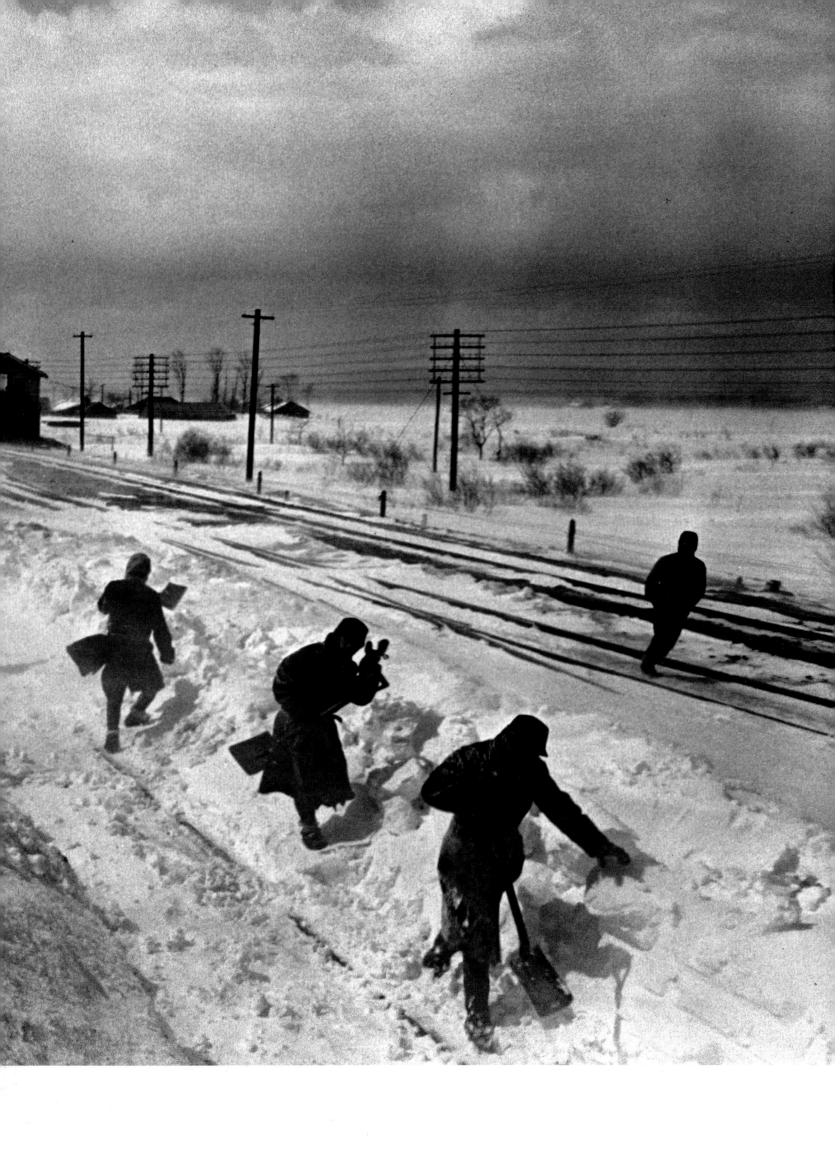

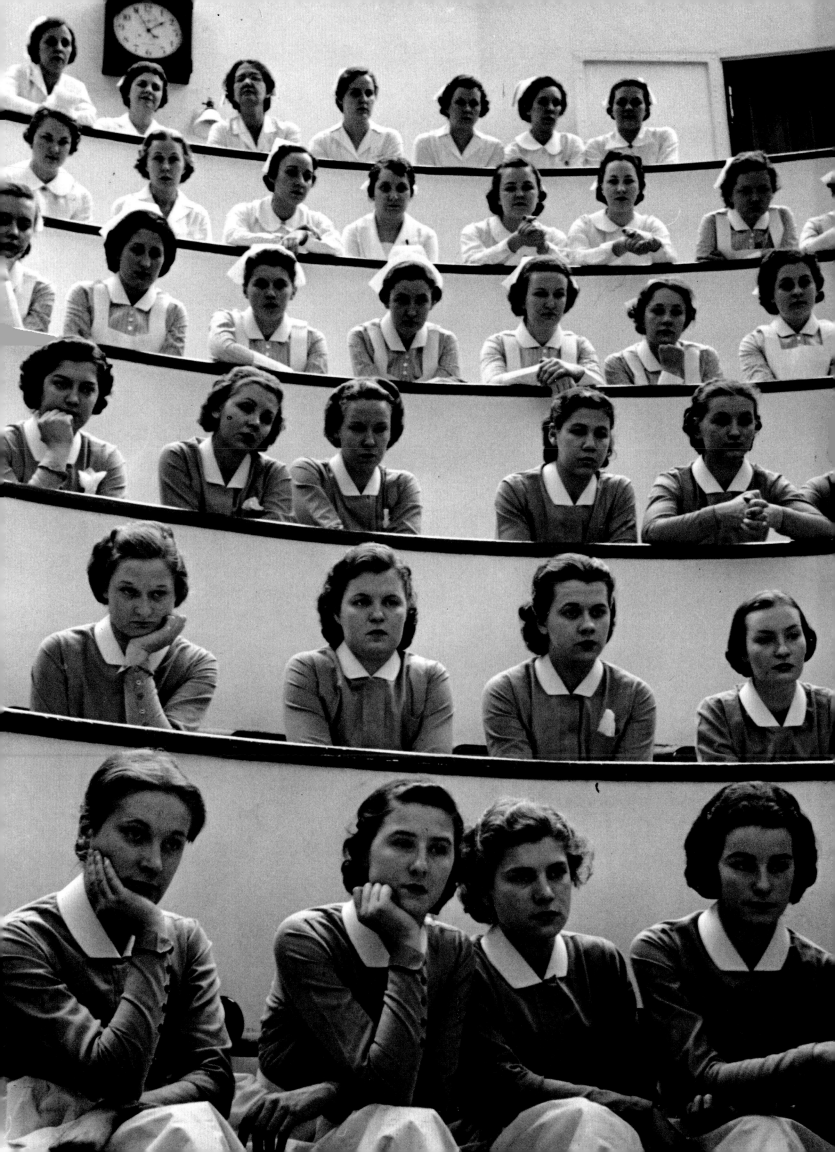

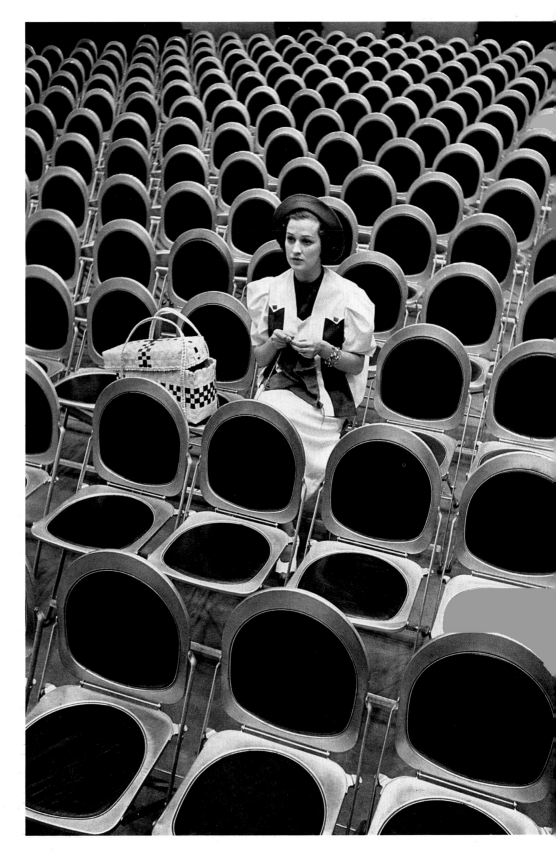

Singer Jane Froman knits while waiting for a rehearsal to begin at NBC Studios, New York City, 1937.

Student nurses in the amphitheater of Roosevelt Hospital, New York City, 1938.

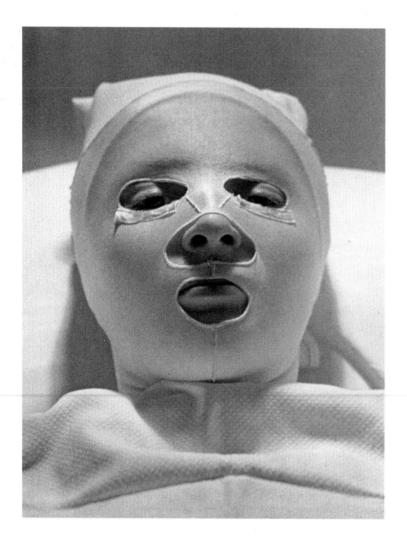

*A beauty mask in use at Helena
Rubinstein's studio, New York City,
1937.*

*Janet MacLeod, a professional model,
wearing a veiled hat designed by Lilly
Daché, New York City, 1937.*

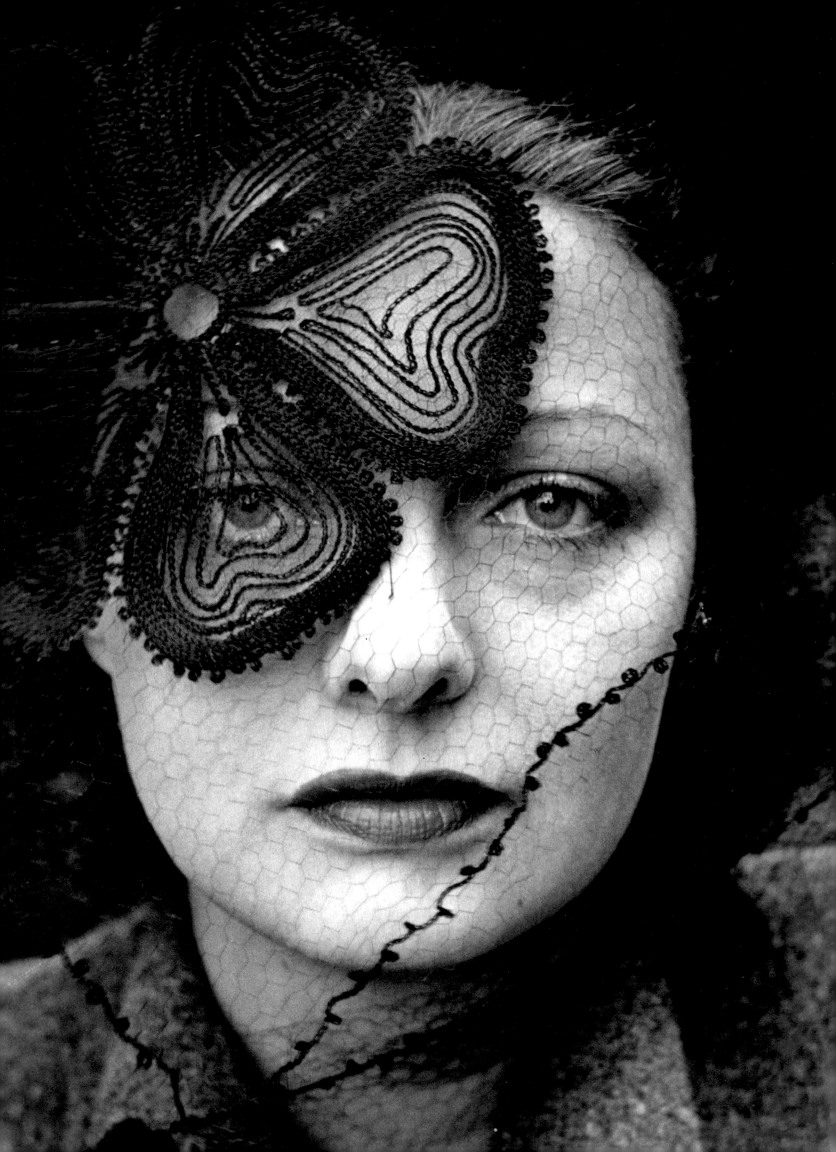

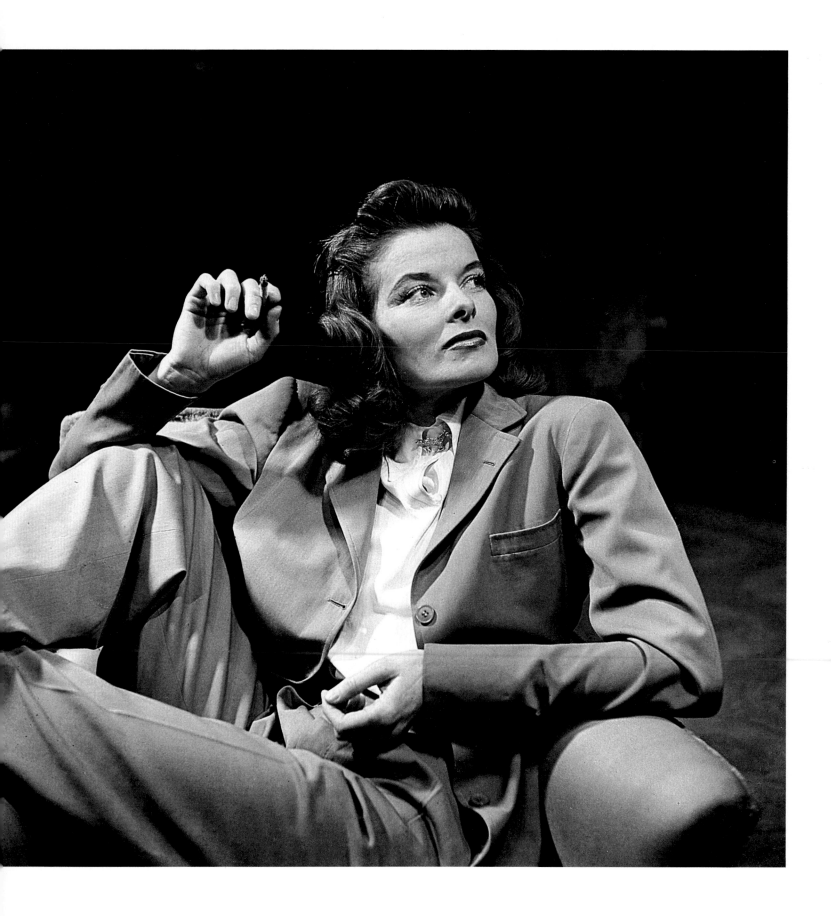

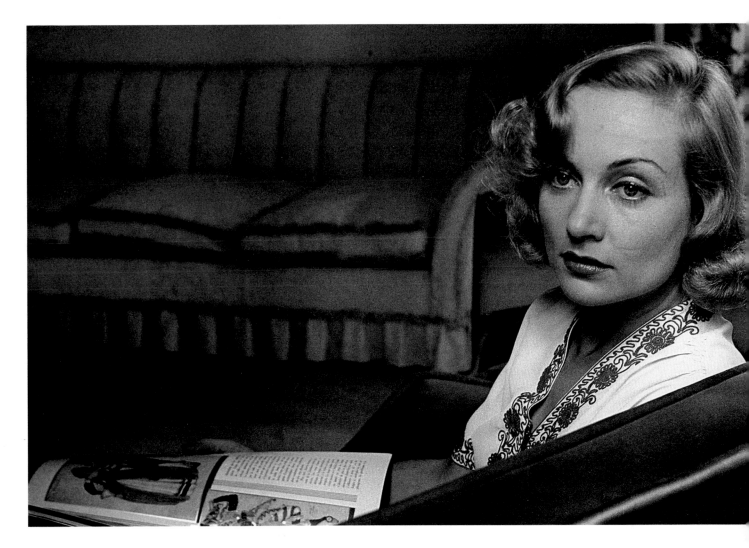

Carole Lombard, one of the greatest
comediennes of motion pictures, at home
in Hollywood, 1938.

Katharine Hepburn, New York City,
1938. She was preparing for her very
successful appearance in Philip Barry's
Philadelphia Story, *which opened on*
Broadway in 1939. Hepburn repeated
her success a year later in the film
version of the play.

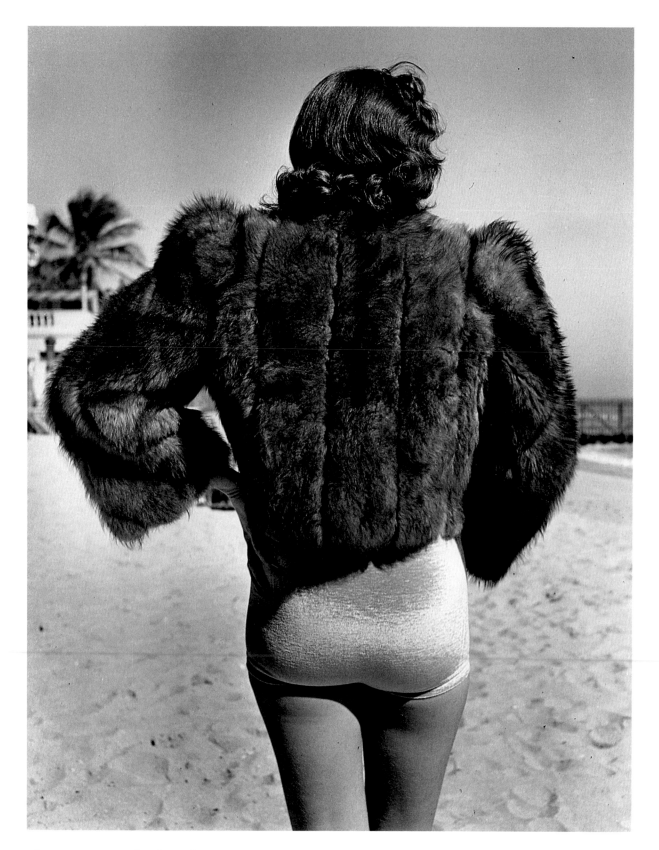

*A woman wearing her fur jacket over
her bathing suit during a cold spell in
Miami Beach, 1940.*

Dancing and singing "My Heart Belongs to Daddy" in Cole Porter's Leave It to Me, *Mary Martin became an overnight star and the toast of Broadway, September 1938.*

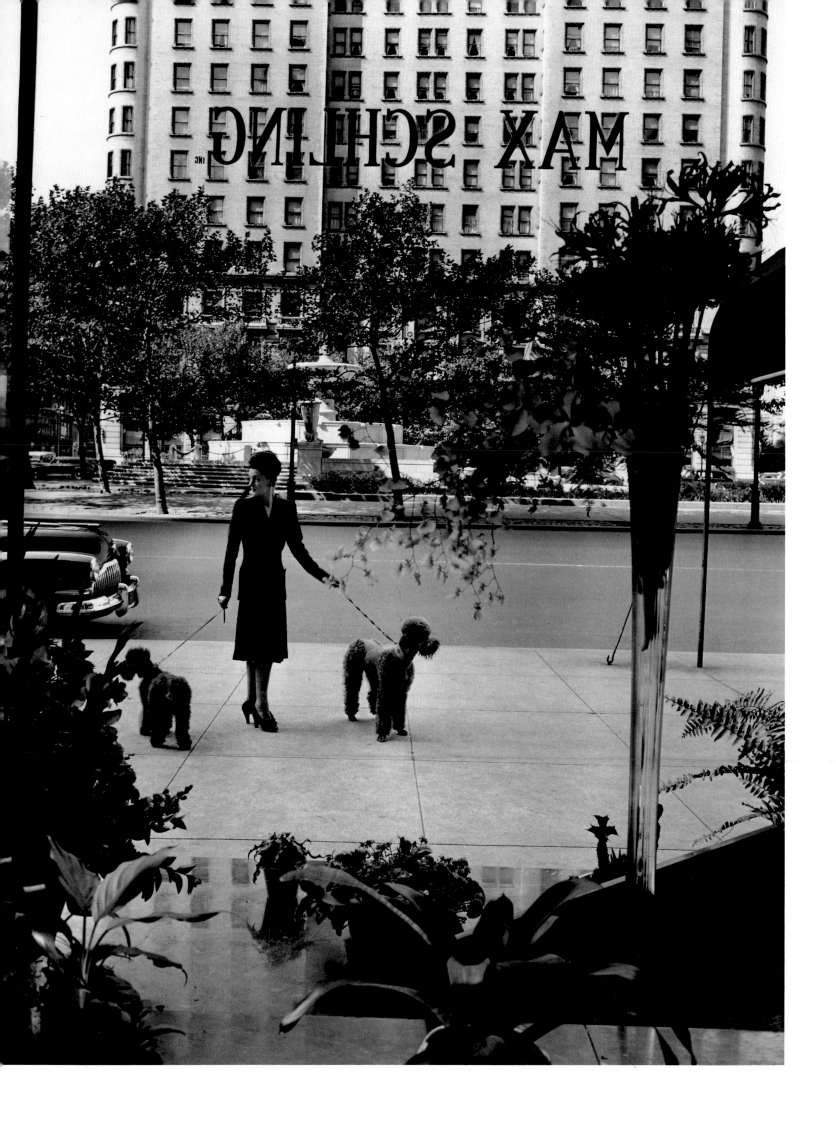

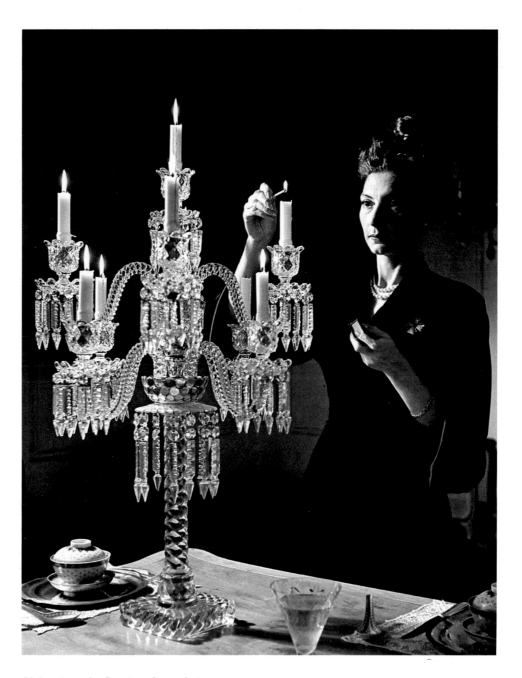

*Valentina, the Russian-born designer
and famous New York hostess, lights an
eighteenth-century candelabrum at one
of her dinner parties, 1944.*

*From a photographic essay on the
essence of Fifth Avenue, New York City,
1947. Inside Max Schling's florist shop,
then located across from the Plaza
Hotel, Eisenstaedt awaited the
appearance of the person who would
best express the mood of that section of
the avenue. This is characteristic of the
way Eisie works: he waits—for the right
lighting, the right balance between
objects, the right people. This time, he
was rewarded when an elegant woman,
who was walking her poodles, stopped
in front of the shop to glance back.*

The famous clock in the old Pennsylvania Station, New York City, 1943.

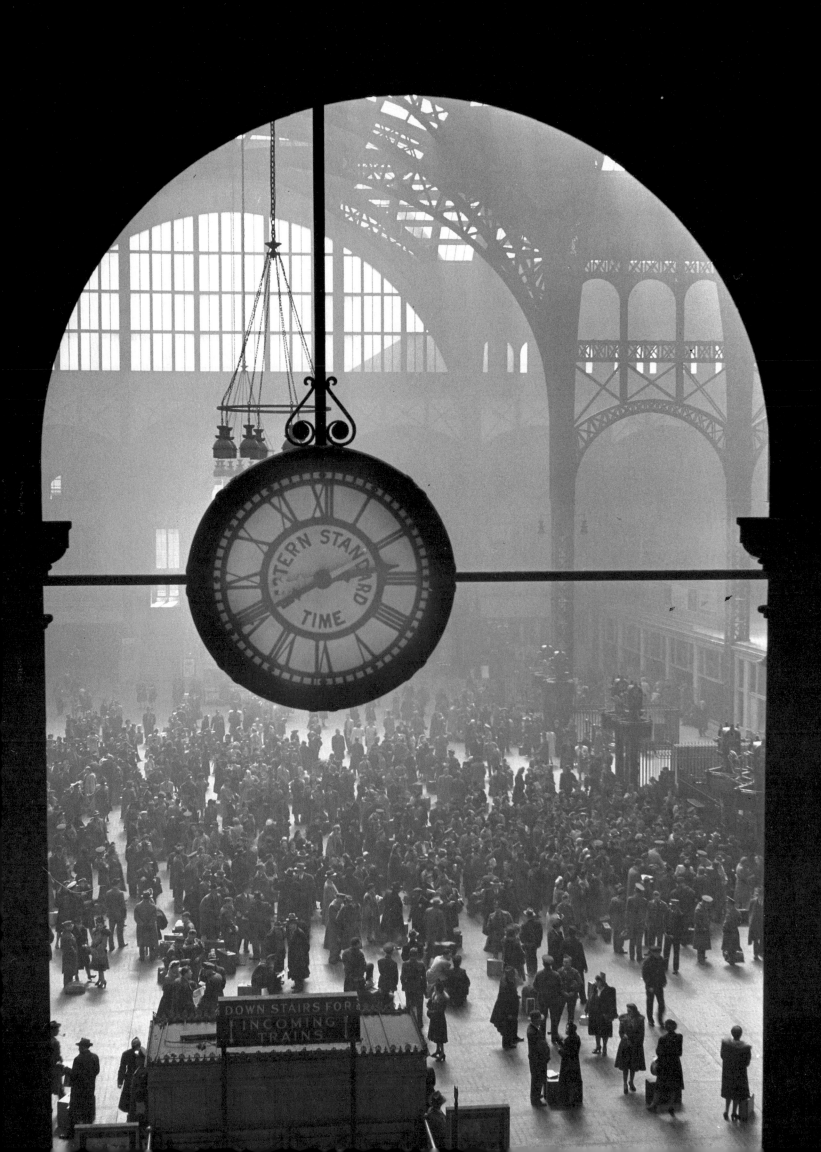

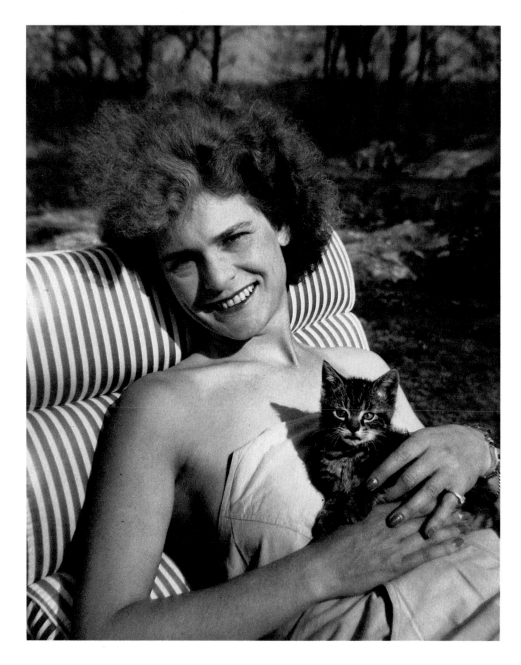

Margaret Bourke-White with a pet
kitten, at her country home in Darien,
Connecticut, 1944. She and Eisie were
close personal friends. A photograph by
Bourke-White appeared on the cover of
the first issue of LIFE, and one by
Eisenstaedt, on the cover of the second.

Maintaining a rigid position while
dining was part of the hazing endured
by a plebe at West Point, 1936. This
picture, Eisenstaedt's first of eighty-six
cover photos for LIFE, led the second
issue of the magazine.

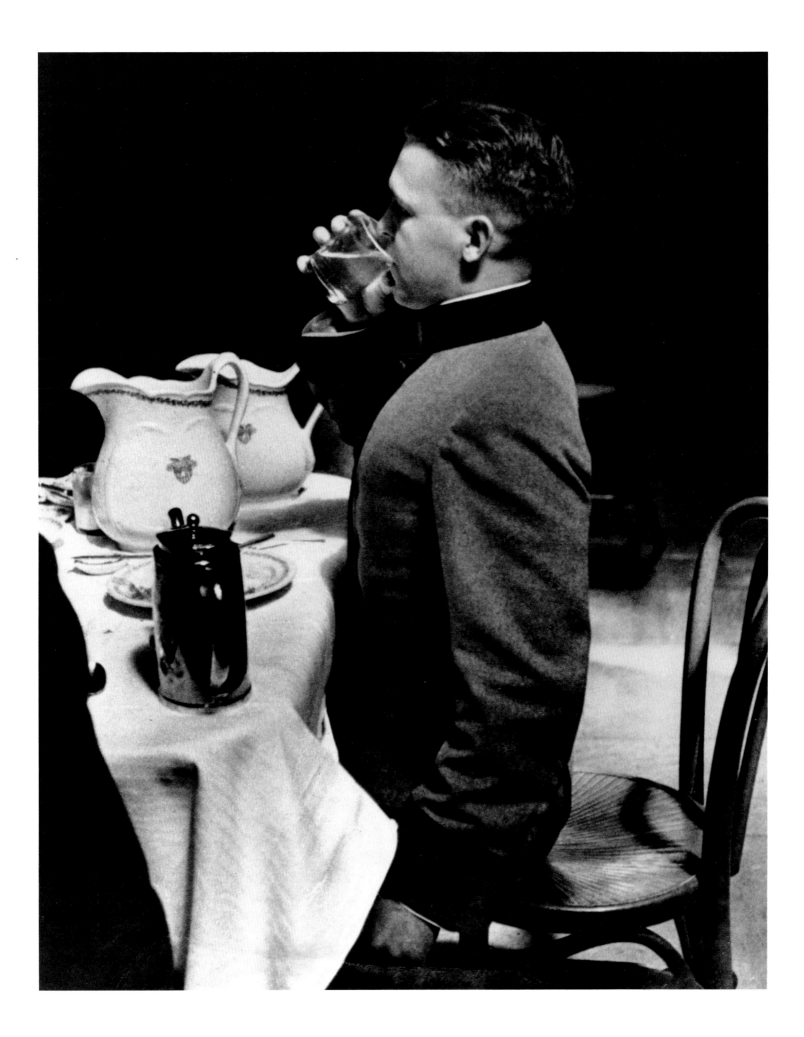

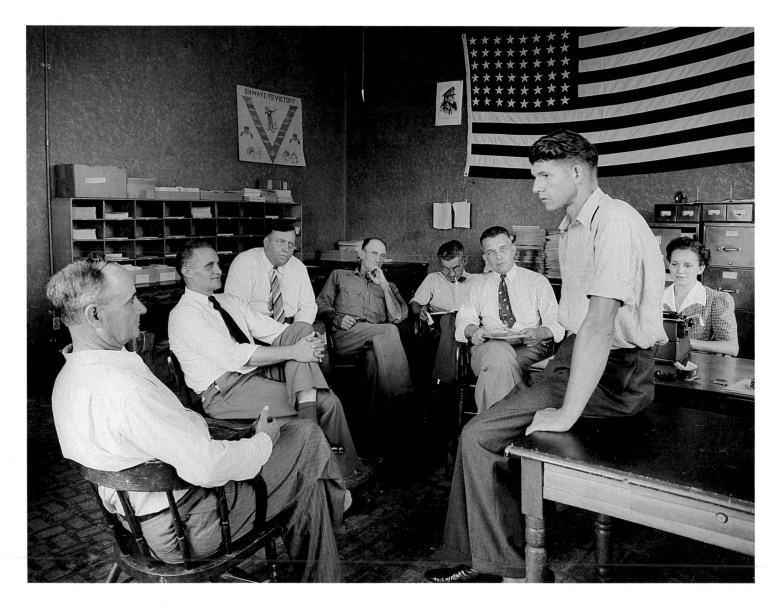

A young farmer appears before his draft board and is classified 2-C, indicating deferment from military service because of the importance of his occupation, Missouri, 1942.

The tumultuous celebration of V-J Day in Times Square, New York City, 1945. Eisenstaedt noticed one particularly exuberant sailor kissing every woman within reach. Eisie ran ahead in order to be in position by the time the dark-uniformed man reached and embraced a white-uniformed nurse—as the photographer had been sure he would. This is probably the most often reproduced and most widely recognized photograph ever to have appeared in LIFE.

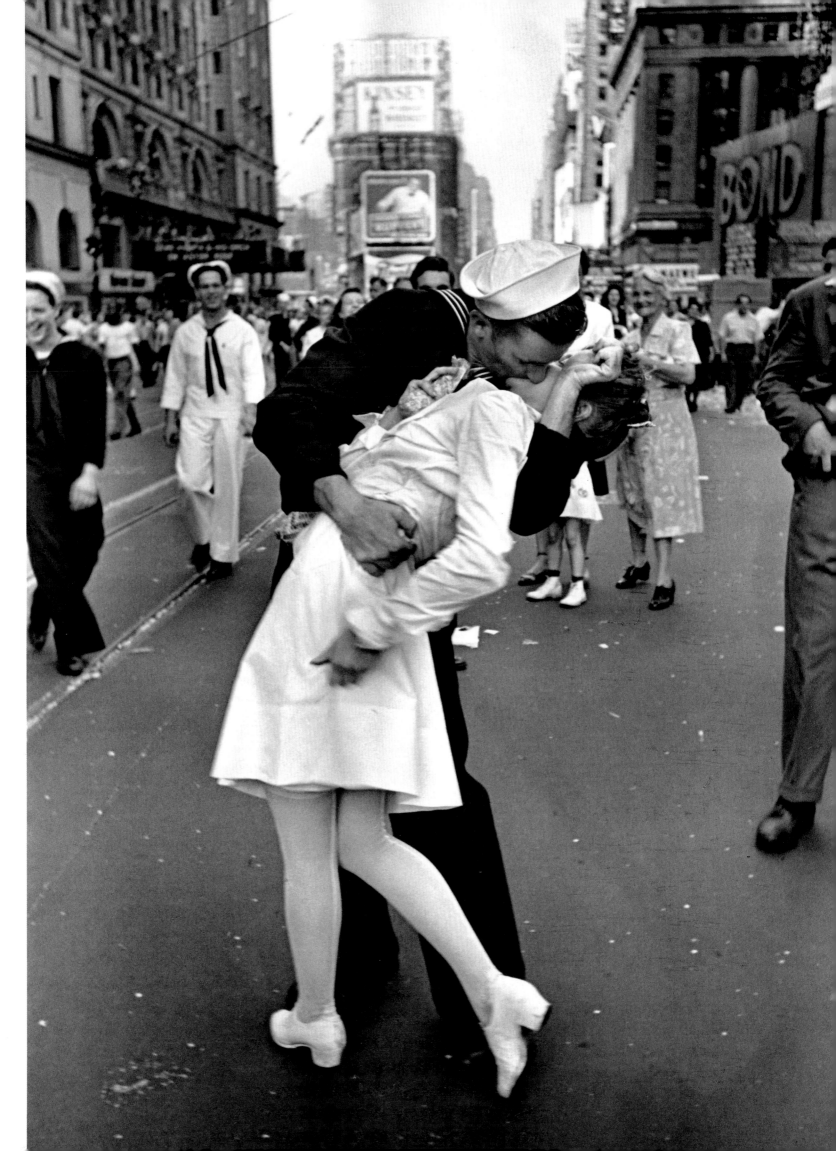

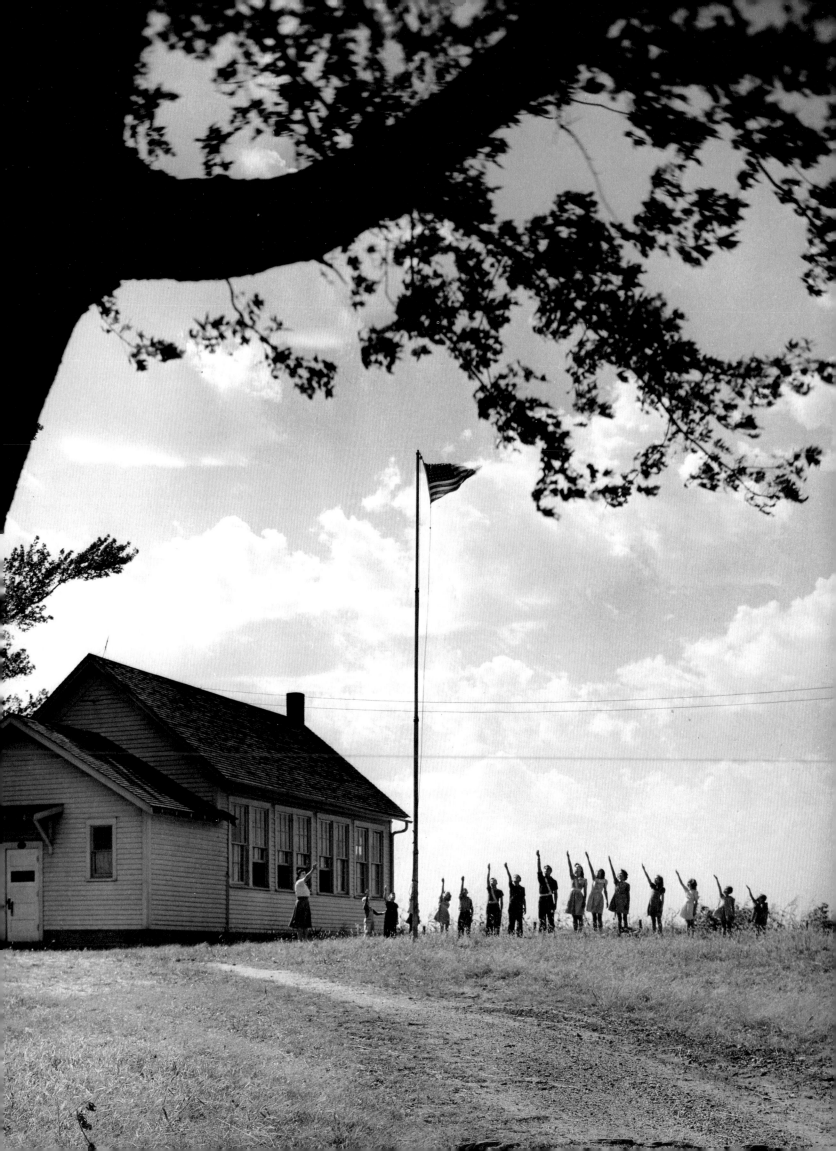

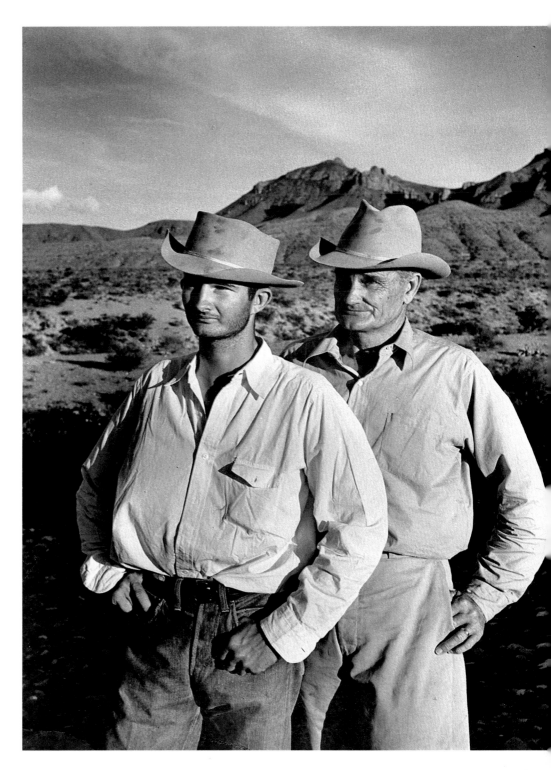

Father and son, ranchers in the Big
Bend region of Texas, 1944.

Children salute the flag outside a
schoolhouse in Polk County, Iowa, 1942.
From a photographic essay on the
American Midwest.

A farm girl preparing for high school, Oklahoma, 1943. The coverlet of her bed is embroidered with the names of her friends.

OVERLEAF:
A line of children emulates a drum major rehearsing at the University of Michigan, Ann Arbor, 1950.

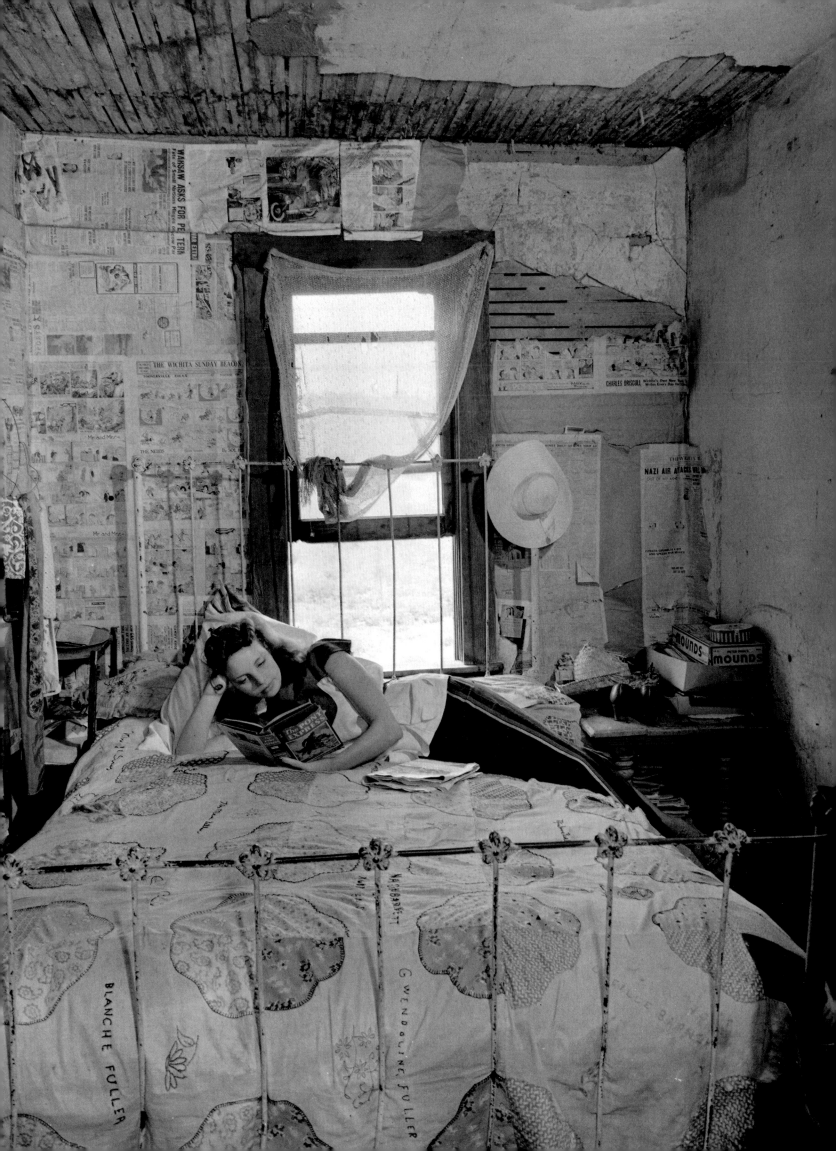

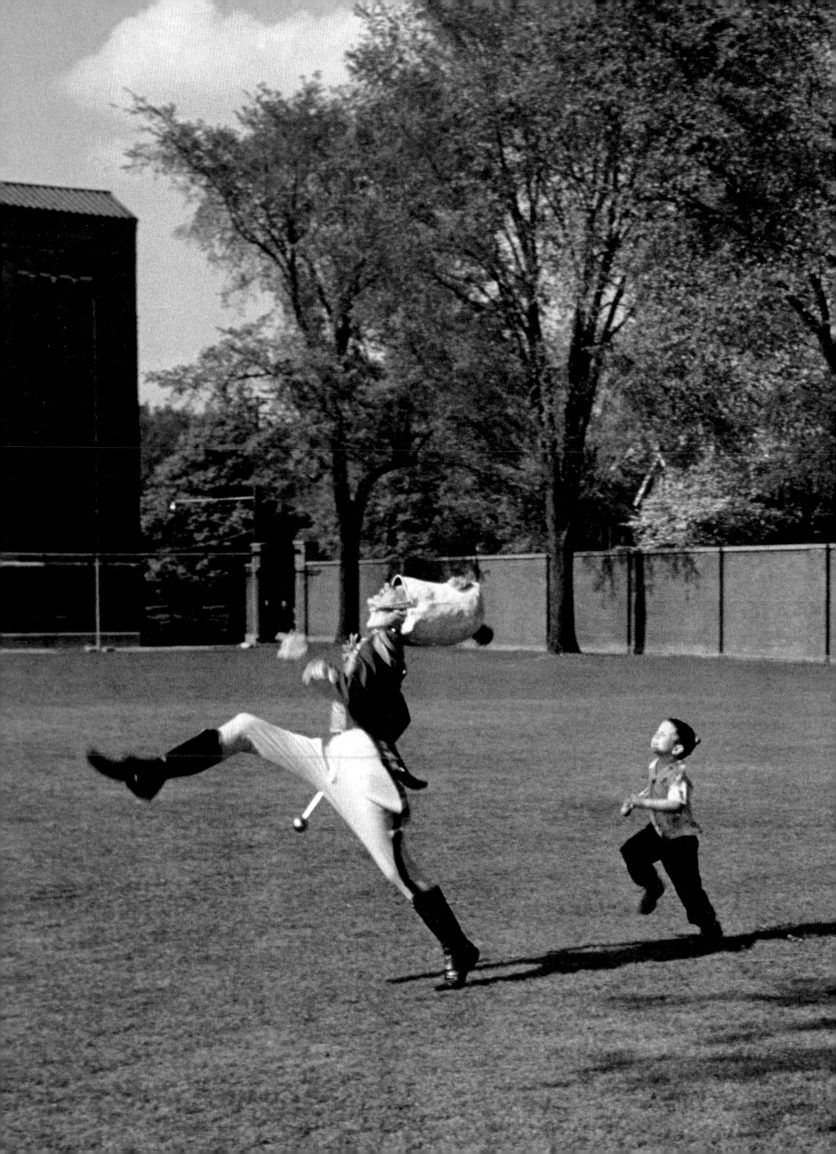

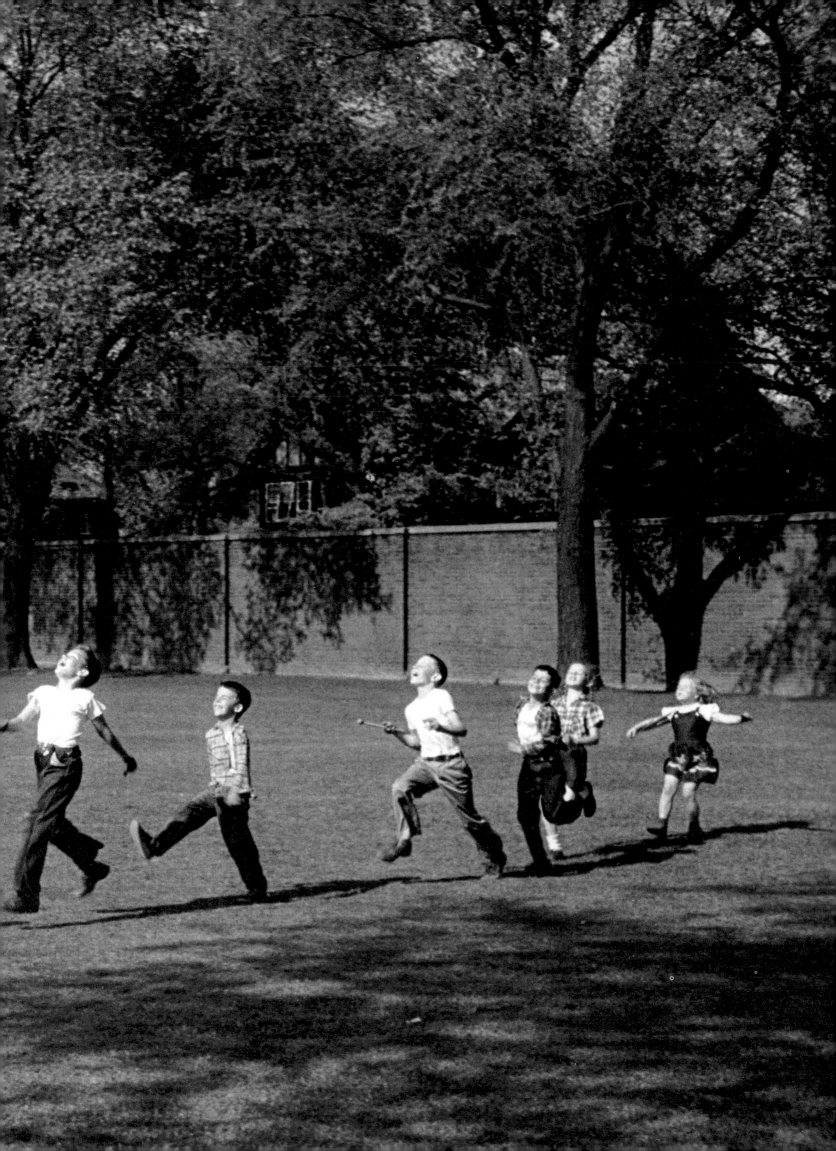

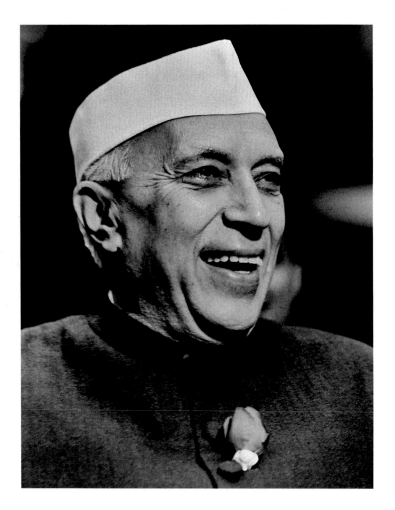

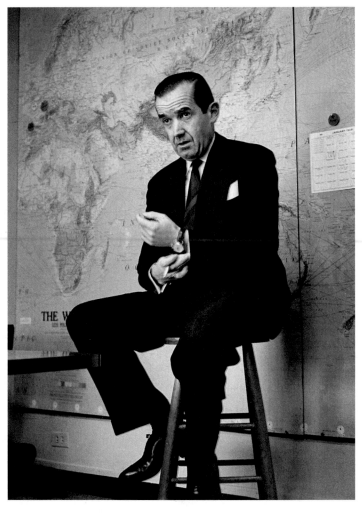

Indian Prime Minister Jawaharlal Nehru at a gathering of delegates from the General Assembly of the United Nations, New York City, September 1960.

Edward R. Murrow in his office at CBS News, New York City, 1959. After taking a sabbatical from television, the celebrated news commentator became the director of the United States Information Agency (USIA).

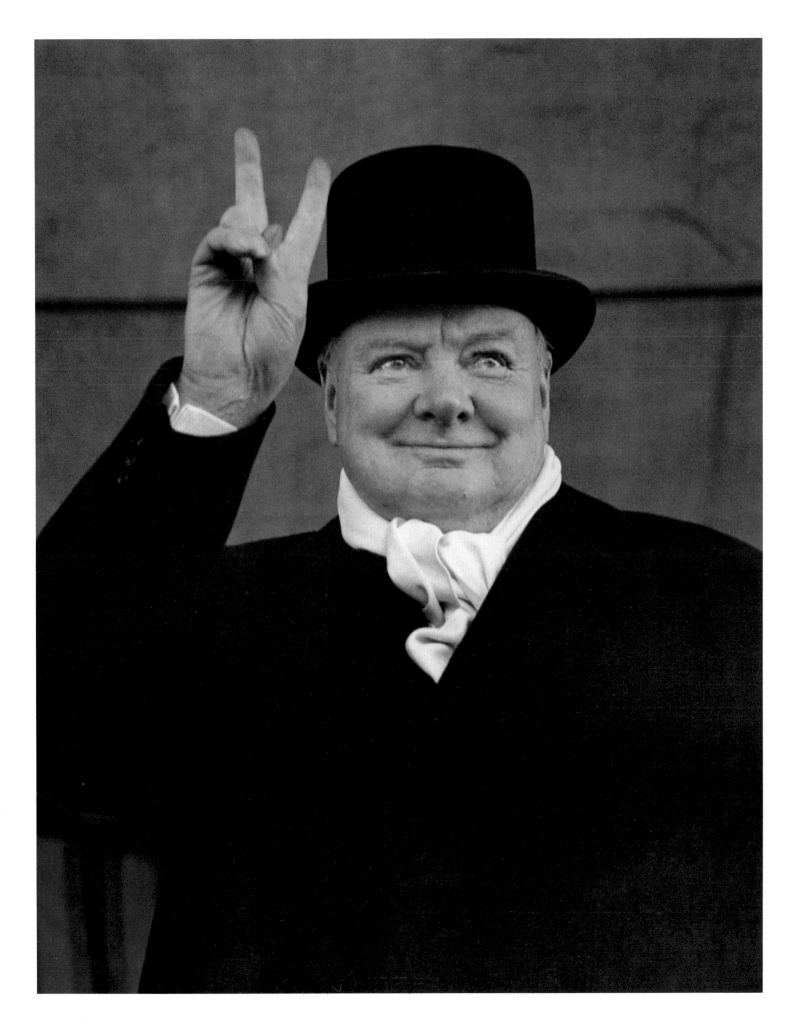

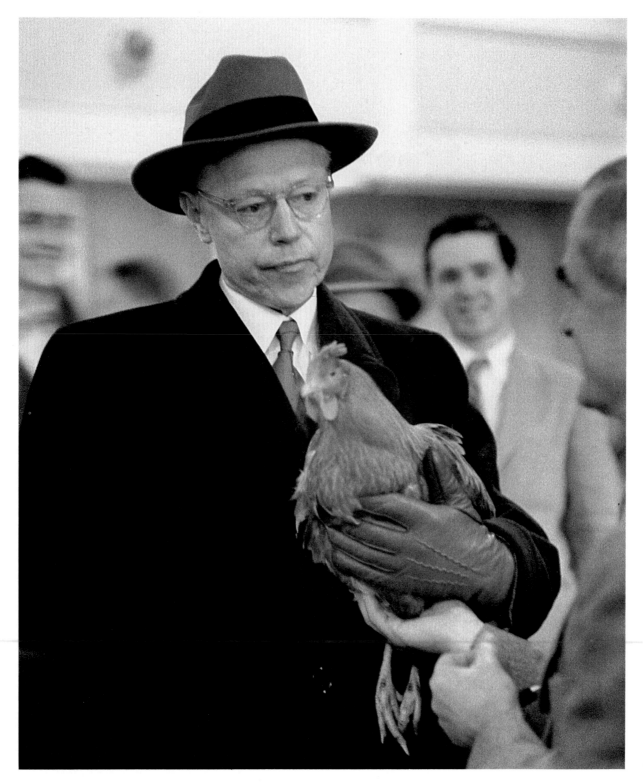

*Robert A. Taft holding a rooster, which
had been thrust into his hands by a
spectator during the senator's
unsuccessful campaign for the
Republican presidential nomination,
New Hampshire, 1952.*

*John F. Kennedy and his daughter,
Caroline, at home in Hyannisport,
Massachusetts, 1960. This was taken
shortly after the senator had become the
Democratic presidential candidate.*

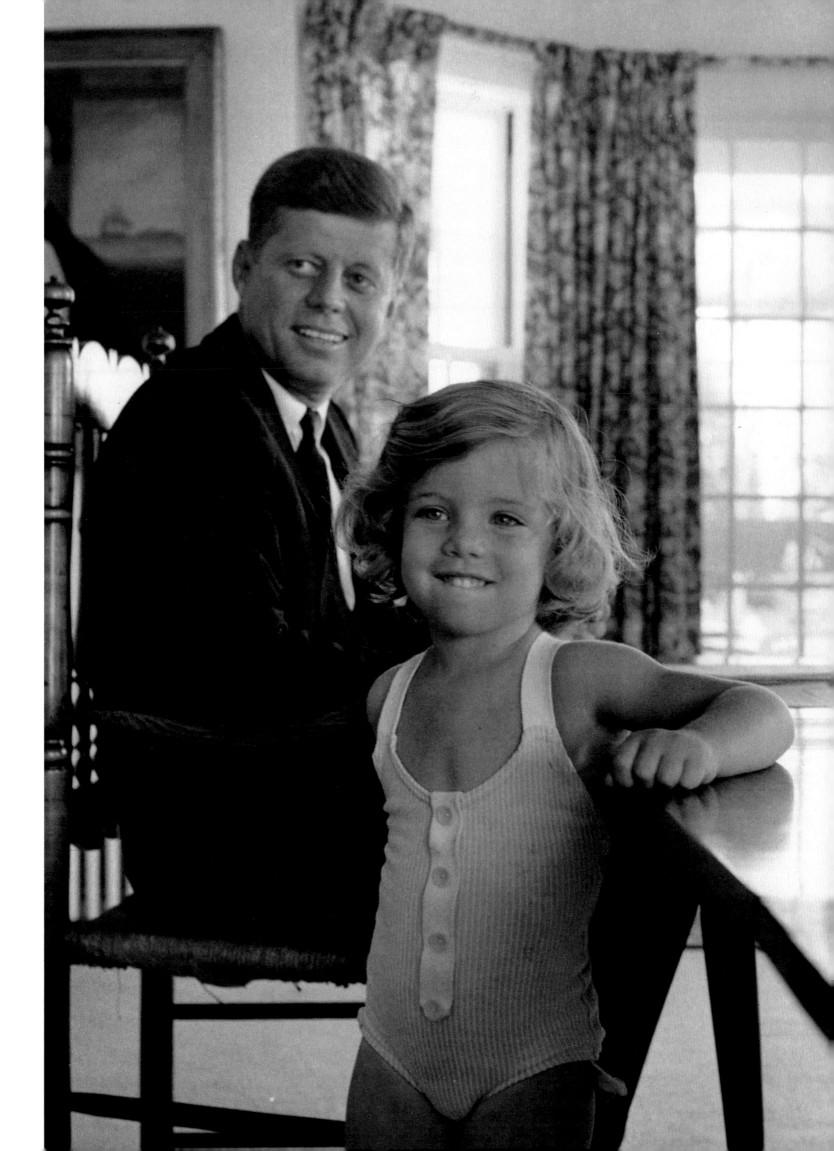

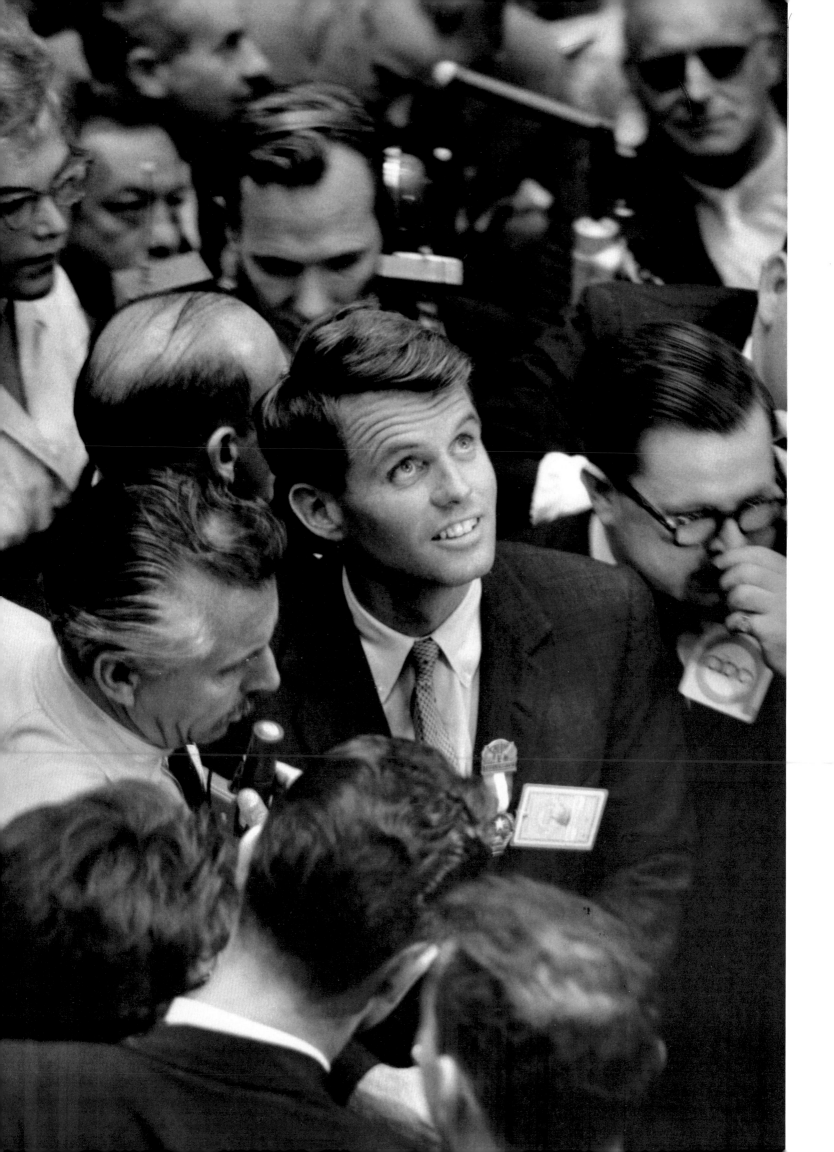

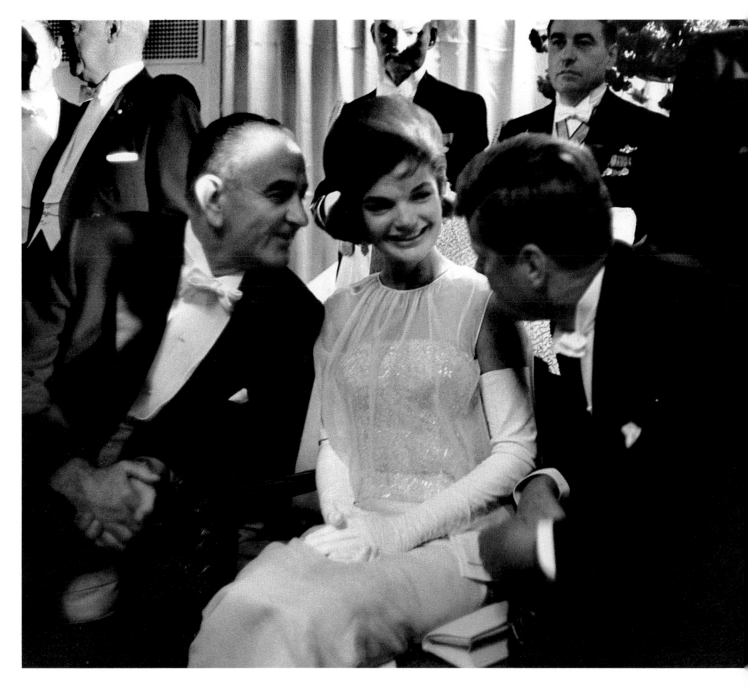

Newly elected President John Fitzgerald
Kennedy with his wife, Jacqueline, and
Vice President Lyndon Baines Johnson at
one of five inaugural celebrations,
Mayflower Hotel, Washington, D.C., 1961.
Only three weeks after taking office
Kennedy wrote in Eisie's autograph book:
"For Alfred Eisenstaedt . . . who has
caught us all on the edge of the New
Frontier. What will the passage of the next
four years show on his revealing plate?"

OVERLEAF:
Dr. Martin Luther King with Kenneth
Kaunda, later president of Zambia, in
King's office in Birmingham, Alabama,
1960.

Robert F. Kennedy, manager of his
brother Jack's successful presidential
campaign, at the Democratic National
Convention in Los Angeles, 1960.

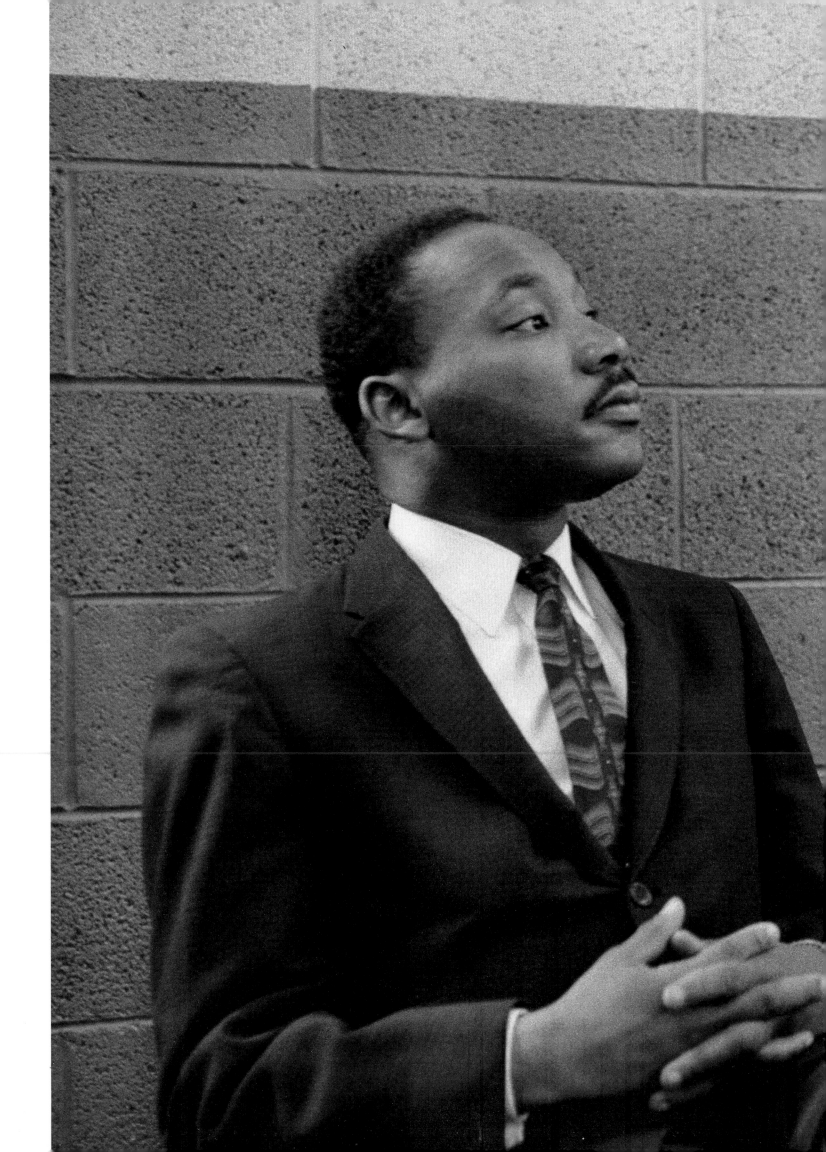

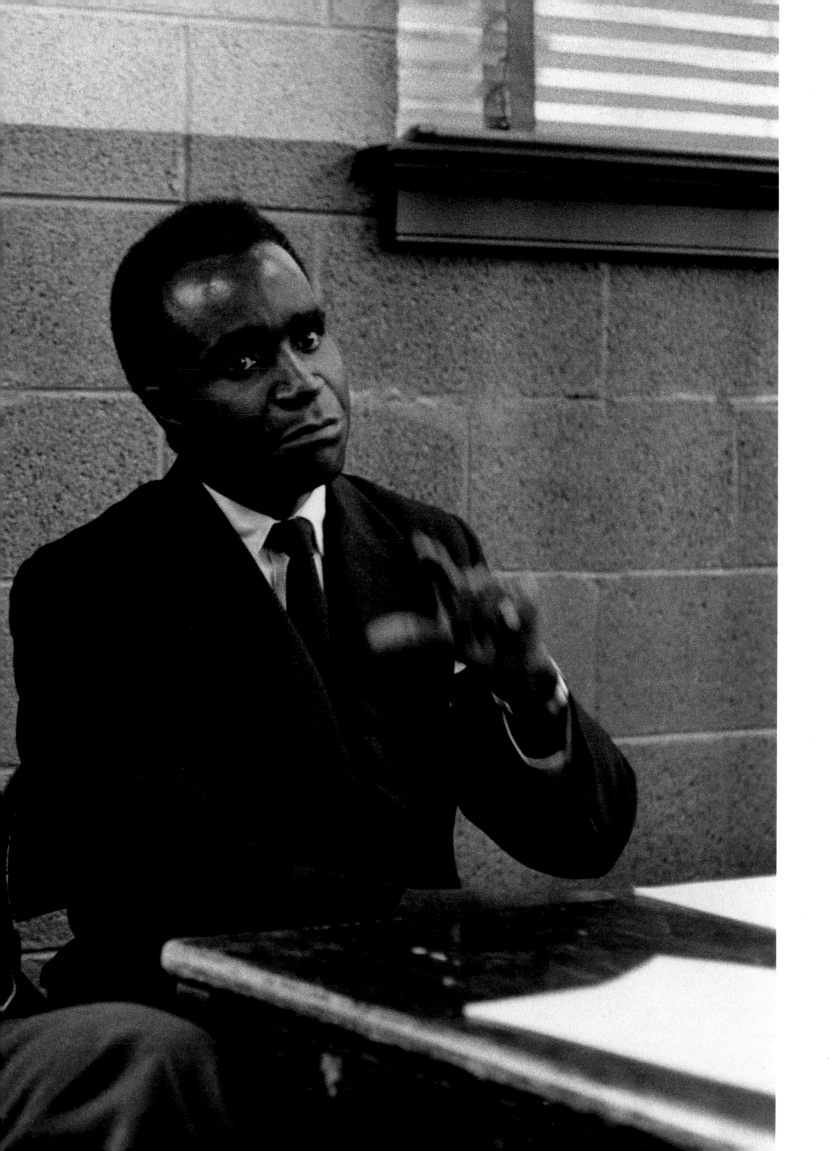

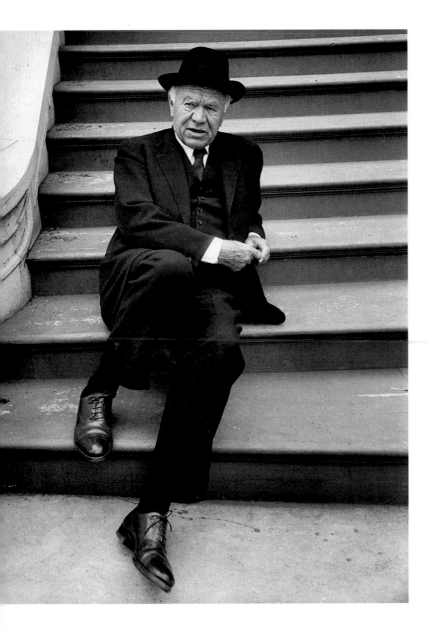

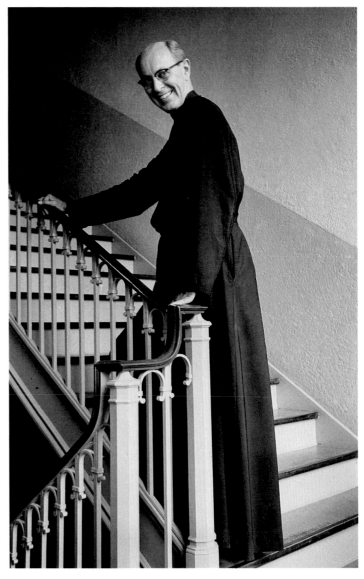

John Courtney Murray, a leading Jesuit
scholar, editor, and teacher, at
Woodstock College, Maryland, 1955.

Lord Beaverbrook (William Maxwell
Aitken), the Canadian-born British
statesman and publisher, at a university
where he was about to receive an
award, New Brunswick, Canada, 1950.

Learned Hand, a judge of the United
States Court of Appeals and one of the
most highly respected jurists in American
history, New York City, 1959.

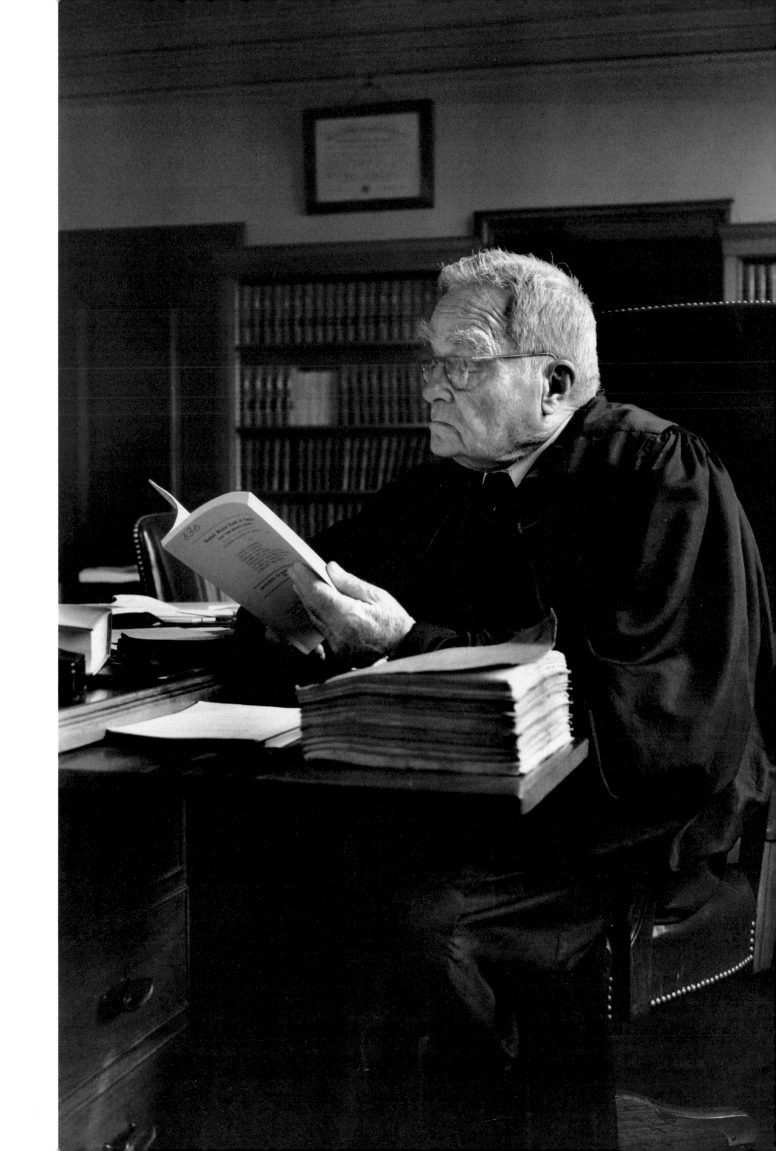

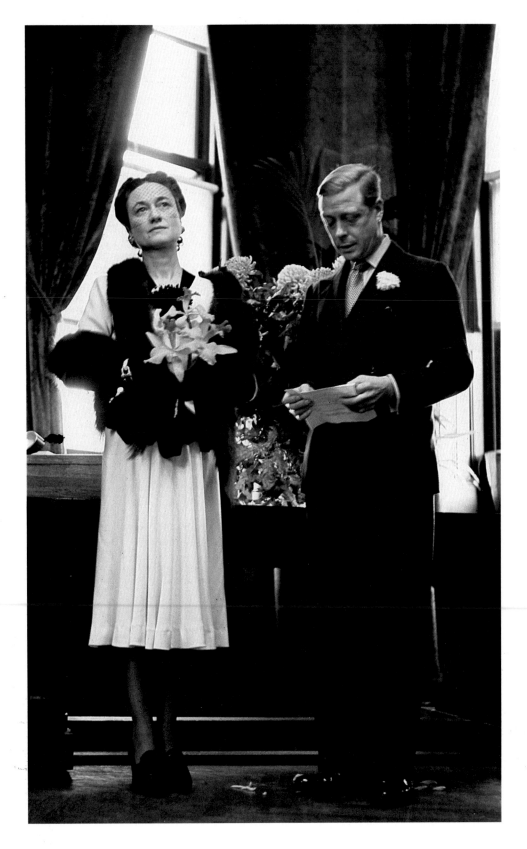

The Duke and Duchess of Windsor on their first official visit to the United States after the Duke had renounced his throne, Baltimore, 1941. In this, the native city of the Duchess, the Duke read a short speech at City Hall.

The Queen of England speaks with actors and actresses after a special screening of Where No Vultures Fly *at the Odeon Theatre, London, 1951. Among the performers present were Zachary Scott, Lizabeth Scott, Jane Russell, and Dame Margaret Rutherford.*

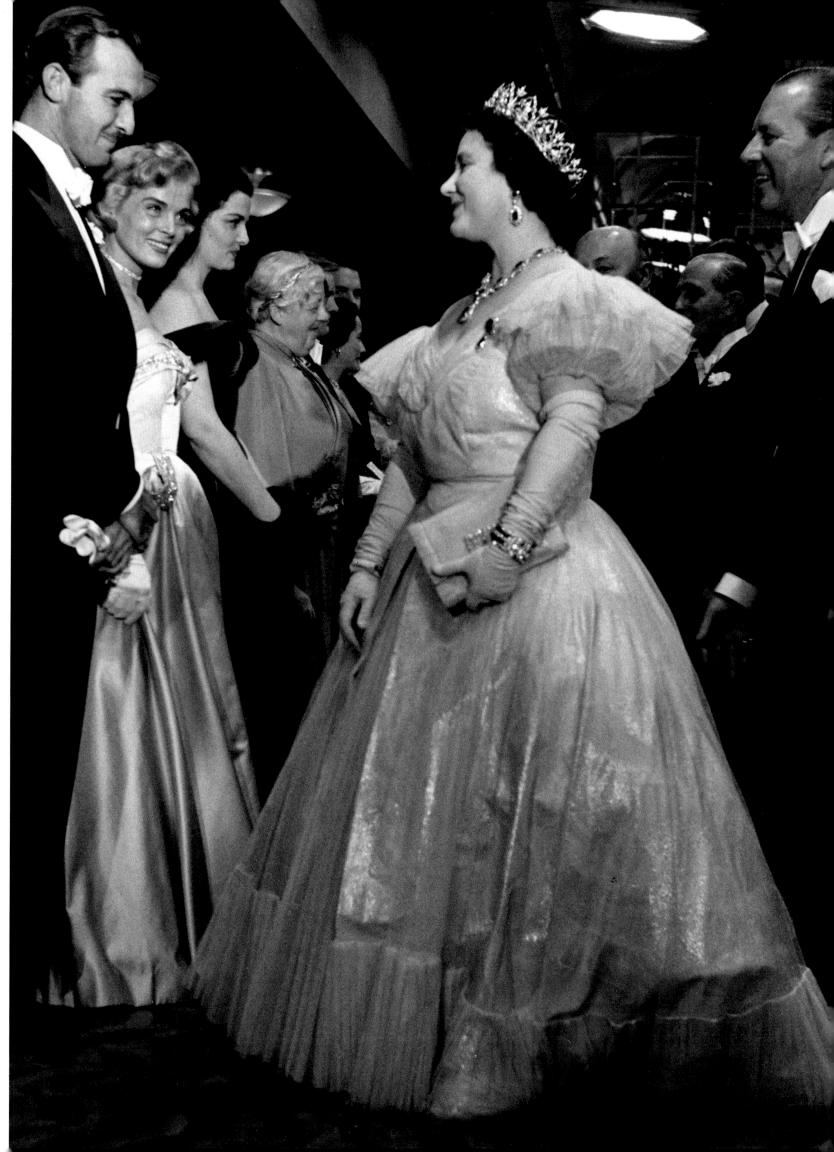

British actor Emlyn Williams portraying Charles Dickens and reading aloud from his works, New York City, 1952.

Charles Laughton, New York City, 1952. The editors of LIFE had invited the acclaimed actor, who had recently become a citizen of the United States, to select for the Fourth of July issue a personal anthology of American writings suitable for being read aloud. Here, Laughton is reading from one of his selections.

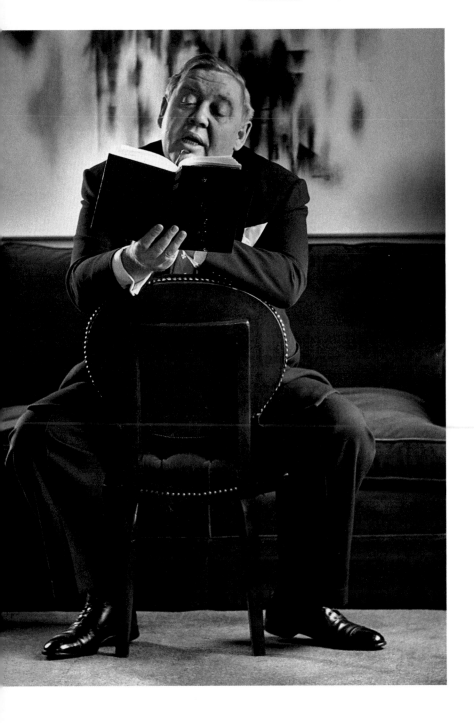

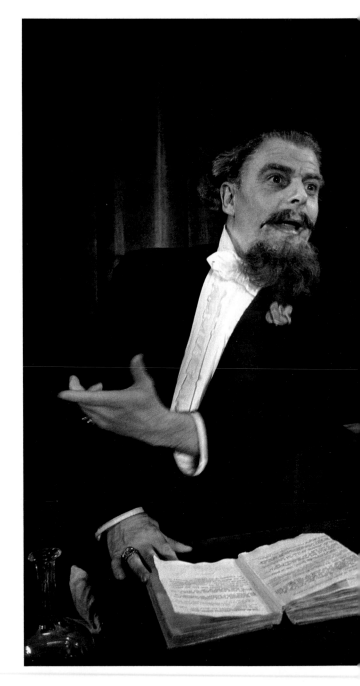

Dame Edith Evans, re-creating her stage role for the film version of Oscar Wilde's The Importance of Being Earnest, *at Pinewood Studios, near London, 1951. Lady Bracknell was one of the many theatrical roles for which Evans was famous.*

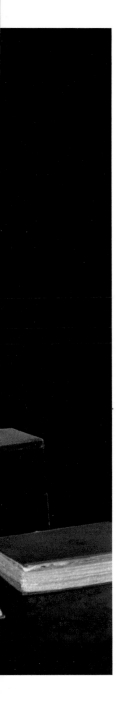

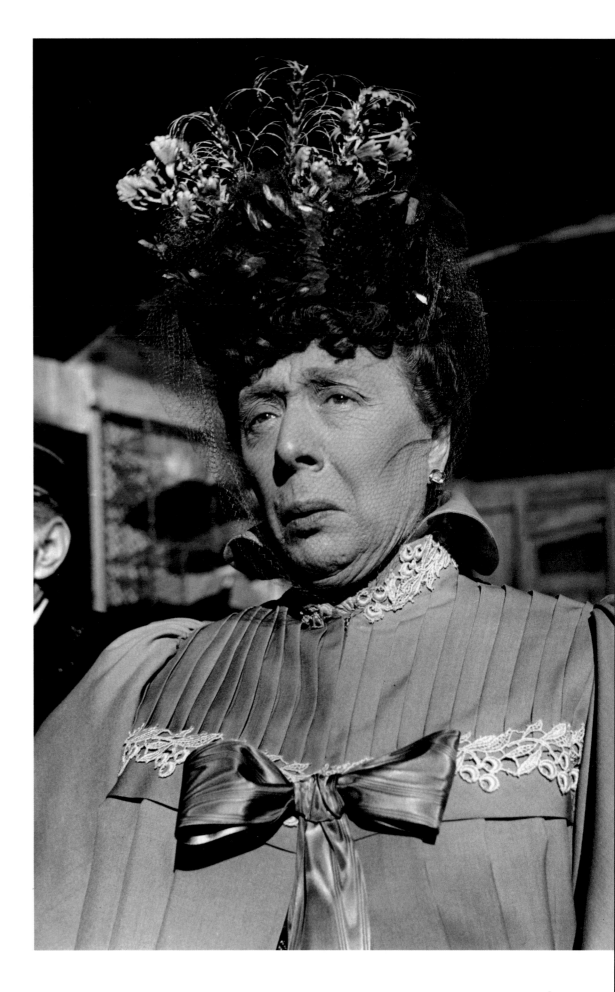

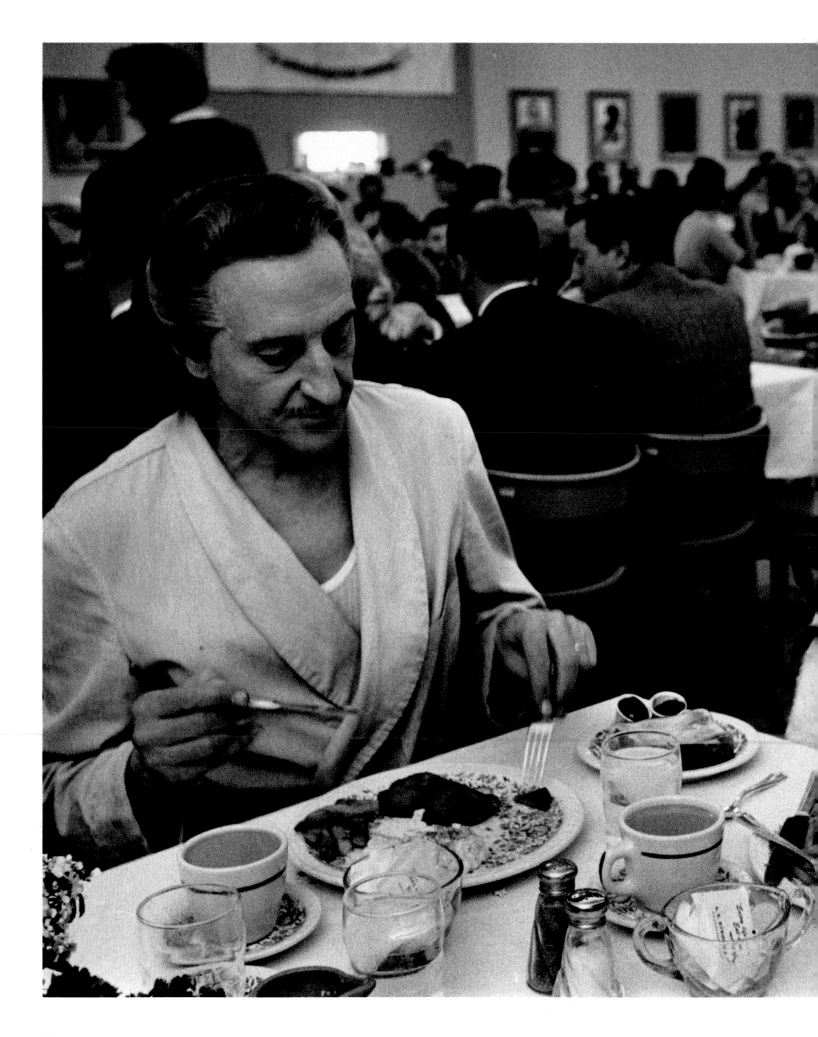

*Basil Rathbone and Angela Lansbury
having lunch at the commissary of
Paramount Studios during the filming
of* The Court Jester, Hollywood, 1953.

89

Marilyn Monroe on the small patio behind her home in Hollywood, 1953. Eisenstaedt recalls that Monroe was a little flustered, and perhaps he was, too, because he confused a camera holding black-and-white film with one holding color, and as a result some of his exposures were slightly off.

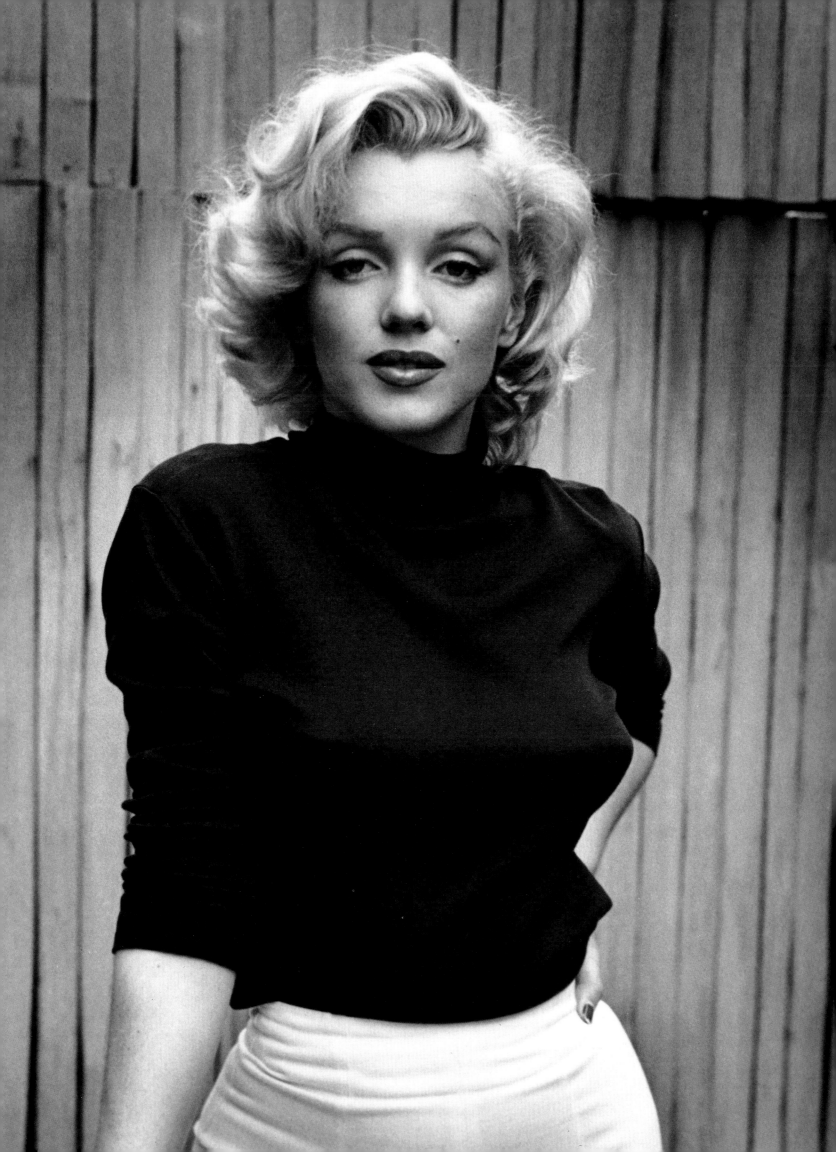

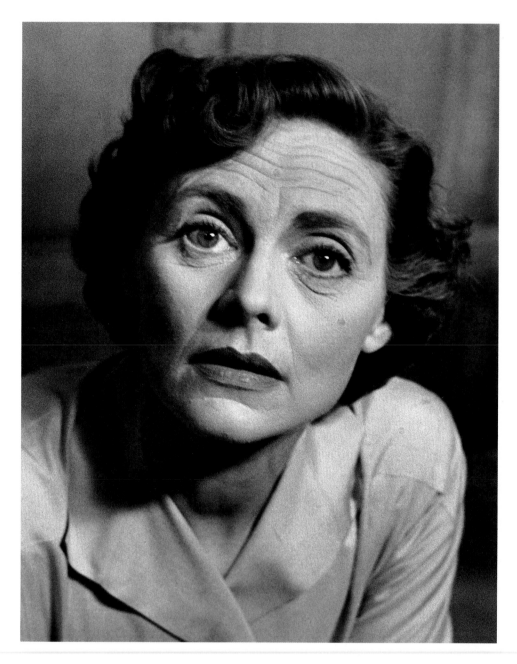

Celia Johnson, a veteran of the British stage, London, 1951. She had just returned from a tour to begin work on a film. Among her best-known movies are In Which We Serve *and* Brief Encounter.

Sophia Loren in character for the movie Marriage Italian Style, *Rome, 1964.*

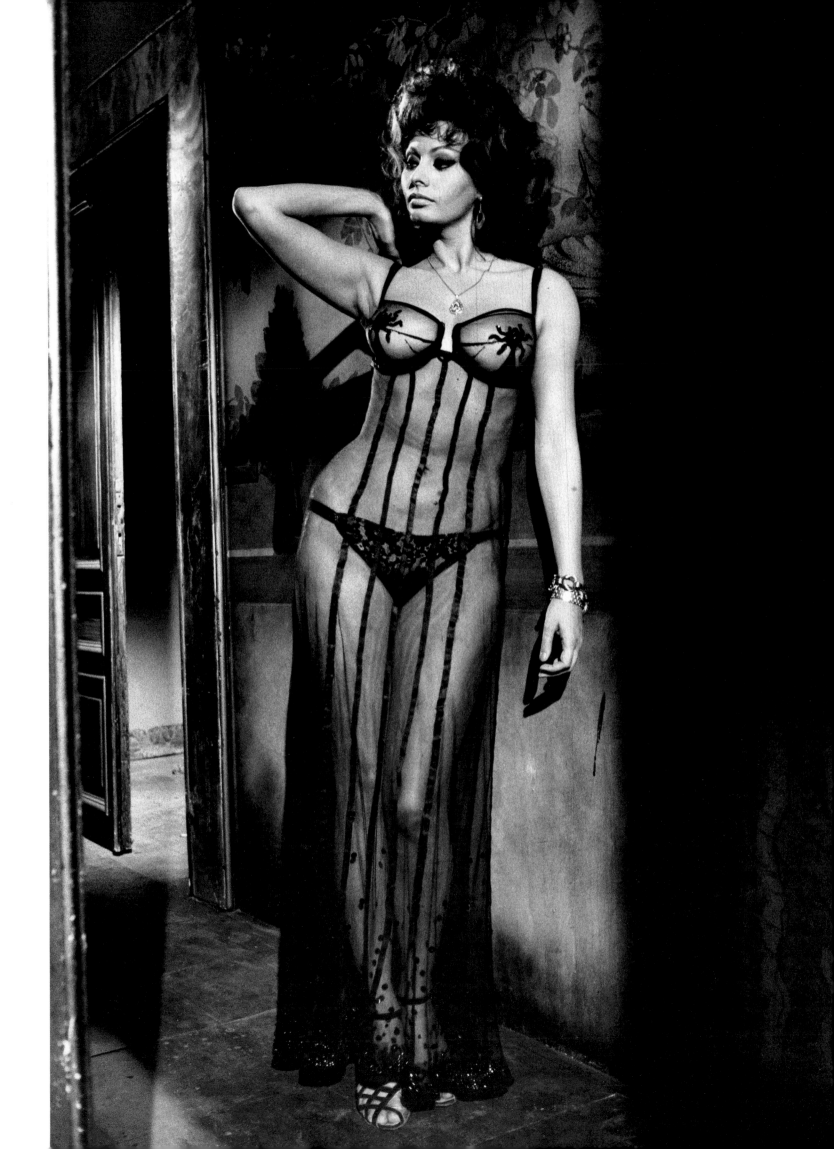

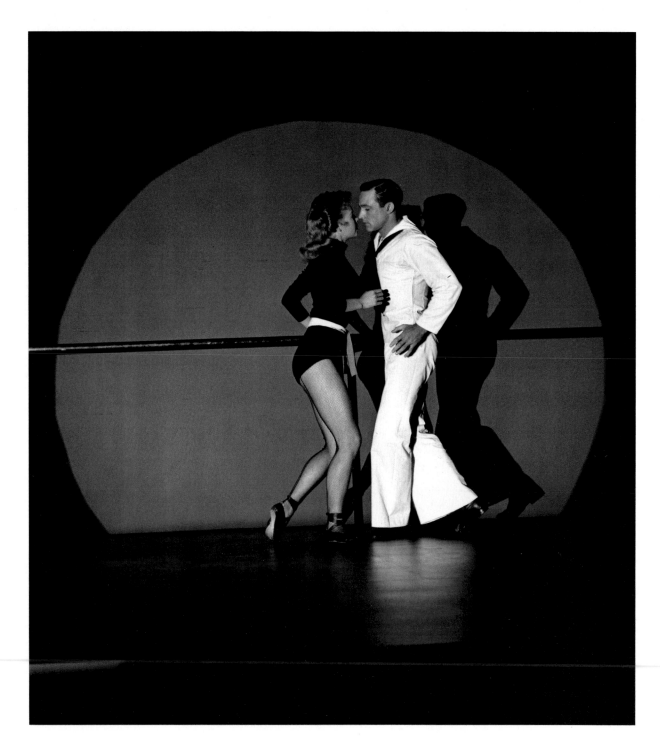

Gene Kelly and Vera-Ellen dancing during the filming of Arthur Freed's production of On the Town, *MGM Studios, Hollywood, 1949.*

Salvador Dalí and his wife, Gala, at a white-tie New Year's Eve party, New York City, 1956.

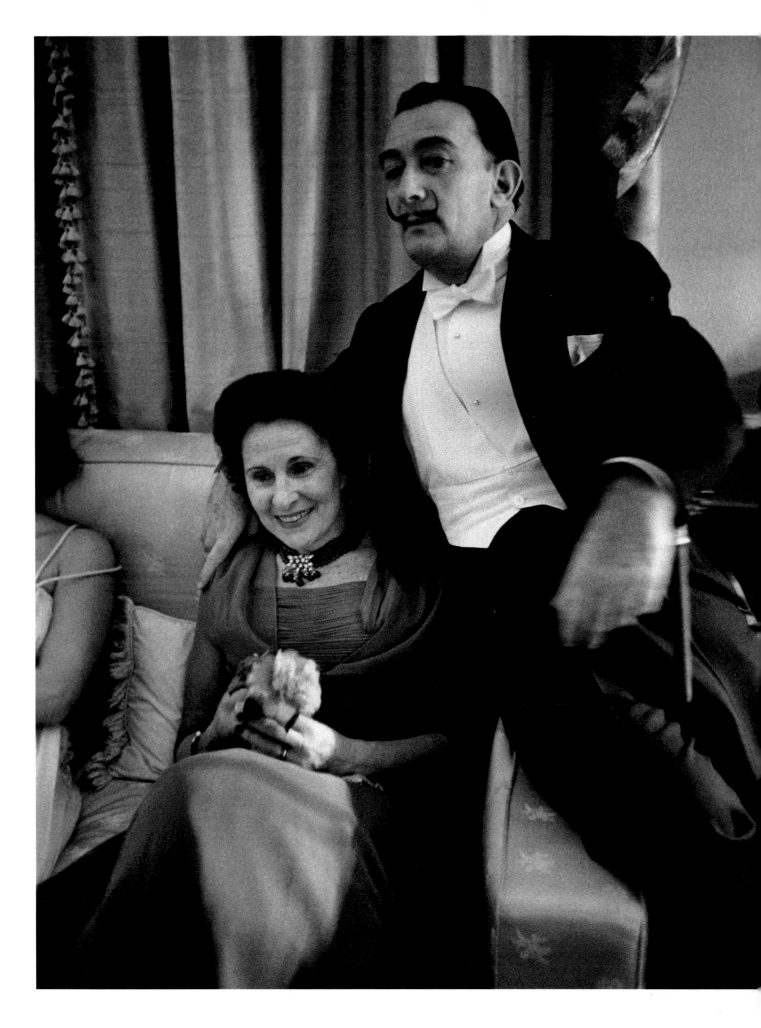

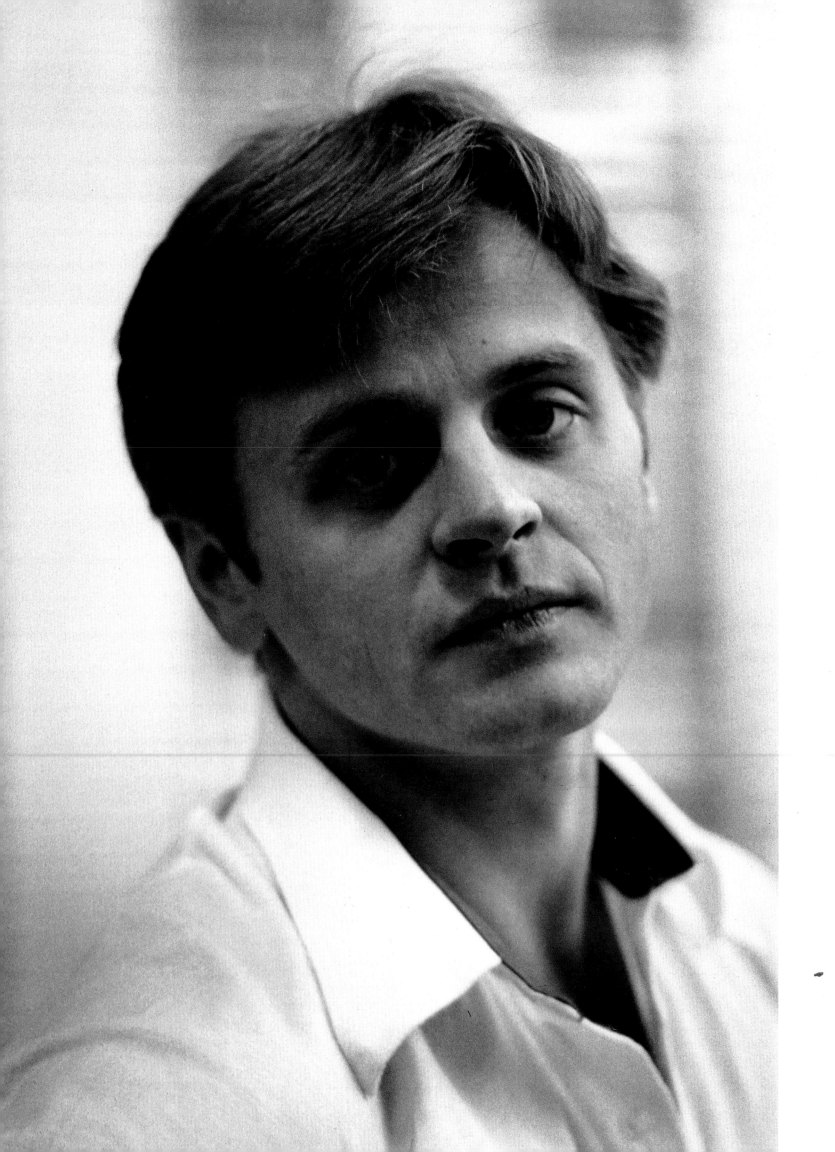

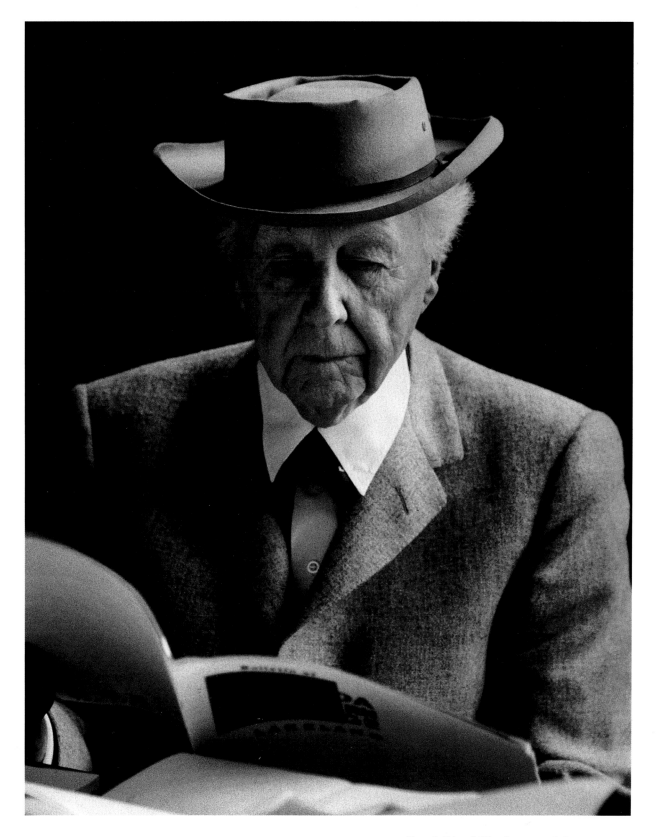

Mikhail Baryshnikov at the Minskoff Theater, New York City, 1979. Rehearsing for a television serial, the dancer could allow Eisenstaedt only four minutes in which to take this portrait.

Frank Lloyd Wright, one of the most outstanding architects of the twentieth century, at his home and studio, Taliesin East, at Spring Green, Wisconsin, 1956.

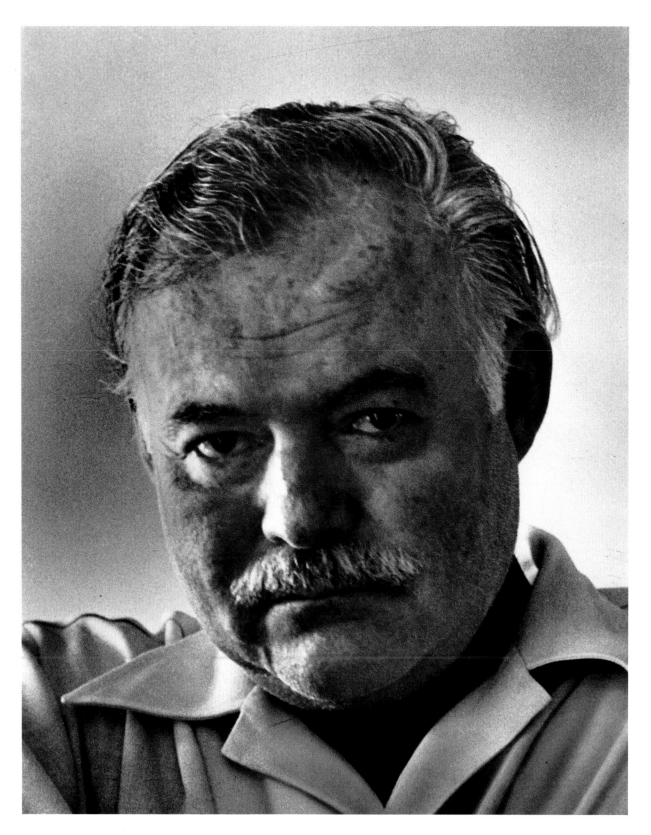

Ernest Hemingway, Cuba, 1952.
Eisie considered Hemingway by far
the most difficult person he ever
had to photograph. The writer was
unpredictable and easily became
enraged.

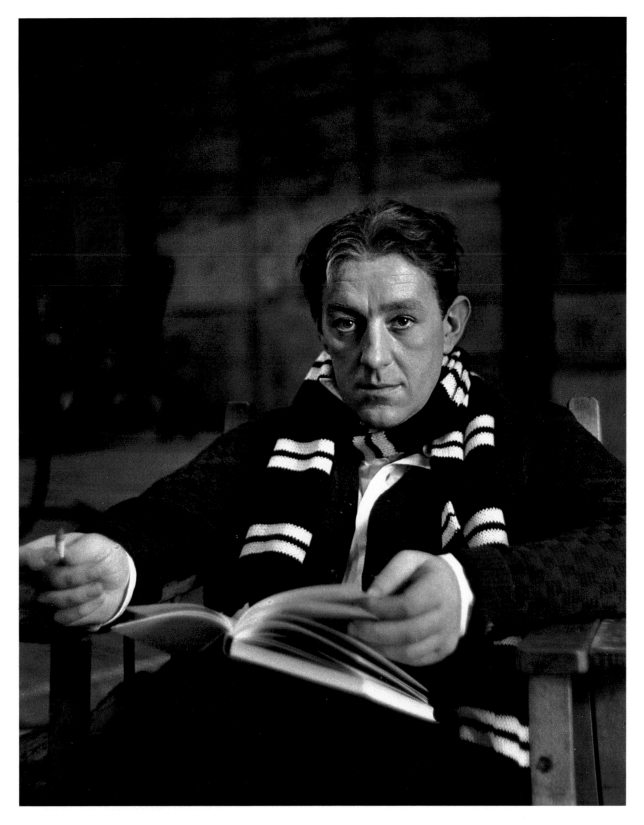

Alec Guinness during the filming of The Promoter *(based on Arnold Bennett's novel* The Card*) at Ealing Studio, London, 1951. Guinness wore his scarf between takes in the unheated studio.*

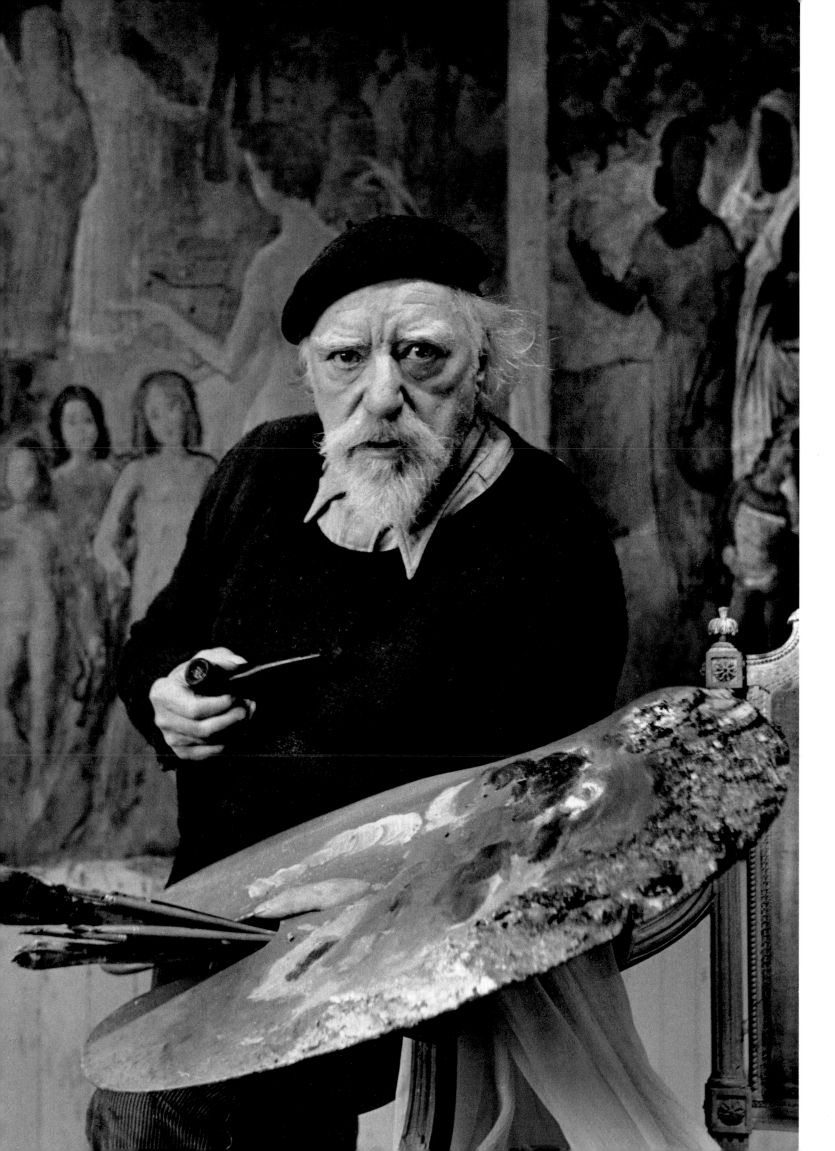

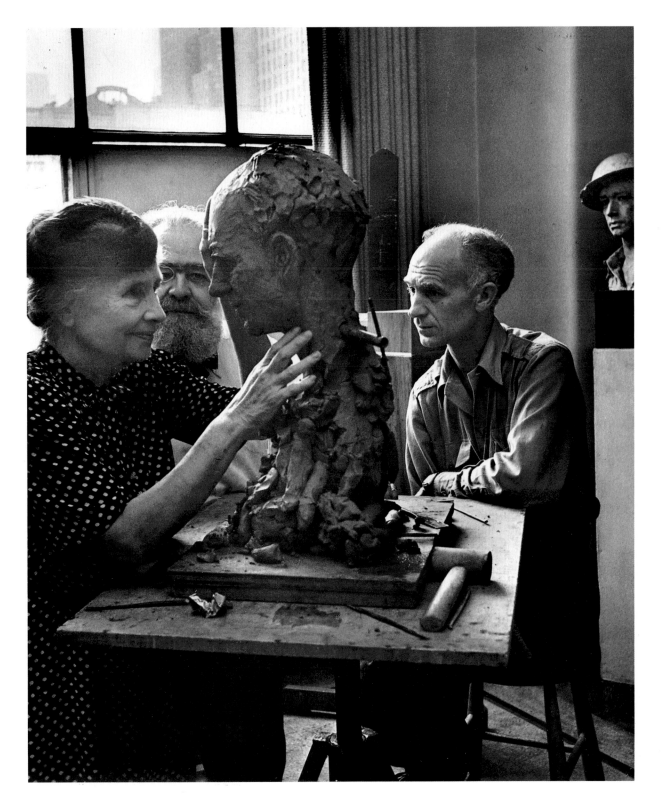

*In the company of sculptor Jo Davidson
and journalist Ernie Pyle, Helen Keller
studies with her fingers the surfaces of
Davidson's bust of Pyle, 1944.*

*Artist Augustus John completing a
portrait in his studio in Hampshire,
England, 1951.*

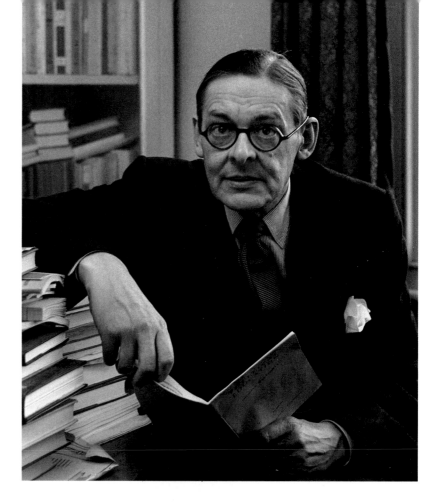

T. S. Eliot in his office at his publishers, Faber and Faber, London, 1951. Eliot had occupied this tiny room for over twenty-five years, spending many nights there during the Blitz. It was so crowded with books that Eisie had to crawl under tables and chairs in order to find a spot from which to take this picture.

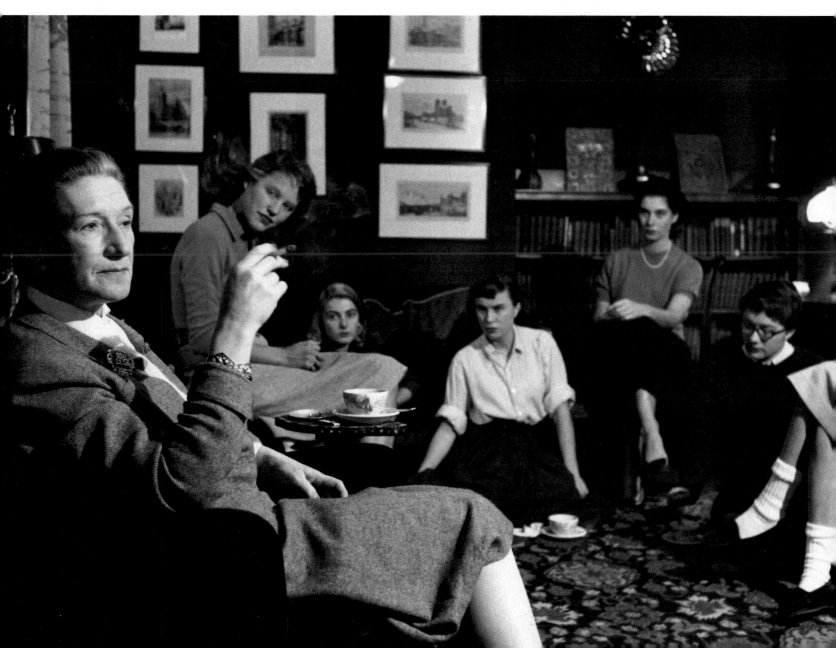

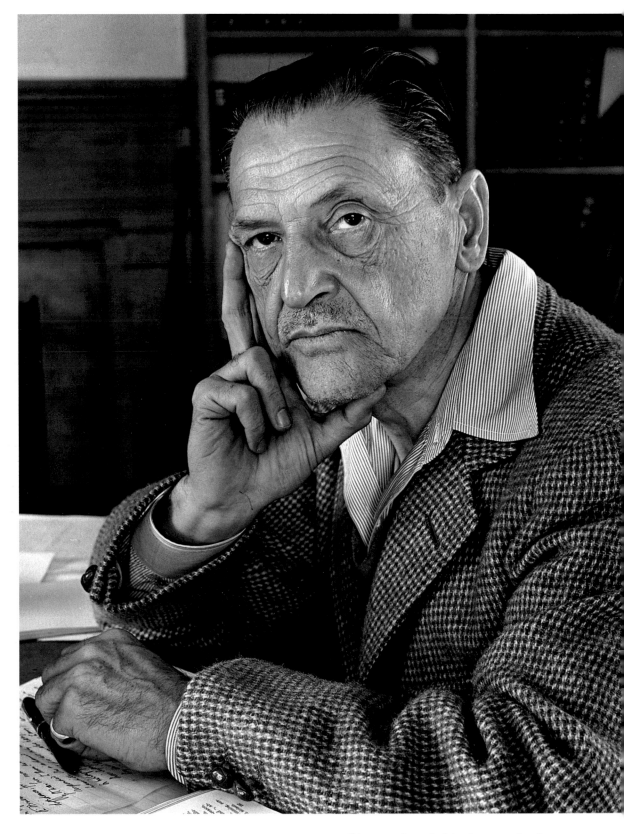

Eisenstaedt took this photograph of English novelist W. Somerset Maugham when the writer was the guest of his publisher, Nelson Doubleday, for a week of duck hunting in South Carolina, 1942.

Elizabeth Bowen, an eminent Irish writer, speaking with students at Bryn Mawr College, 1956.

103

Poet Robert Lowell at his home in Boston, 1959. From a photographic essay on the Lowell family. A leading American literary figure, Lowell wrote poems characterized by sensitivity and an interest in other than materialistic concerns.

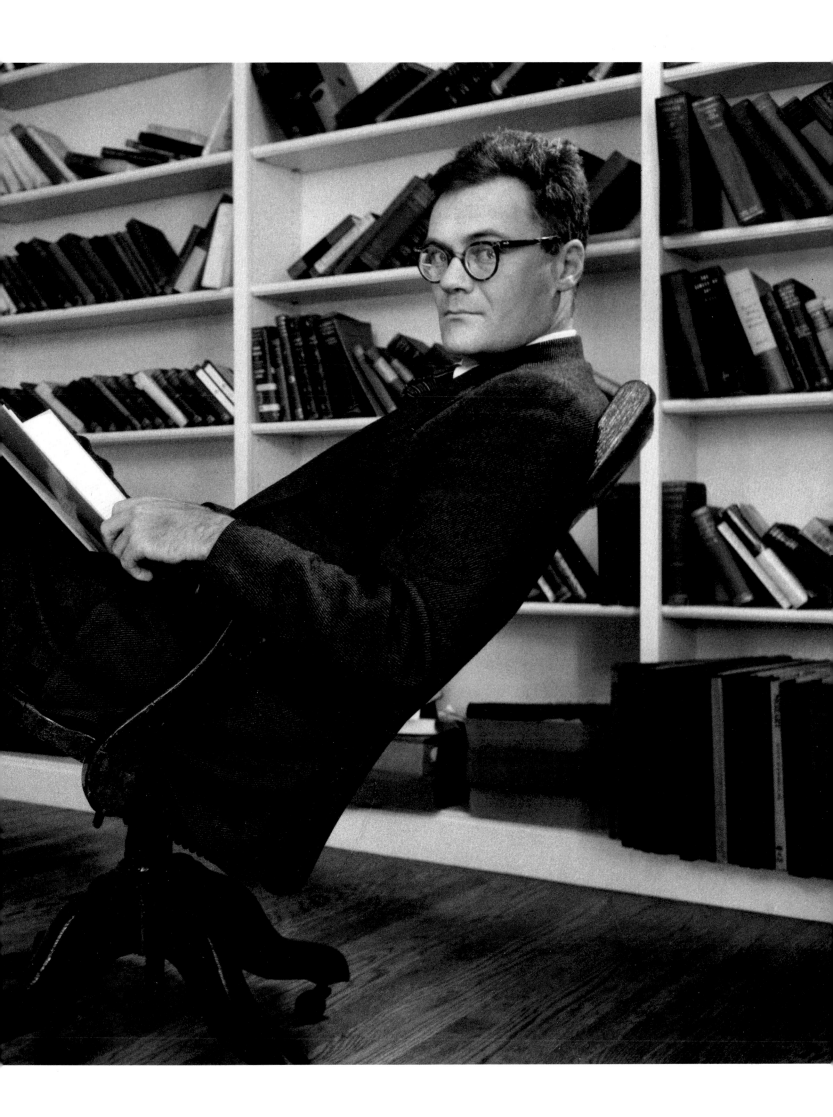

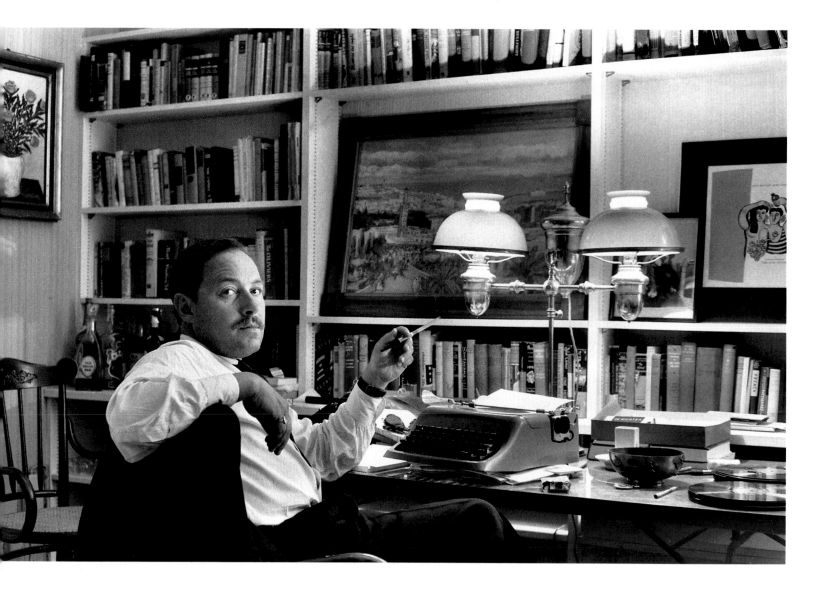

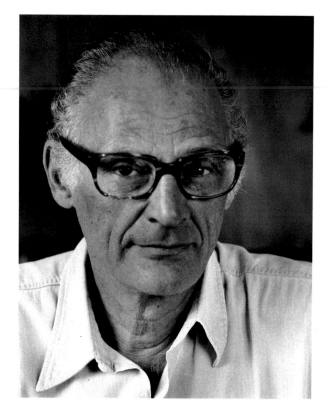

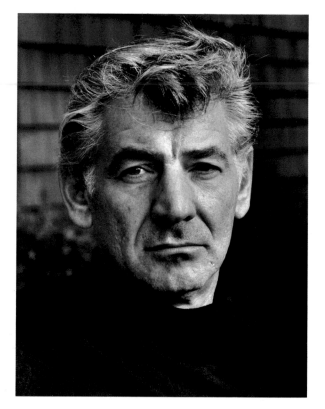

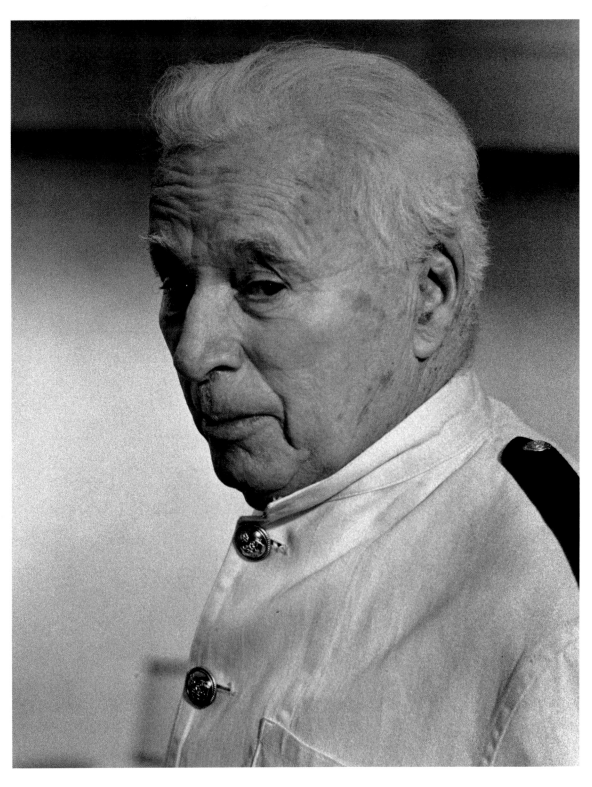

Charlie Chaplin, during the production of his film A Countess from Hong Kong, *London, 1966.*

ABOVE LEFT: *Tennessee Williams in his study, New York City, 1956. The playwright had recently won the Pulitzer Prize and the New York Drama Critics' Circle Award for* Cat on a Hot Tin Roof.

FAR LEFT: *Playwright Arthur Miller at his home in Roxbury, Connecticut, 1977.*

LEFT: *Leonard Bernstein, the dynamic composer, conductor, and pianist, Greenfield Hill, Connecticut, 1968.*

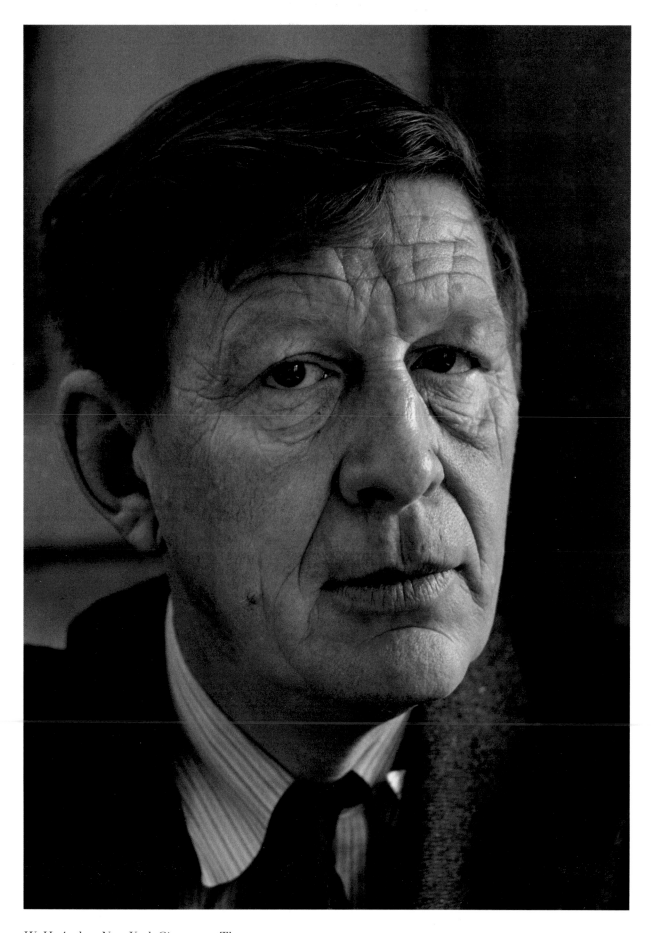

W. H. Auden, New York City, 1955. The English poet became an American citizen, and lived in New York City until 1972. He then returned to England, living in Oxford until his death the following year.

Hanna Schygulla, the German film star, applying her makeup for a scene in Berlin Alexanderplatz, *Munich, 1980.*

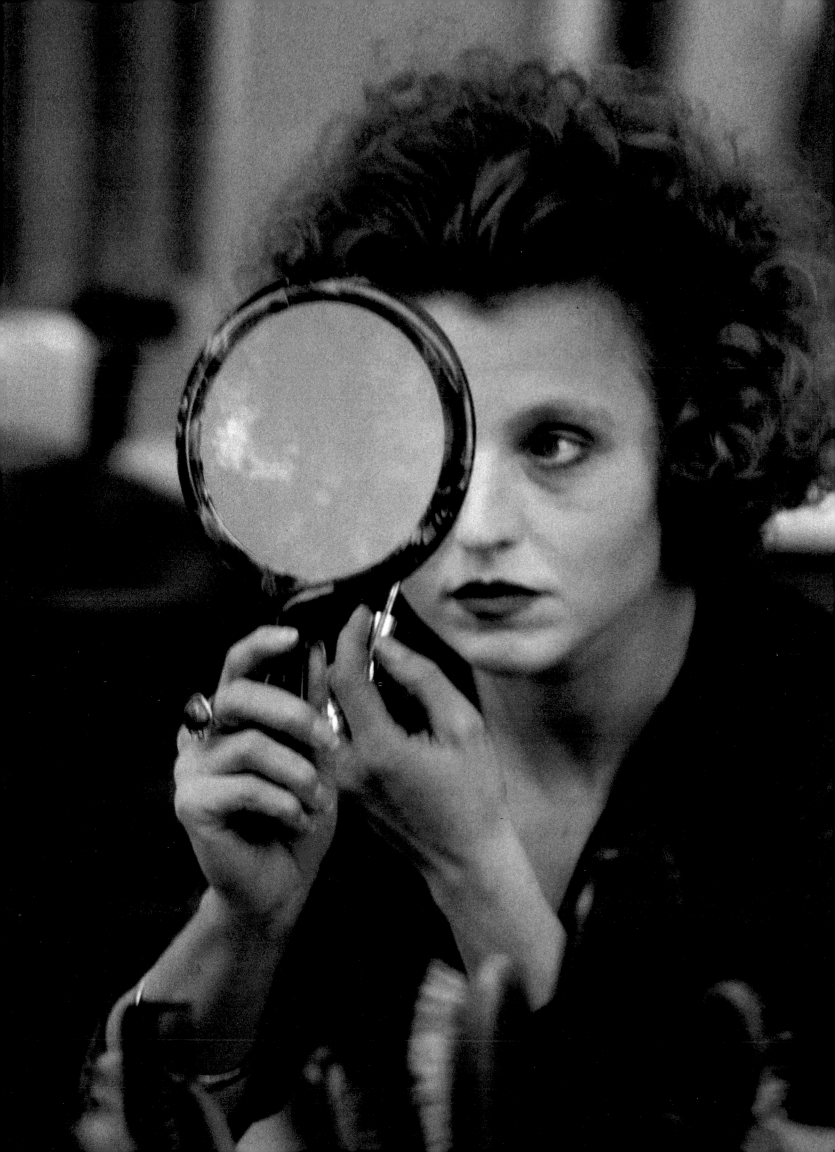

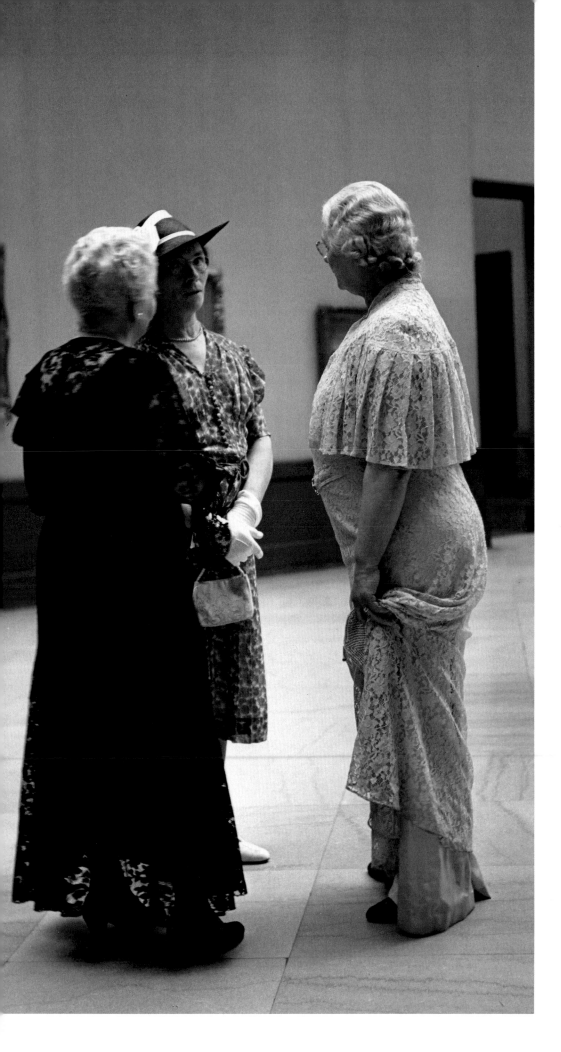

LEFT: *A gala opening at the Toledo Museum of Art, Toledo, Ohio, 1939.*

ABOVE: *Nineteenth-century gowns in Dukes County Museum, Edgartown, Martha's Vineyard, 1968.*

RIGHT: *Hedda Hopper at Laguna Beach, 1949. Eisie caught the gossip columnist saying: "Definitely not!"*

FAR RIGHT: *Dame Ninette de Valois rehearsing dancers of Sadler's Wells Ballet (now the Royal Ballet), London, 1951.*

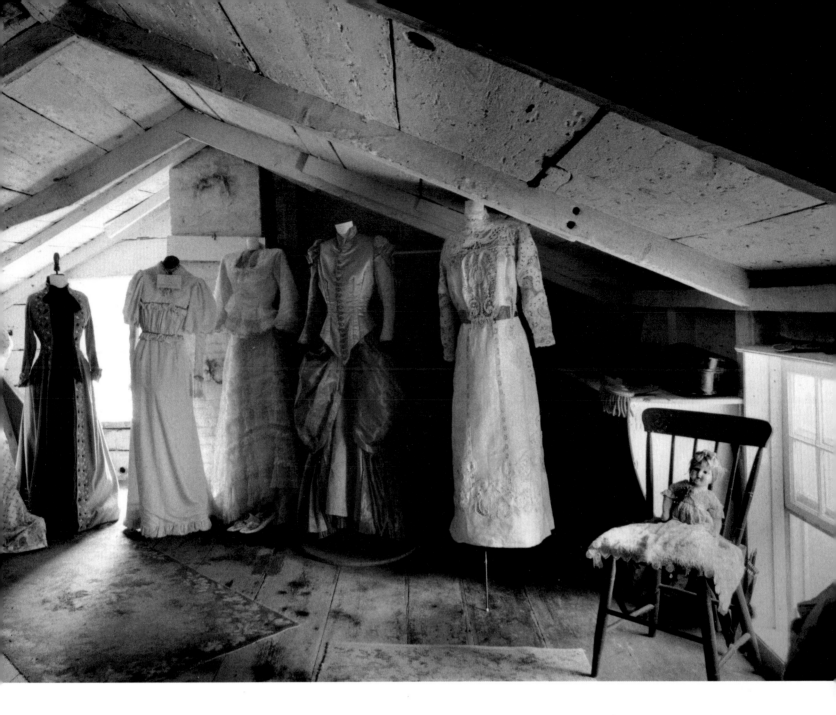

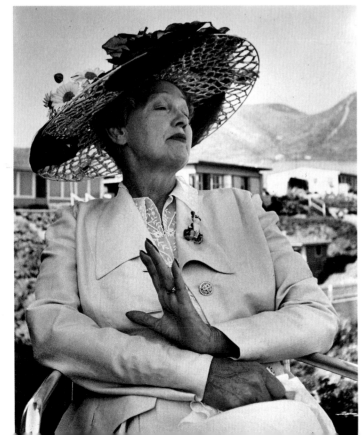

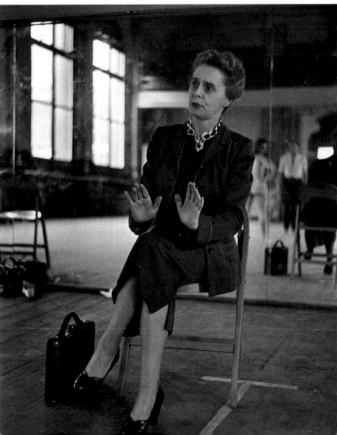

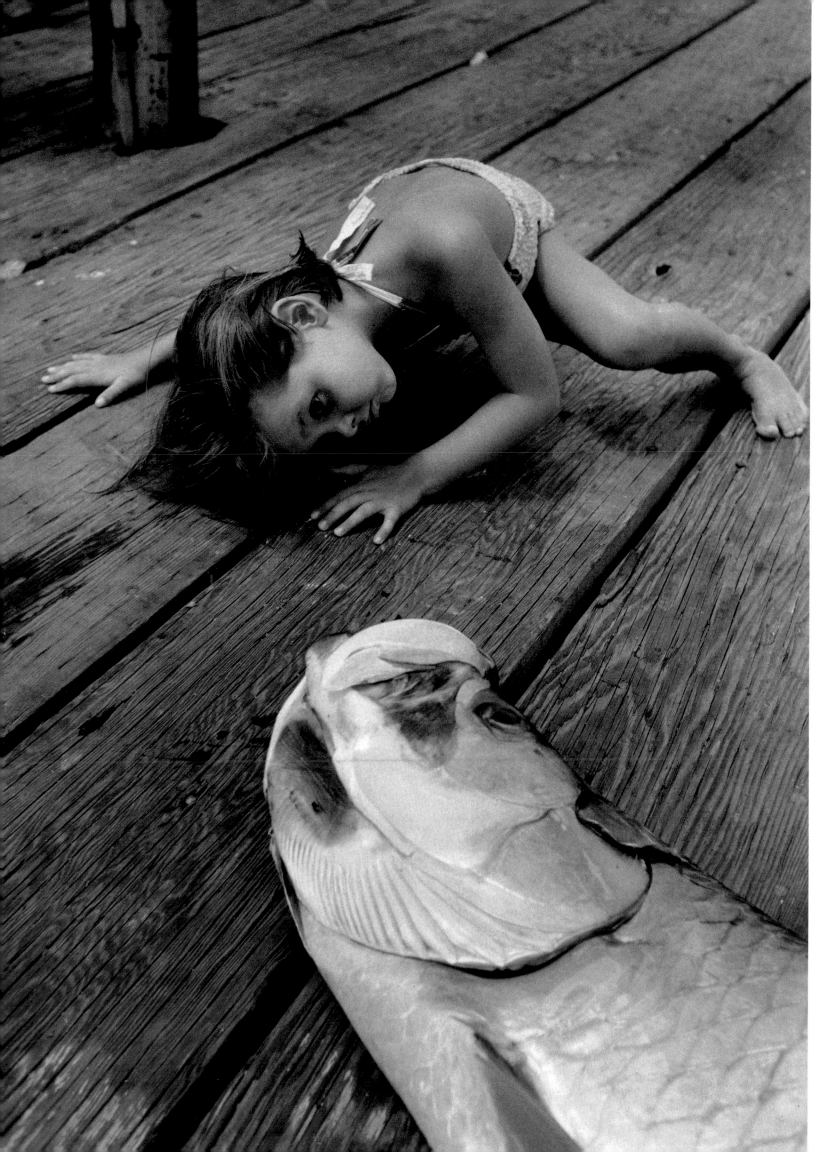

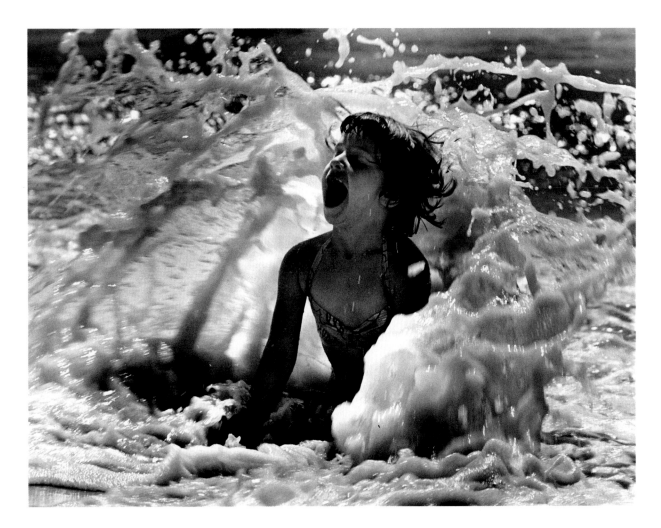

*Eisenstaedt caught the unrestrained glee
of a child playing in the surf at Jones
Beach, Long Island, 1951.*

*A small girl marvels at a just-caught
fish, Sarasota, Florida, 1956.*

OVERLEAF:
*Children watching the story of "Saint
George and the Dragon," at the puppet
theater in the Tuileries, Paris, 1963.
Eisie had crouched down in front of the
children, who became so emotionally
involved in the play that, by the time the
dragon was slain, they were totally
unaware of the photographer's presence.*

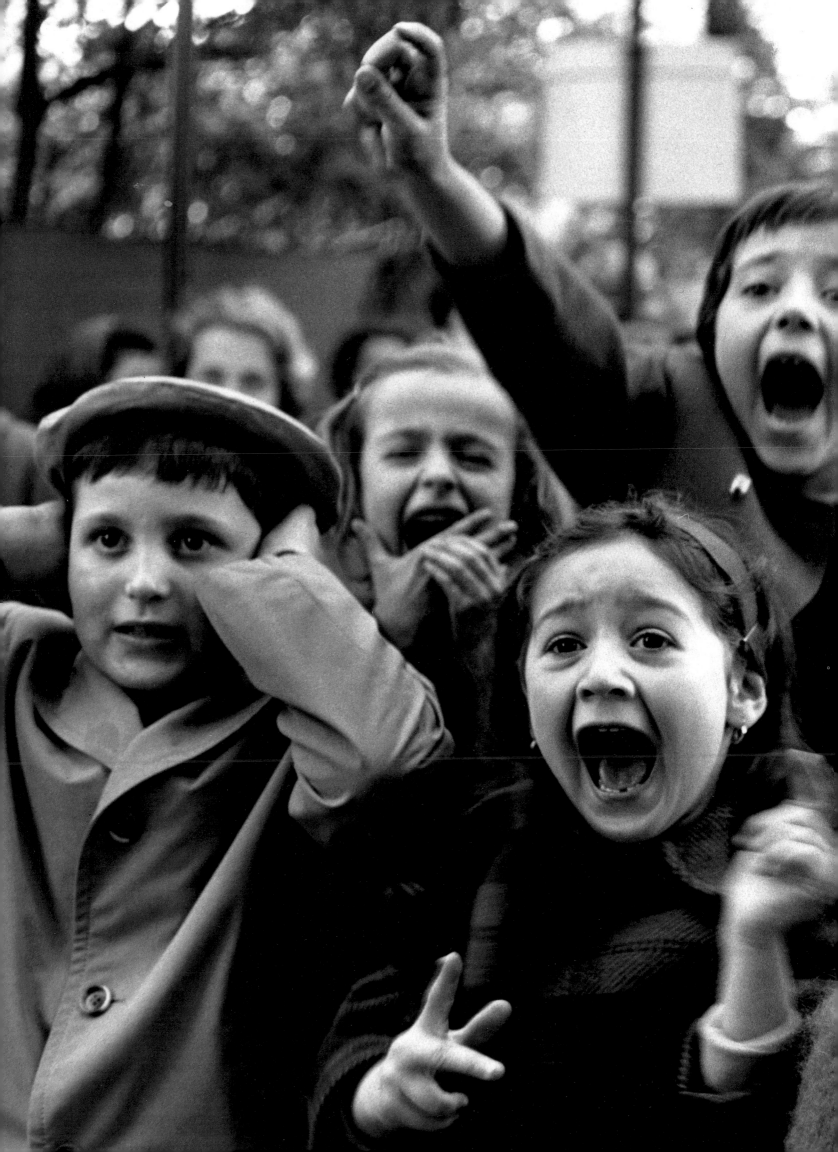

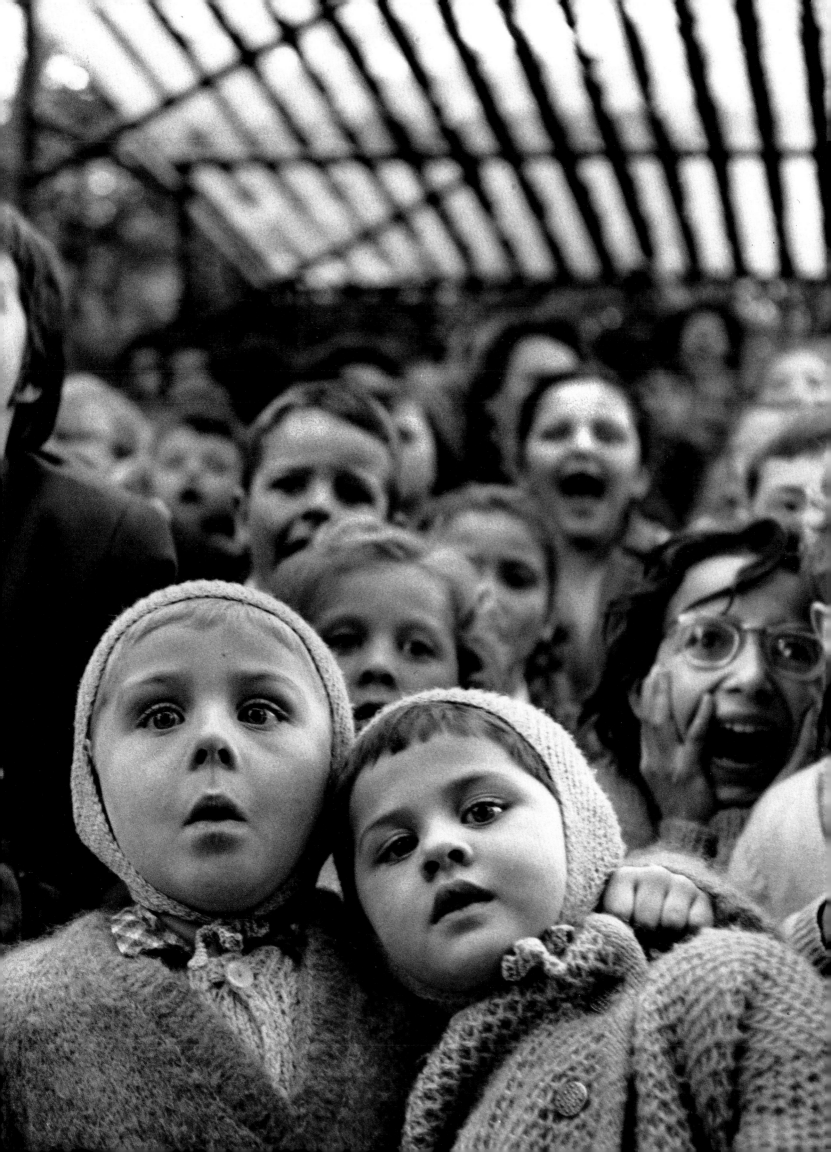

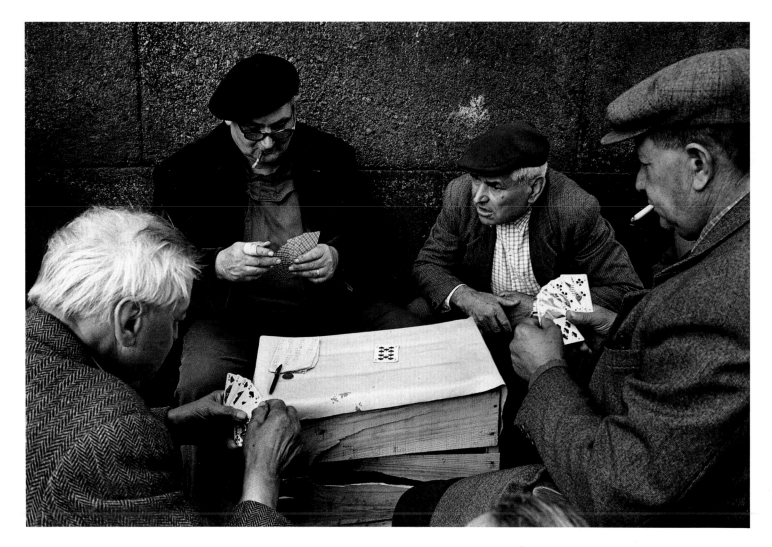

Card players on the Ile de la Cité, Paris, 1963.

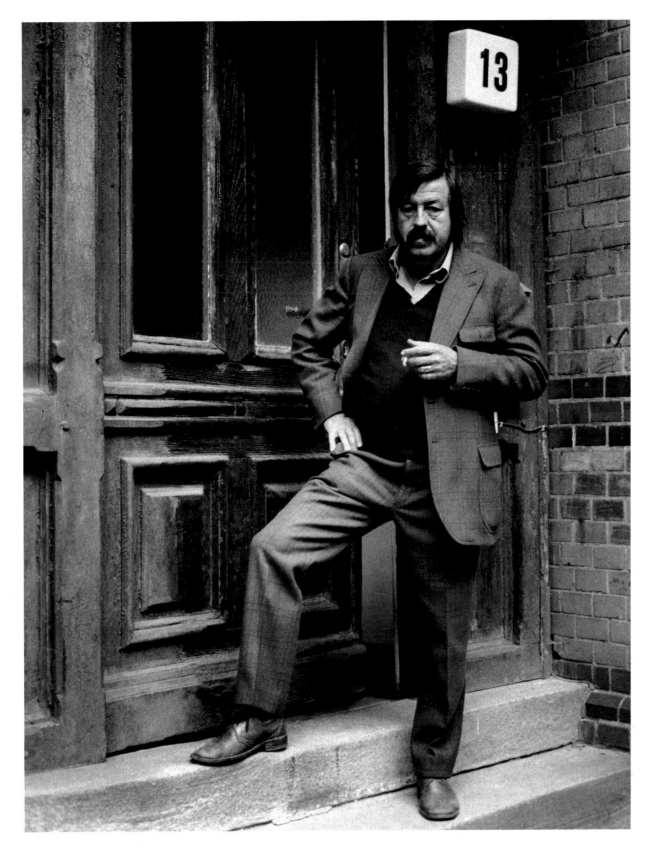

*German novelist Günter Grass standing
at the doorway of his home in West
Berlin, 1979.*

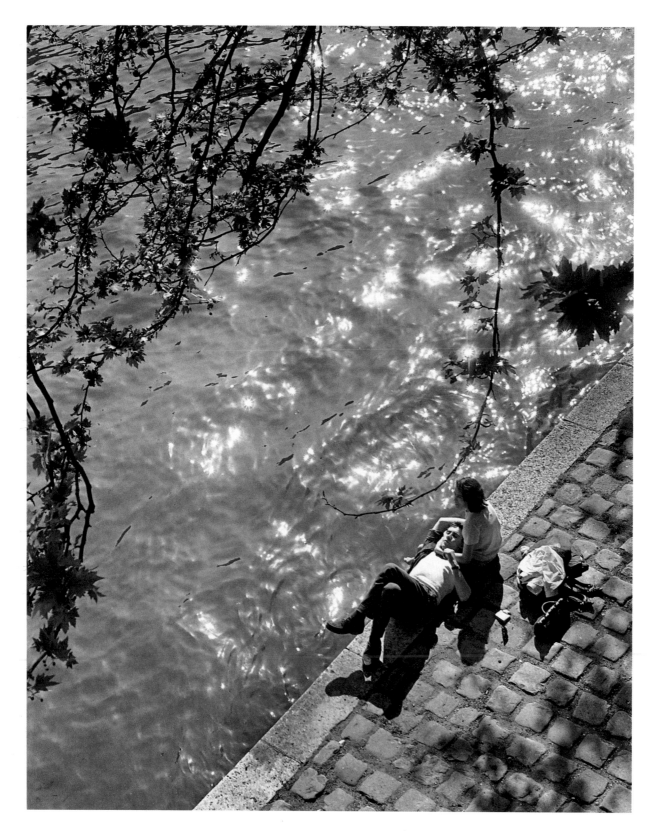

*A young couple enjoying lunch on the
Right Bank of the Seine, just below
Notre Dame, Paris, 1963.*

*A courtyard and a curving staircase,
Paris, 1963.*

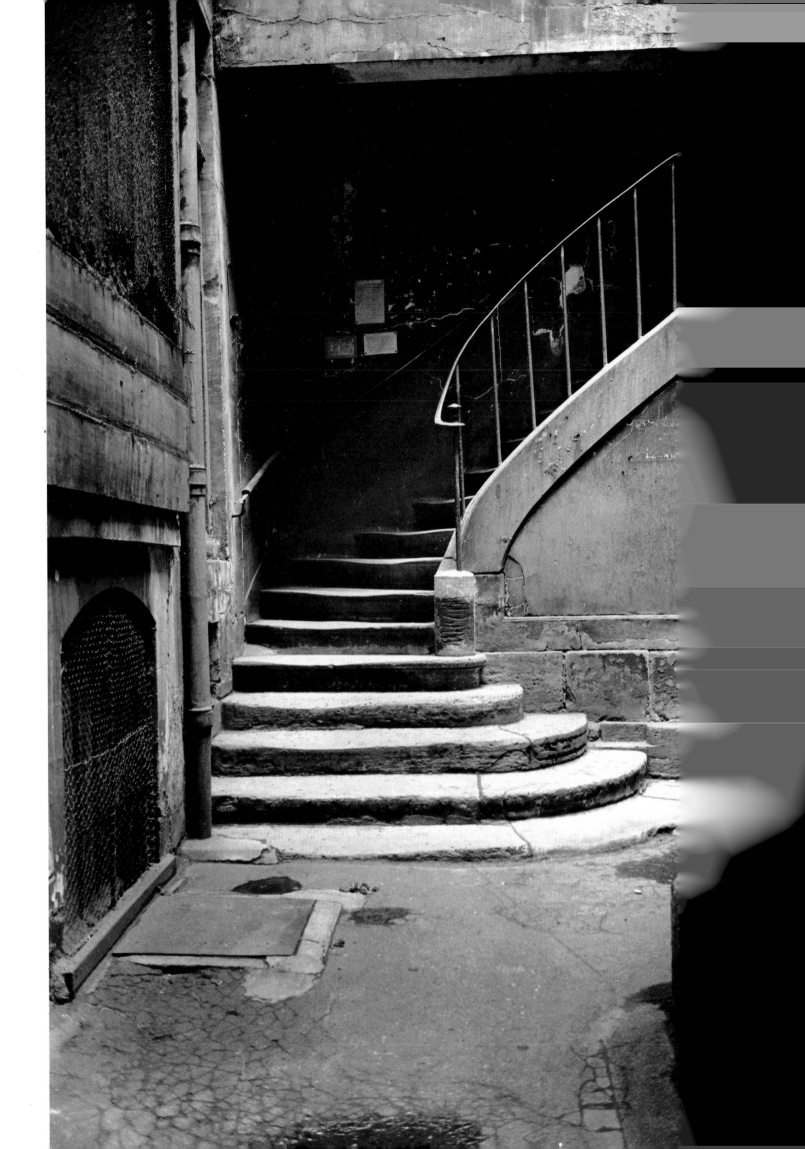

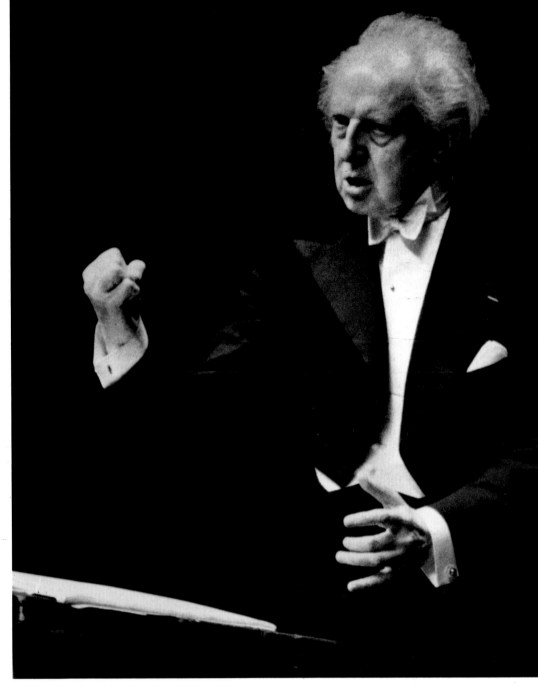

Lylah Tiffany playing the accordion and begging from passersby at a side entrance to Carnegie Hall, New York City, 1960. The eighty-year-old musician lived in a studio at the hall and supported herself in this way. At this time, much of the musical activity in New York was shifting to the partially completed Lincoln Center for the Performing Arts, and Isaac Stern and other musicians were leading a fight to prevent the destruction of the venerable building. From a photographic essay about the many facets of life at Carnegie Hall.

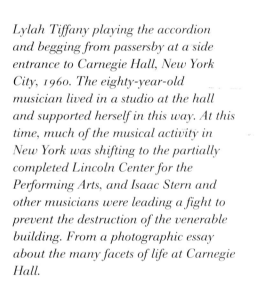

Leopold Stokowski conducting at Carnegie Hall, 1960.

Alma Mahler closes her eyes in concentration as she listens to a rehearsal of her husband Gustav's Second Symphony, "The Resurrection," conducted by Leonard Bernstein at Carnegie Hall, 1960.

121

French composer Darius Milhaud in residence at the University of Iowa, 1961.

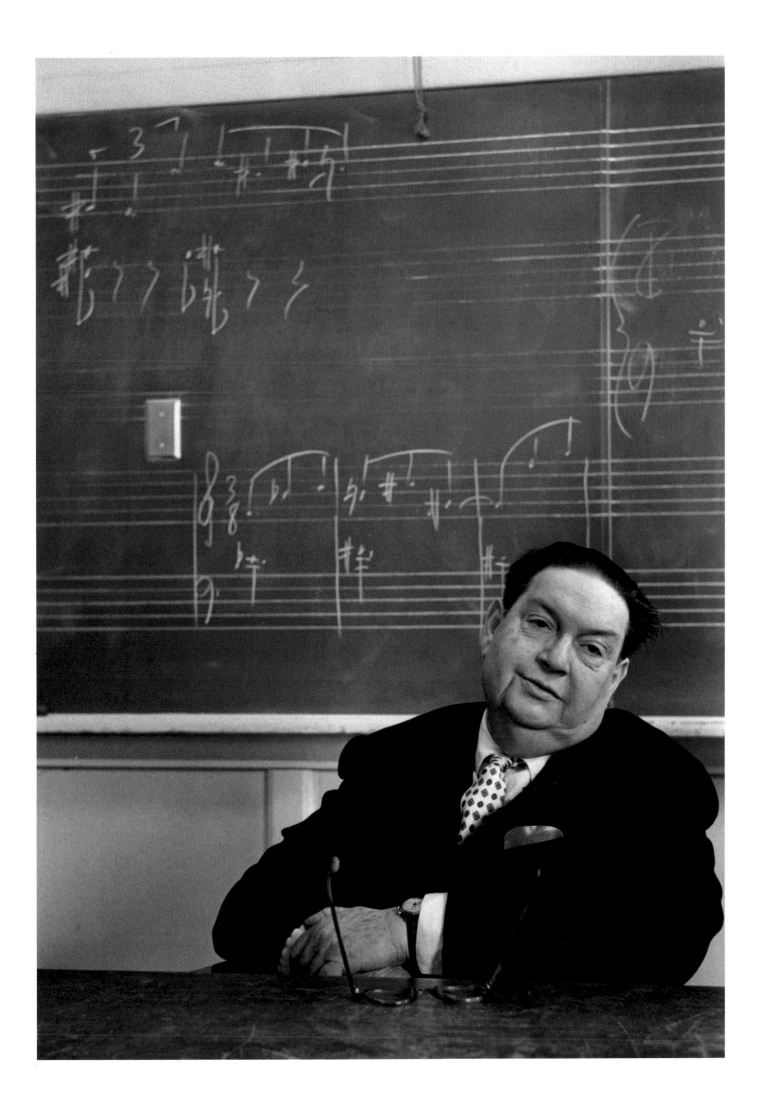

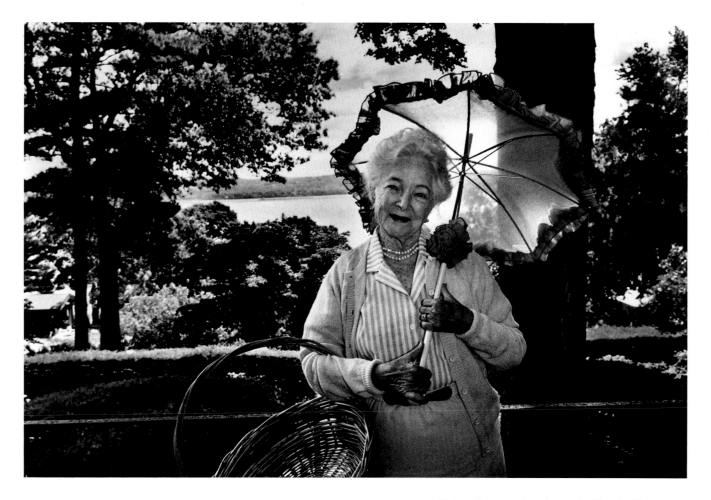

Helen Hayes at her home in Nyack, New York, 1986. In the background is the Hudson River. Eisie had photographed the renowned actress once before, during a performance on radio in 1936.

Gordon Parks, a fellow photographer and a multitalented man for whom Eisie has great respect and admiration, New York City, 1980.

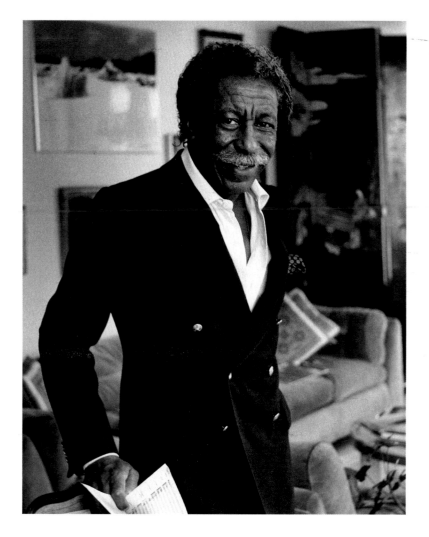

Norman Rockwell in his studio, Stockbridge, Massachusetts, 1974.

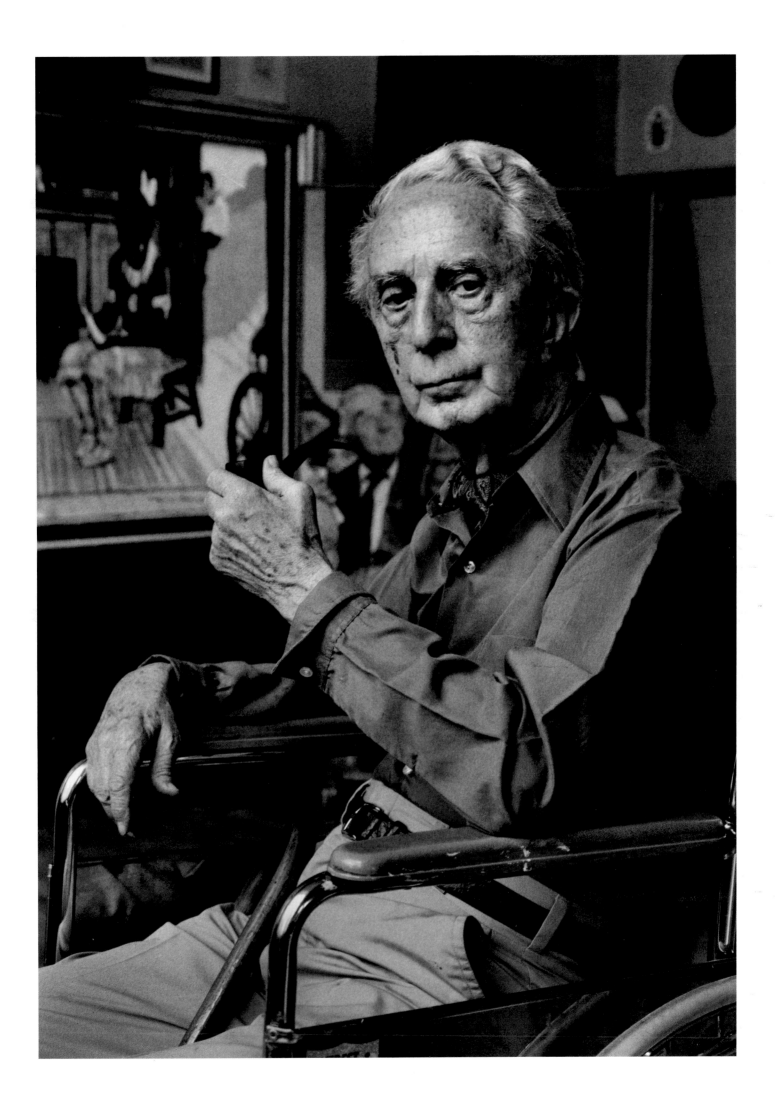

Dame Rebecca West, London, 1979.
From a photographic essay showing
eminent octogenarians who were
still engaged in creative work. Eisie
himself was eighty at the time.

English sculptor Henry Moore at his
home in Much Hadham, Hertfordshire,
1979. He is holding a stone he found
along the shore at Fécamp, France, on
the English Channel. Moore felt that the
holes in such stones emphasized their
three-dimensional quality, and he often
used them as inspiration for his vast
sculptures.

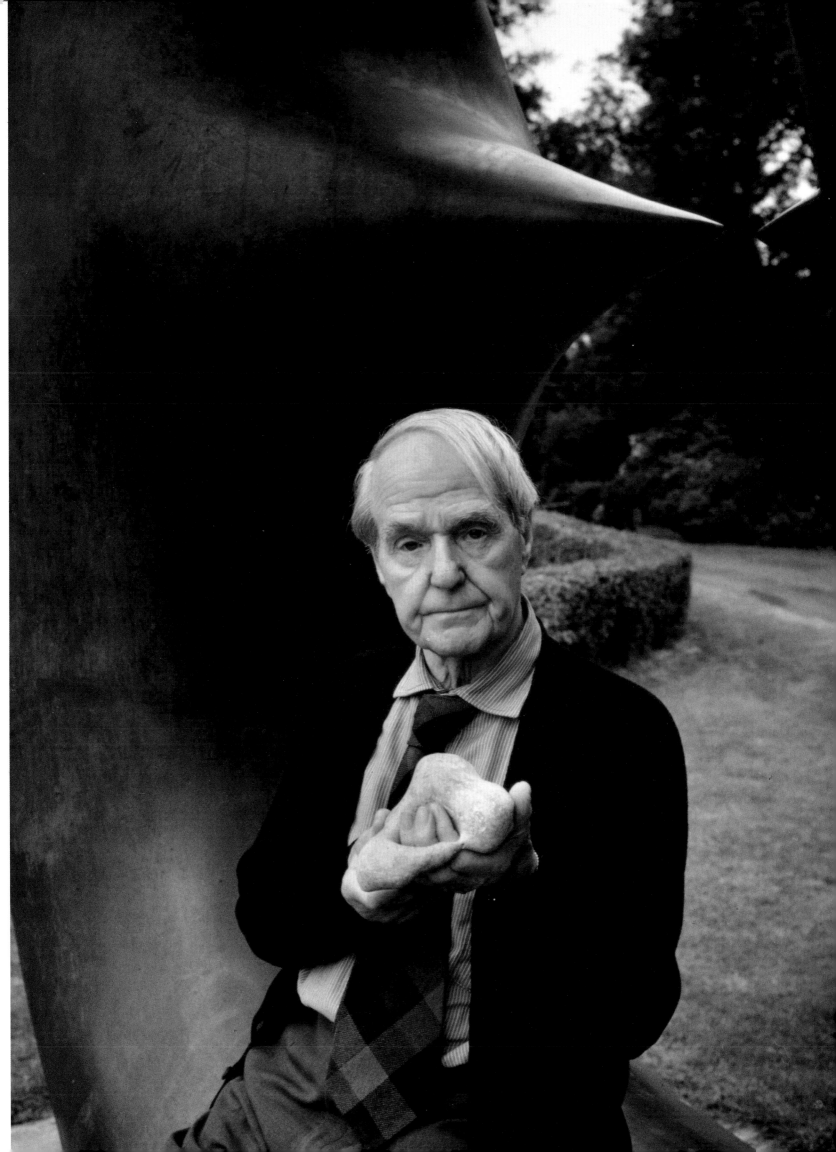

Gilbert Murray, a great English classical scholar, Oxford, 1951. His translations of the works of the Greek writers have become standards in the literature.

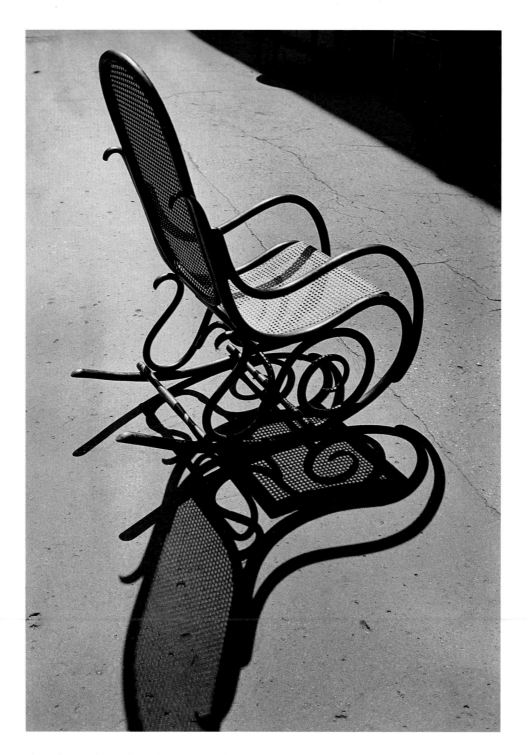

A wicker rocking chair for sale in a flea market, Paris, 1963.

Shadows cast in the early morning light, Nantucket, 1969.

OVERLEAF:
Menemsha Harbor, Martha's Vineyard, 1951. Since 1937, Eisie has spent part of each summer on the island, and many of his loveliest photographs were taken there.

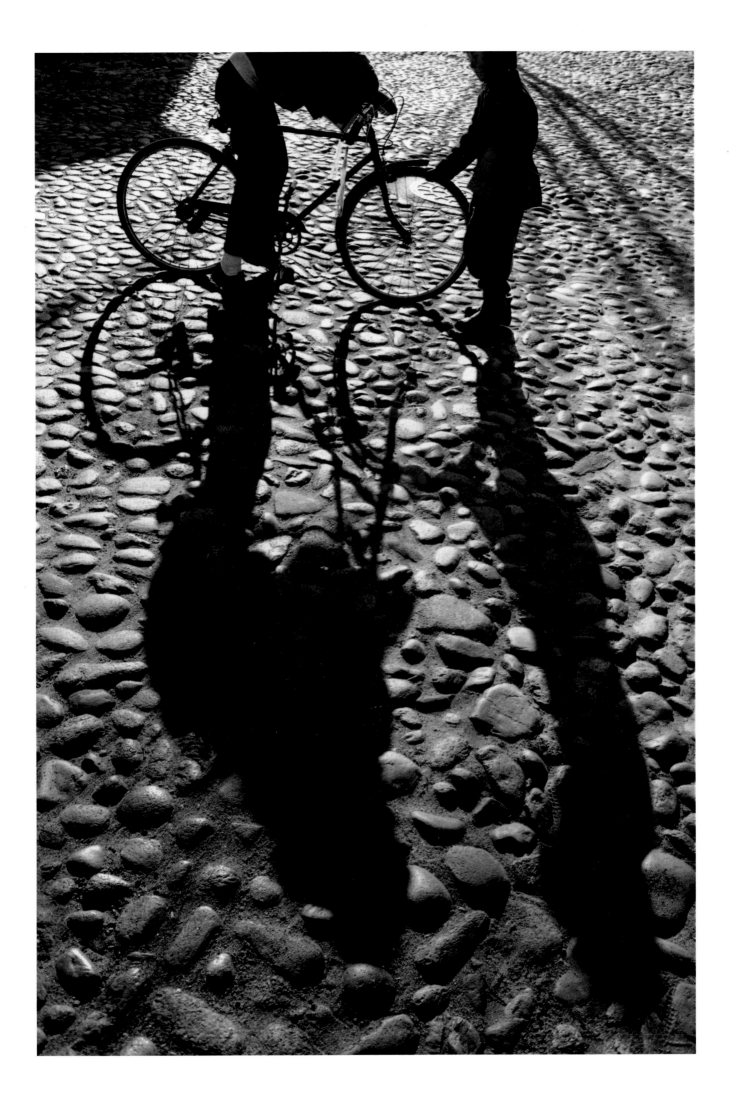

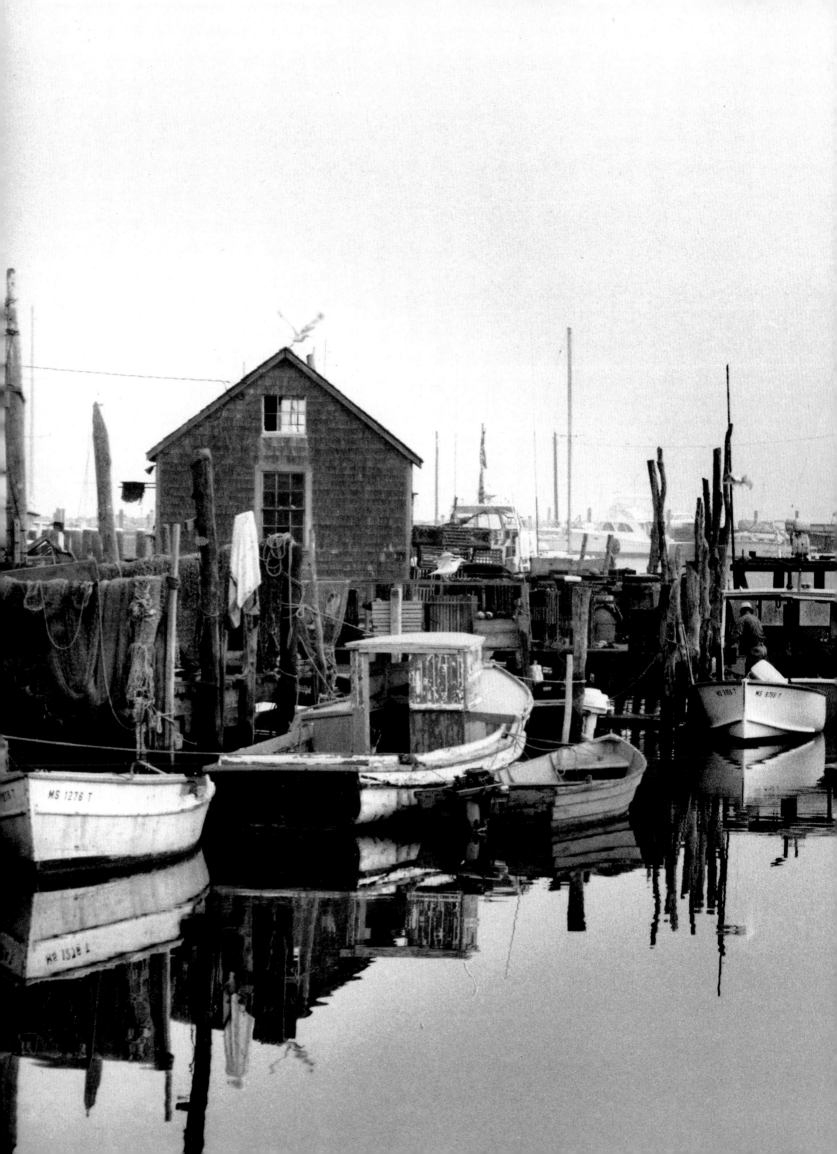

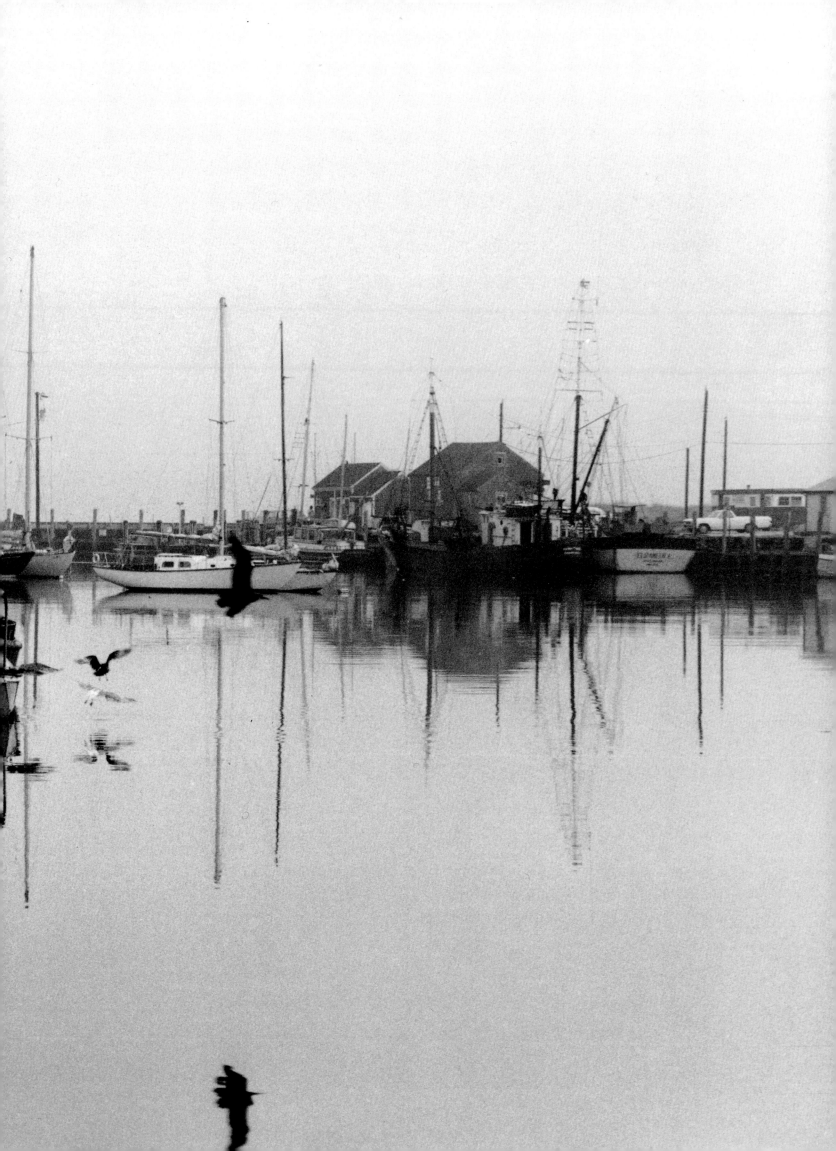

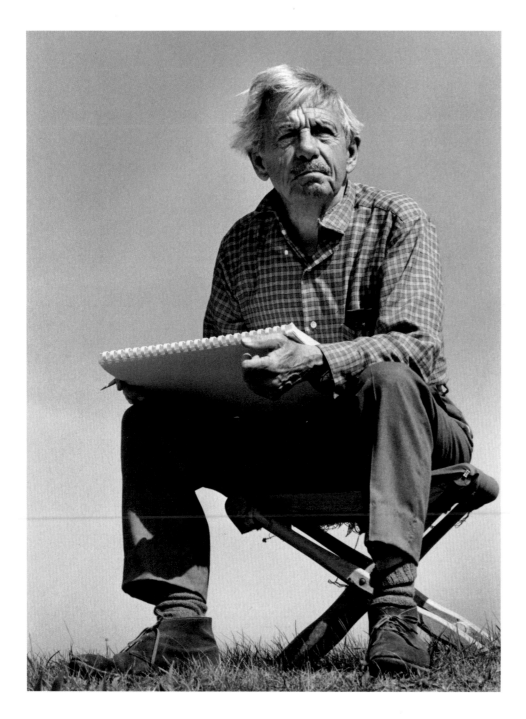

Artist Thomas Hart Benton sketching at Gay Head, Martha's Vineyard, 1969.

Eisenstaedt waited almost two hours for this sailboat, which he had spotted in the distance, to reach the point where he wanted it to be, Gay Head, 1966. An example of the importance of patience to the making of a good photograph.

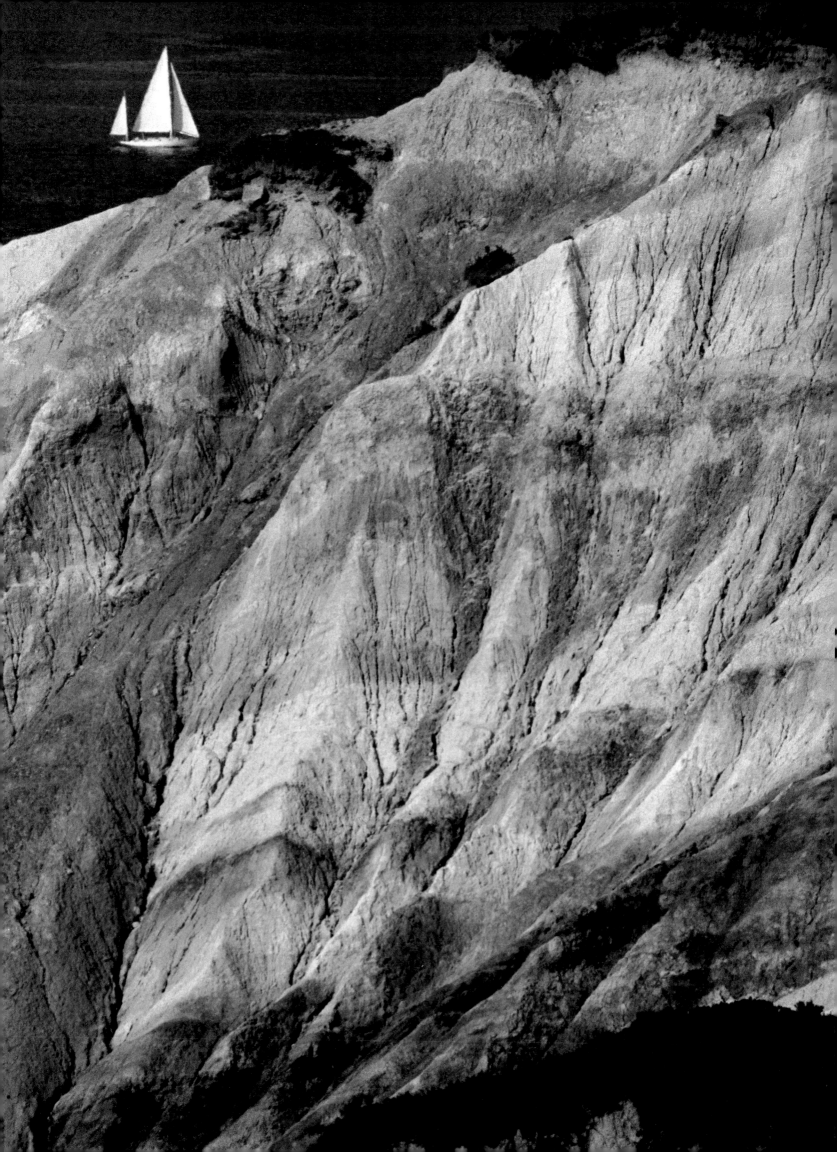

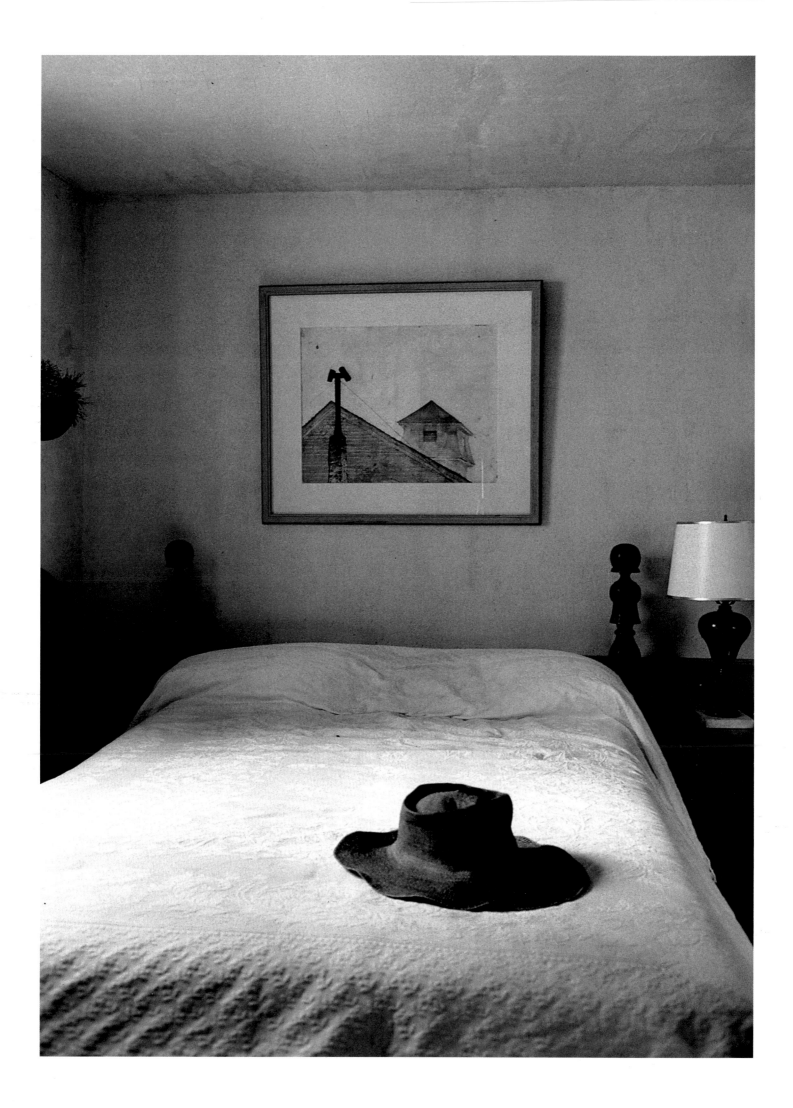

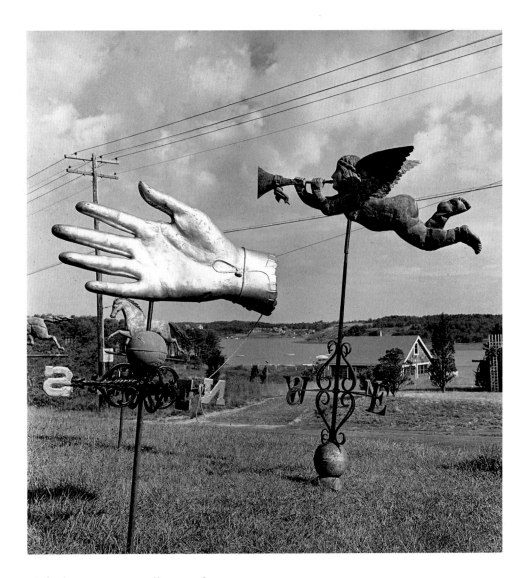

*A dealer in antiques offers weather
vanes for sale in Vermont, 1940.*

OVERLEAF:
*A giant white oak, North Tisbury,
Martha's Vineyard, 1968. Thought to be
between 150 and 200 years old, this tree
is still standing.*

*Andrew Wyeth's bedroom, Cushing,
Maine, 1965.*

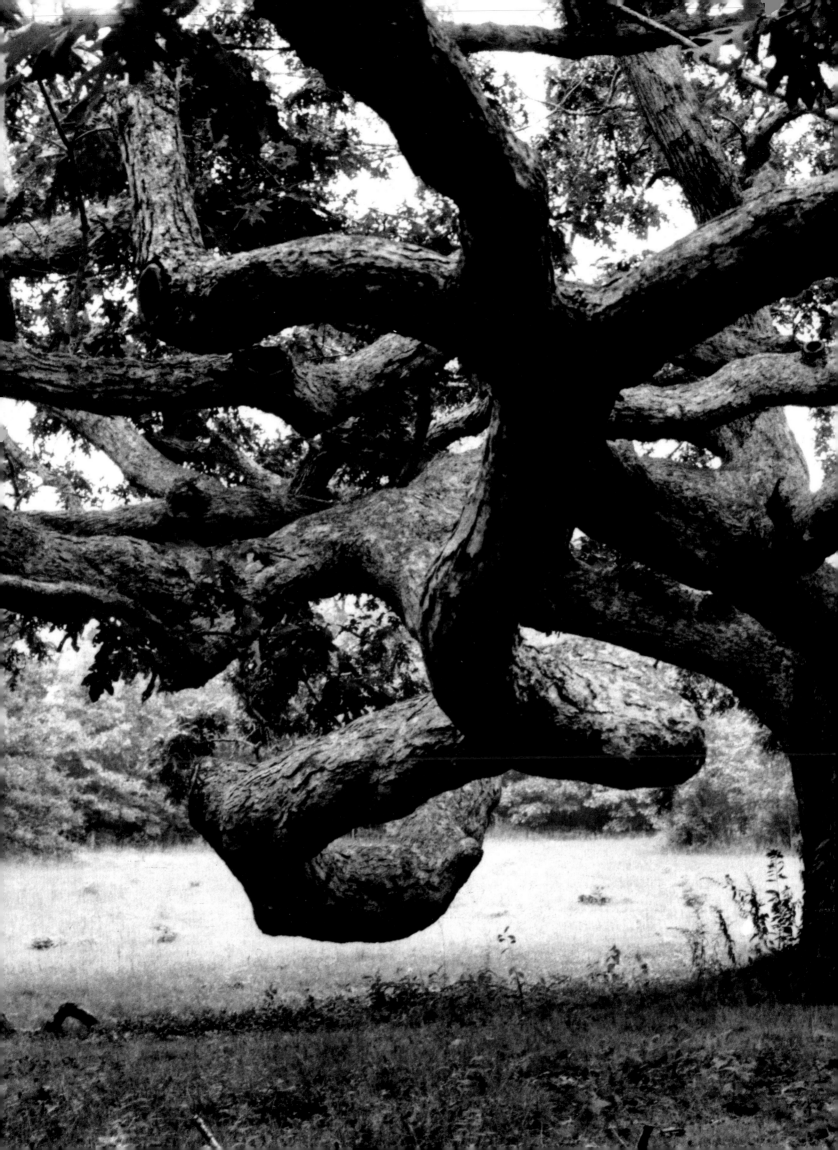

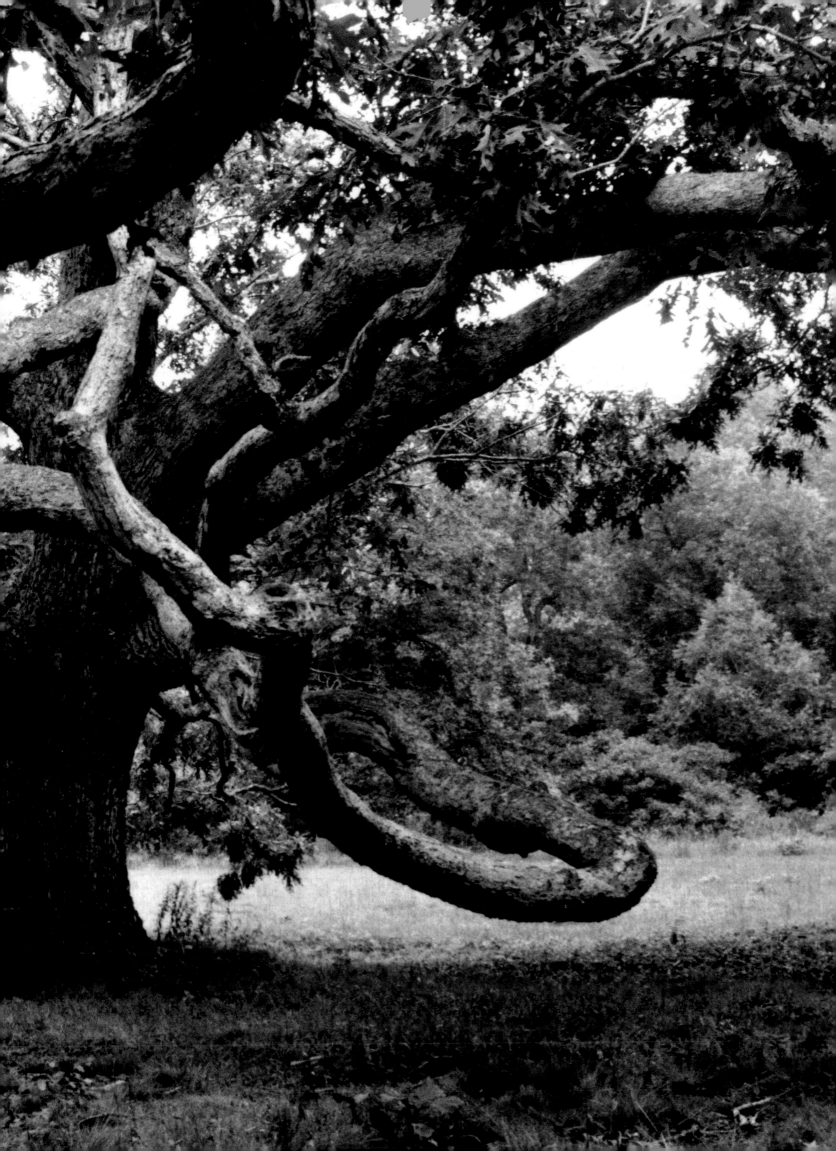

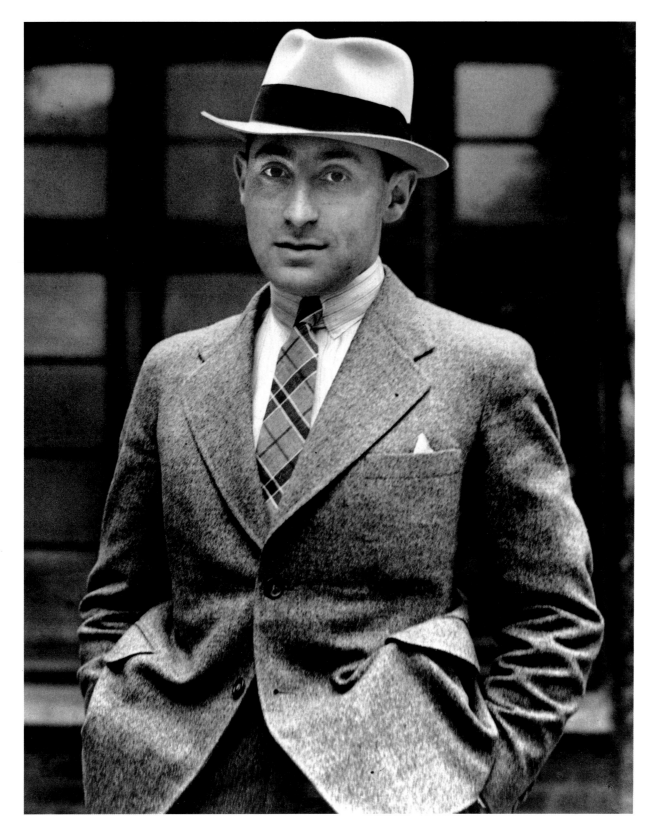

Alfred Eisenstaedt as a young man in London, 1932.